I0235809

IMAGES
of America

SAN FRANCISCO'S
BERNAL HEIGHTS

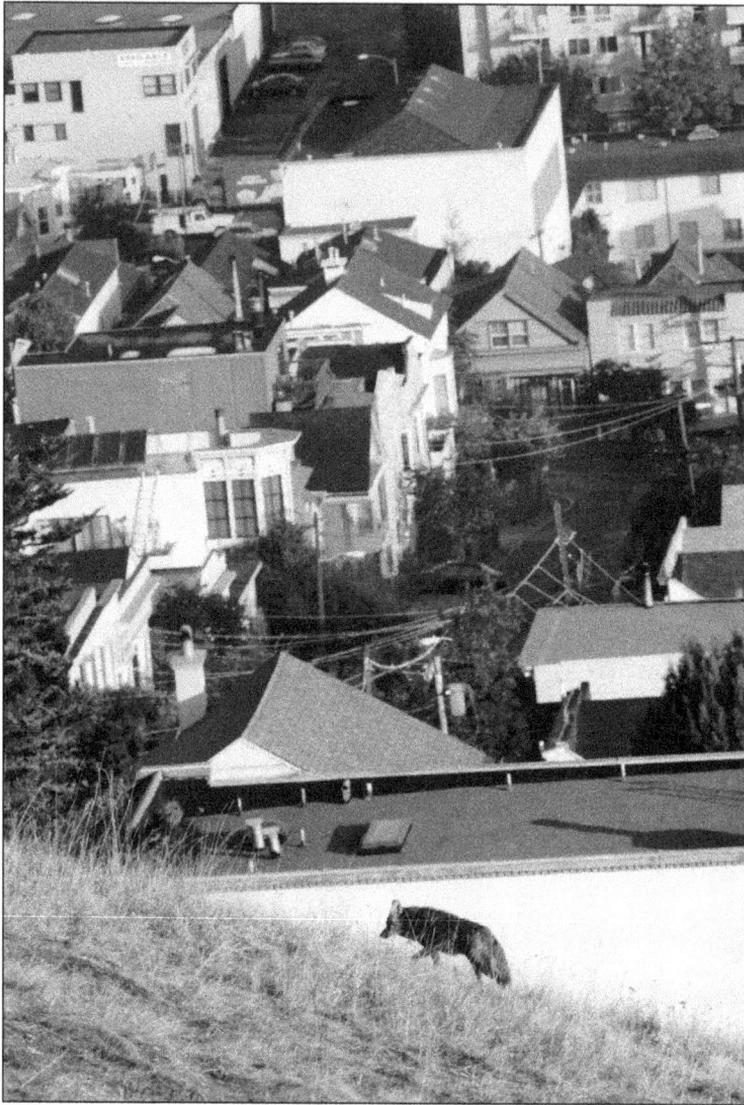

Some of the wild things have returned to Bernal Heights. A coyote mysteriously appeared to take up residence several years ago and became an instant icon. Nobody knows how it traveled here, but dog walkers still catch glimpses of the animal patrolling Bernal Hill. On the north slope, close to houses and with St. Anthony's School in the background, the coyote seems perfectly at home. The latest arrivals are a pair of great horned owls. (Courtesy Anna Kuperberg.)

ON THE COVER: In the late 1920s and early 1930s, the San Francisco Seals sponsored the annual Baseball Hunt, in which baseballs, including one ball painted gold, were hidden around the top of Bernal Heights. Horsemen in full cowboy regalia held the crowd back. A municipal band played. Finally, a local dignitary, often Mayor "Sunny" Jim Rolph, gave the word to go and the hunt was on. Each ball unearthed won a prize; the golden baseball won the grand prize, maybe a bicycle. Seals players would also autograph the balls. Jim Gleason remembers attending at age 12, next to Joe DiMaggio, who played for the Seals for three years before going up to the Yankees. Other neighbors remember getting up early and sneaking up to unearth balls before everyone got there. (Courtesy Kristen and Jeff Daniel.)

IMAGES
of America

SAN FRANCISCO'S
BERNAL HEIGHTS

Bernal History Project
Foreword by Carl Nolte

Bernal History Project:
Tim Holland
Sheila Mahoney
Molly Martin
Terry Milne
Valerie Reichert
Vicky Walker (editor)

ARCADIA
PUBLISHING

Copyright © 2007 by Bernal History Project
ISBN 978-1-5316-2899-4

Published by Arcadia Publishing
Charleston, South Carolina

Library of Congress Catalog Card Number: 2006939749

For all general information contact Arcadia Publishing at:
Telephone 843-853-2070
Fax 843-853-0044
E-mail sales@arcadiapublishing.com
For customer service and orders:
Toll-Free 1-888-313-2665

Visit us on the Internet at www.arcadiapublishing.com

*Dedicated to Elizabeth "Lee" Egger, born and raised on Bernal Heights
and longtime Bernal historian.*

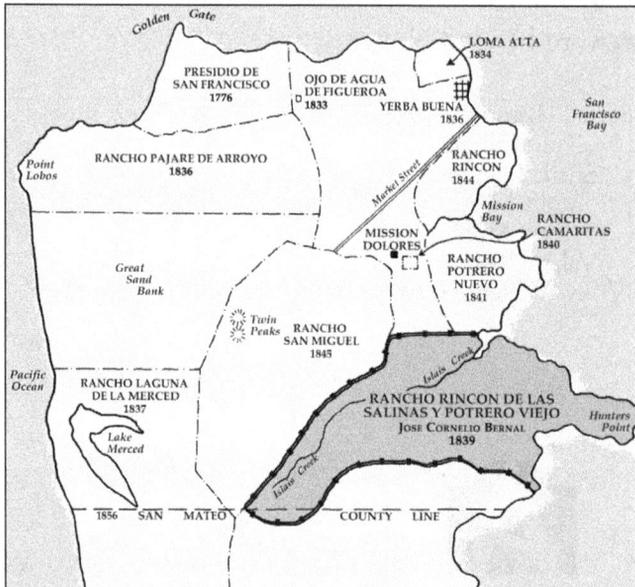

Two adjoining parcels were granted to Jose Cornelio Bernal in 1839 and 1840. The name Rincon de las Salinas y Potrero Viejo (corner of the salty marsh and the old pasture) still appears on government maps. When Mexico secularized the missions in 1834, prominent residents applied for grants. The Bernal land grant was approximately 20 percent of present-day San Francisco. (Courtesy Anne Batmale.)

CONTENTS

Acknowledgments 6

Foreword 7

1. In the Beginning 9

2. Earthquake, Fire, and Aftermath 31

3. A Neighborhood Grows Up 39

4. Faces of Bernal Heights 75

5. The Little Town in the Big City 101

ACKNOWLEDGMENTS

The generous people of Bernal Heights helped put this book together, and we thank them all. Without their photographs, family stories, and knowledge, this project would not have been possible. All of them had a deep appreciation and lasting love for the neighborhood. We tried to incorporate as much of their spirit as we could into this book.

The following were of special service: Jeanne Hangauer and Taina Kissinger of Visual Presentation, archivist extraordinaire Greg Gaar, our librarian Lisa Dunseth, the Egger family, Philip Hoffman, Max Kirkeberg, Gloria Wiegner Lane, Mary Marchetti, and Ebbe Yovino-Smith. We also thank Anne Batmale, Bill Cassidy, Patricia Paton Cavagnaro, Marie Driscoll, Katherine Du Tiel of the SFPUC Archive, Tom and Walt Ferenz, Walter and Fern Feyling, Betty Mikulas Kancler, Tim Kelley, Erik and Carolyn Lund, Carmen Magana of the SF Muni Archive, Elizabeth Hird Mikulas, Petrina Caruso Paton, our Arcadia editor John Poultney, Mary Ramirez, the staff at the San Francisco History Center, Jerry Schimmel, Herb and Emilia Smith, and Janet Mikulas Thompson.

All of these people and many more contributed: Marie Annuzzi, the Ayoob family, Bernice Bidwell, Janet Bowker, Chris Carlsson, Phil Canevari, Florence Cepeda of California Pacific Medical Center/Archives, Roseann Cirelli, Kristen and Jeff Daniel, Carole Deutch, Theresa Dorn, Carol Eversole, Allen Foy, David Gallagher, Roger Giovannetti, Jim Gleeson, Cathie Guntli, Lurilla Harris, Beverly Hennessey, Naomi Hui Hui, Ed Huson, Ben Jones, Joel Kamisher, Woody LaBounty, Peter Linenthal, Lynn Ludlow, Gloria McKay, Victoria Mahoric, Rochelle Mankin, Phiz Mezey, Nancy Mifflin Keane, Paul Miller, Diane Mode Smith, Doug Mount, Yvette and Manuel Neves, Carl Nolte, Greg Pabst, Melissa Peabody, Jacque Phillips, Ray Rainford, Violetta Reiser, Spain Rodriguez, the San Francisco Labor History Archives and Research Center, Jack Tillmany, Amy Trachtenberg, Flora Valente, Rose Cozzo Vallerga, Jane Weems, George Williams, Sylvia Williams-Reed, Linda Wobbe of St Mary's College archive, Larry Wonderling, and all the others who took time to show us their archives and tell us their stories.

This book is an effort to illuminate the unique character of our neighborhood. The Bernal History Project was initiated by Bernal Heights Preservation: Valerie Adamson, Dennis Davenport, James Frame, Kendall Goh, Wade Grubbs, Tim Holland, Rolf Kvalvik, Arthur Levy, Rosanne Liggett, Sheila Mahoney, Molly Martin, Antoinette Meza, Terry Milne, Jacalyn Morri, Tom Pugh, Valerie Reichert, Ginger Rhea, Andre Rothblatt, Gail Sansbury, Vicky Walker, and Peter Wiley.

www.bernalheightspreservation.org
www.bernalhistoryproject.org

FOREWORD

The Bernal Heights neighborhood in San Francisco is built on the gentle slopes of one of the hills that make the city famous. The district has narrow streets, colorful older houses, and great views. The residents of Bernal Heights think of their neighborhood as special—a somewhat obscure little town surrounded by a world-famous big city, like an island.

The neighborhood has distinct boundaries—Mission Street is the western edge, Cesar Chavez Street is the northern one. On the east and south, the neighborhood is nearly circled by freeways—the Bayshore on the east and the Interstate 280 on the south. Everything outside those boundaries is somewhere else.

Bernal Heights itself—the 440-foot-tall hill that is the centerpiece of the neighborhood—is very old. Its core is a dark-reddish rock called Franciscan formation chert. This part of California was once at the bottom of the sea, and the bedrock of Bernal Heights is made up of compressed tiny sea creatures.

The first people here were Native Americans, members of a loose tribe called the Ohlone. Many of them lived in a village along the shores of a saltwater lagoon near what is now Sixteenth Street, about a mile from Bernal Heights. They lived a simple, idyllic life, fishing in the nearby bay, catching animals and birds. There were grizzly bears, much feared, and small animals the Ohlone caught and skinned to make clothes.

In the fall of 1769 came strange bearded men riding horses. They discovered a harbor, which they said was big enough to hold all the ships of the King of Spain. The Ohlone, of course, had no ships and had never before heard of the King of Spain. But the Spanish saw a fair land, and they came and took it.

In 1776, a party of Spanish colonists came and founded a mission they named for St. Francis on the shores of a lagoon they called Dolores. Among the colonists were Juan Francisco Bernal, with his wife and seven children. One son was Jose Cornelio Bernal, born in 1796. Jose was a soldier like his father, and in 1839, the governor of Alta California gave him a land grant—4,446 acres in what is now San Francisco, called the Rancho Rincon de las Salinas y Potrero Viejo. The land was open, rolling pasture, good for cattle and sheep. In 1844, Jose Bernal built an adobe house near the Mission Road. It was the first house in the area.

In the summer of 1846, the U.S. Navy seized the little town on the shores of San Francisco Bay. They replaced the Mexicans, who had replaced the Spanish, who had replaced the Ohlone people. It was a pattern of immigration that has marked San Francisco and its neighborhoods in all of its history.

In 1848, the Americans discovered gold in California and set off one of the greatest mass migrations in history—the California Gold Rush. By 1850, only 11 years after the soldier Jose Cornelio Bernal got his land grant, California was the newest state in the United States.

At first, the Gold Rush had no impact on Bernal Heights. The infant city of San Francisco was miles away. Bernal Hill was a cow pasture out in the country. But in 1863, a railroad linking San Francisco and San Jose was built out along the old Mission Road—the El Camino Real of the Spanish days. The railroad meant that Bernal Heights was accessible to downtown.

In the 1860s, too, land developers saw a chance to sell lots and houses in what was then called South San Francisco. A horsecar line to downtown San Francisco was built out along Valencia Street to terminate out in the country near present-day Cesar Chavez Street.

In 1863, the year the railroad came to the fringes of Bernal Heights, the Catholic Church opened the brand-new St. Mary's College on the southern edge of Bernal. The location was windswept

and the students were few, but the residents of the southern part of San Francisco had a college and a station on a main-line railroad.

In 1876, there was even a short-lived "gold rush," when prospectors mistook some quartz for a mother lode.

In the 1880s, Hubert Howe Bancroft relocated his huge history library to Valencia and Army Streets, and in 1883, Valencia Street's one horsecar line was converted to the newest thing in transit—cable cars.

One might think that the Bernal Heights neighborhood turned into something big. But it did not. In 1889, the college moved to Oakland; in 1906, Bancroft's library moved to Berkeley.

There were only a few houses on Bernal Heights; there was a toll road; and the little commercial district along the grandly named Cortland Avenue was pretty small potatoes.

The land was open and the streets were unpaved—dusty in summer and muddy in winter. There were a few grand houses but not many. Most of the residents were Irish immigrants; there were some Italians and Scandinavians. They were almost all working people: stonecutters, ship caulkers, and dairy farmers. They had a village mentality, too. People from the rest of the city were looked upon with suspicion. When the city's animal-control officers, who were paid a bounty to pick up stray animals, impounded a fine dairy cow belonging to a widow named O'Brien, local boys and men set the dogs on the animal catchers, beat them up, and told them never to return. The story of the widow O'Brien and her cow is still told in Bernal Heights, a sort of instructive legend of the independence and resolution of the people of the hill.

"Bernal Heights was so remote and inaccessible in the old days, that people were in the habit of relating apocryphal tales about the locality," wrote Edward Morphy in the *San Francisco Chronicle* in 1918.

It was a disaster—the great earthquake and fire of 1906—that put Bernal Heights on the city map. Nearly all of San Francisco was destroyed in a huge firestorm. But Bernal Heights, with its open hills, unpaved streets, and cow pastures, was both inexpensive and available.

Within a year of the disaster, 600 new homes were built on Bernal Heights. It was still a family neighborhood; there were big families, and most people had ordinary jobs. There were corner stores, butcher shops, and two movie theaters.

The old Market Street Railway extended a streetcar line out from Mission Street along Cortland Avenue. The streetcar was an important link to the city—hardly anyone in those days had an automobile. The old pictures show dirt streets and plenty of parking spaces.

World War II produced big changes in San Francisco and in Bernal Heights. New people moved in—African Americans and, after the war, many Filipinos and other Asians.

In the 1960s, a consulting firm recommended to the city that Bernal Heights be "redeveloped," which meant major changes to its character. "It's not like the city," the consultant's report states, "And though the houses are old and inexpensive, they have lots of possibilities."

But what the Bernal Heights people thought the city had in mind was redevelopment by bulldozer, and they were against it. There were huge rallies—crowds on the top of the hill waving signs and flags. The Bernal Heights residents turned up the heat; "Our area has 14,000 voters," a neighborhood paper pointed out, "Let's use our influence in a way City Hall understands." The spirit of the widow O'Brien's cow was still alive.

That was another Bernal Heights, too. By the 1970s, the neighborhood had a crime and neglect problem. In the 1980s, the Bank of America seriously considered pulling out of Bernal.

But by the 1990s, new waves of people from other parts of San Francisco, from other parts of the country, and from other lifestyles came. There was a large influx of gay and lesbian residents. People fixed up their houses, and once-dowdy Cortland Avenue, the district's main street, became trendy. Housing prices shot through the roof. But through it all, the neighborhood's special quality remains; it's still a small town in the city, snuggling around its hill like an urban island.

—Carl Nolte
Longtime Bernal Heights resident and reporter for the *San Francisco Chronicle*

One

IN THE BEGINNING

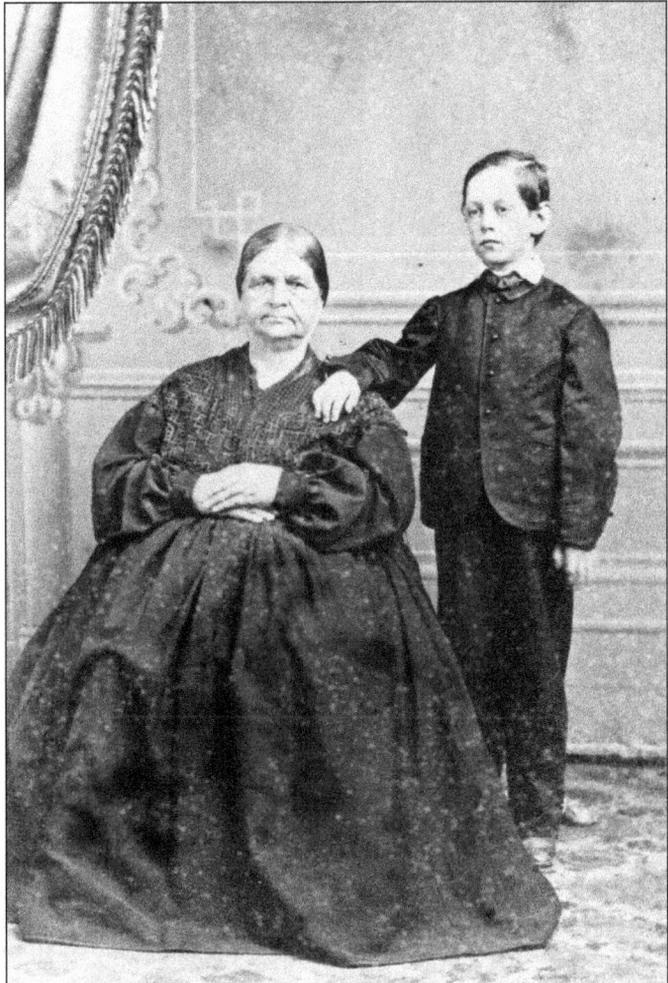

Carmen Sibrian Bernal was the widow of Jose Cornelio Bernal, the namesake of Bernal Heights. Jose received a land grant from the Mexican government and built an adobe ranch house where St. Luke's Hospital is today. Soon after receiving the grant, he died and left his widow to care for the property. She built a new home on San Jose Road, near the crossing of today's Mission Street and Ocean Avenue. From there she fought to legitimize the Bernal claim in U.S. courts. Although the Bernals won their extended legal battle, they lost all their land to lawyers' fees and foreclosed mortgages. This carte de visite shows Carmen with her grandson Jose Cornelio. (Courtesy California Historical Society, FN-30302.)

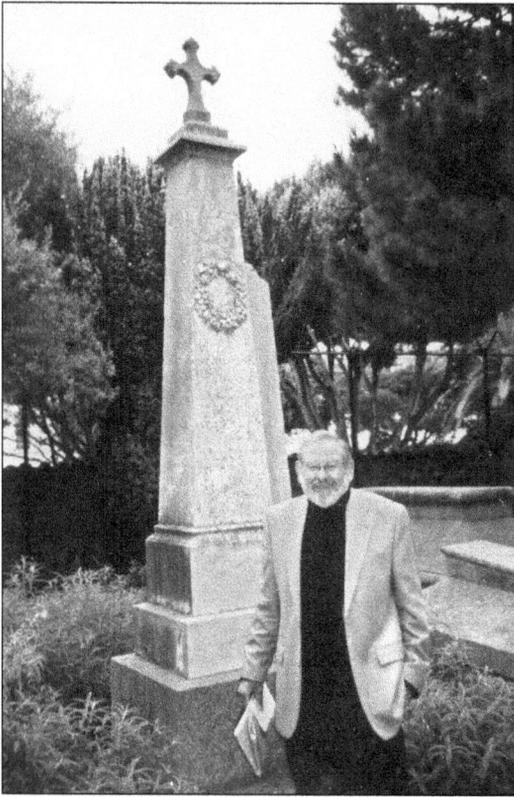

The Bernal family from Sinaloa, Mexico, was one of 20 civilian families to arrive in San Francisco with the Anza expedition in June 1776. In return for colonizing the land of New Spain, Juan Francisco Bernal, Jose Cornelio's father, was trained as a soldier, served at the Presidio, and, in 1802, became the first in the family to be buried at Mission Dolores. Eventually three generations ended up in the graveyard. Newspaperman Carl Nolte stands by the gravestone. (Photograph by Milne.)

Early maps show Islais Creek and wetlands curling around Bernal Heights (seen in the distance) on the east and south. The filling of Islais swamp continued for decades. The first big impetus was a special rail line to dump the downtown debris after the 1906 earthquake. Bernal's east side was carved into cliffs by excavations for Bayshore Boulevard and the 101 Freeway, which added more fill. Old-timers remember going down to Islais Creek to fish, float rafts, or engage in other youthful hijinks as late as the 1940s.

Samuel Marsden Brookes was one of the foremost West Coast painters of his day. He was one of the founders of the Bohemian Club. Born in England, he came to San Francisco from the Midwest in 1858. He flourished from the 1860s to 1880s. His most famous work was *The Peacock* for Mrs. Mark Hopkins, but his specialty was still lifes of flowers, fruit, and fish. Pictured here is *Salmon Trout and Smelt* (1873). (Courtesy Fine Arts Museums of San Francisco, gift of Collis P. Huntington, 7115.)

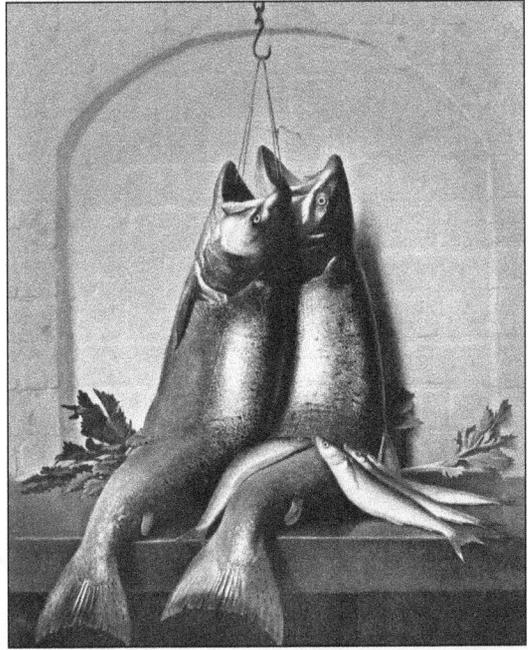

This house at 34 Prospect Avenue was Brookes's home from the 1860s until it was sold out of the family in 1942. The artist bought the home to live in the countryside, an attitude that still exists in some residents today. He was the precursor to the strong artistic tradition in the neighborhood. This house has been recorded as the oldest house in Bernal Heights and is featured in the *Here Today* architectural heritage book. The family of sculptor C. B. Johnson owns it today. (Photograph by Tim Holland.)

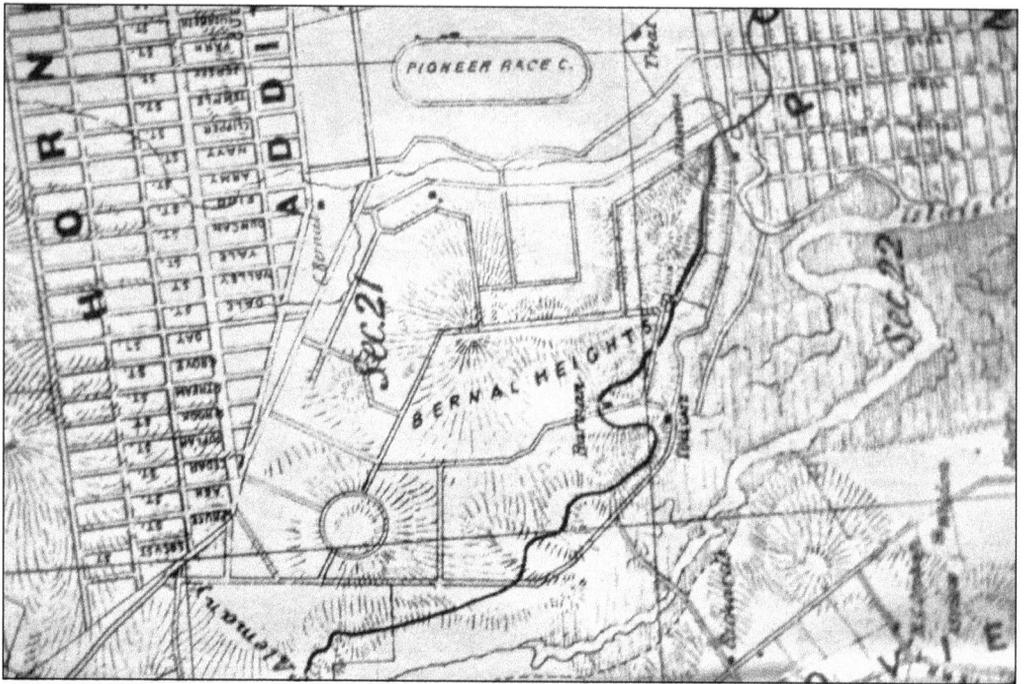

Vitus Wackenreuder was a Swiss-German surveyor with offices in San Francisco and San Mateo. This detail of his 1861 map shows the Pioneer Race Track north of Precita Creek with some streets laid out and the flume from the Spring Valley Water Company going around the south and east slopes. At one time, a section of Mullen Avenue was named Tomasa Street after Wackenreuder's wife. Some streets were not actually paved until the 1990s. (Courtesy Max Kirkeberg.)

Adam and Eve Streets were two short blocks below the northeast corner of Bernal Heights. Wackenreuder lived in this house with his family and operated the Franconia Nursery on San Bruno Road in 1875. Other nurseries were located to the south of the hill. One of Wackenreuder's surveyor sons ran a grocery store on Wool Street for a few years after 1900. This whole area is now buried under the lanes of the James Lick 101 Freeway.

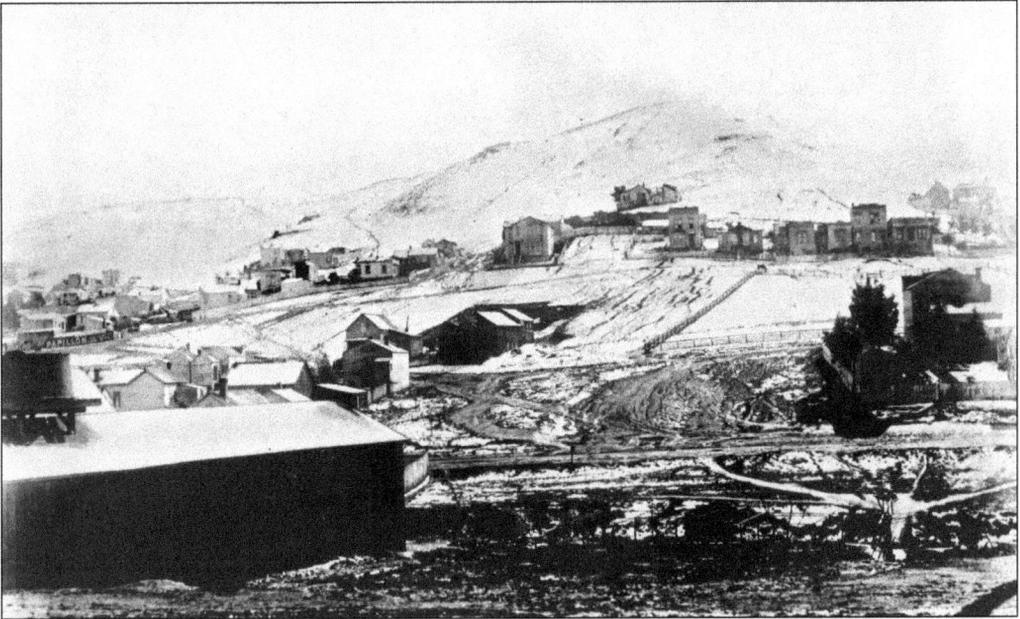

Snow came to the north slope in December 1882. This view looks south from the edge of the Mission across Army Street (now Cesar Chavez Street), which was being built on the channel of Precita Creek. In the middle is the farmhouse at the corner of Shotwell Street and Mirabel Avenue. The industrial building in the foreground was a tannery—one of at least a dozen arrayed along the north and east sides of the hill—with drying racks for hides in the open space.

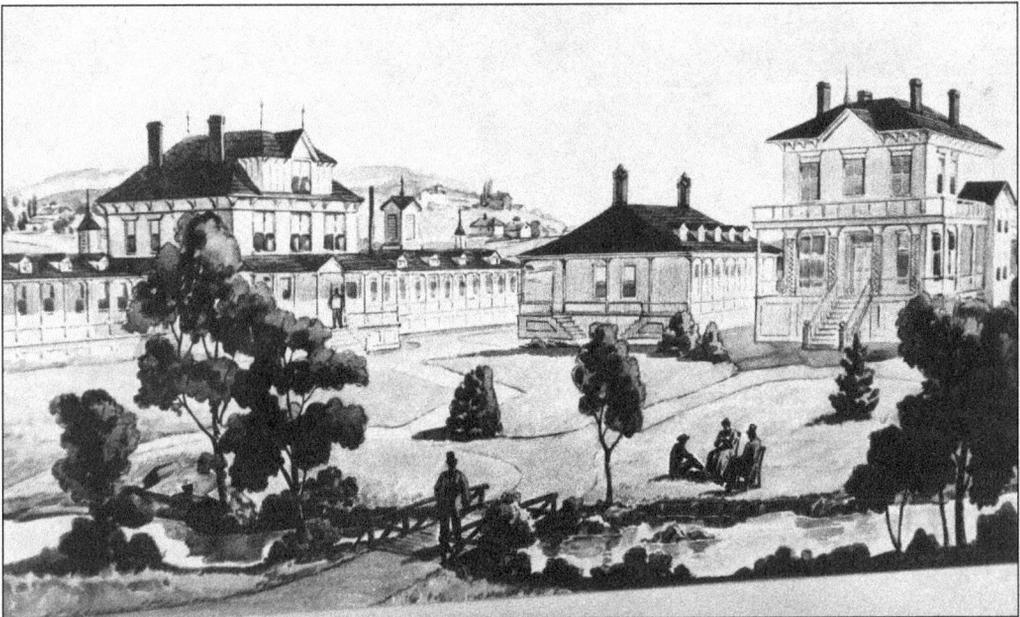

St. Luke's Hospital opened in 1872 with 17 beds in two rented houses on Lundys Lane "across a deep gulch" from the end of Valencia Street. This drawing depicts the hospital in 1875, when it moved down the hill to the site of the Bernal adobe. Financing was problematic, and St. Luke's closed from 1880 to 1885, renting its buildings to the Episcopal Old Ladies' Home and the Homeopathic Hospital Association. (Courtesy California Pacific Medical Center/Archives.)

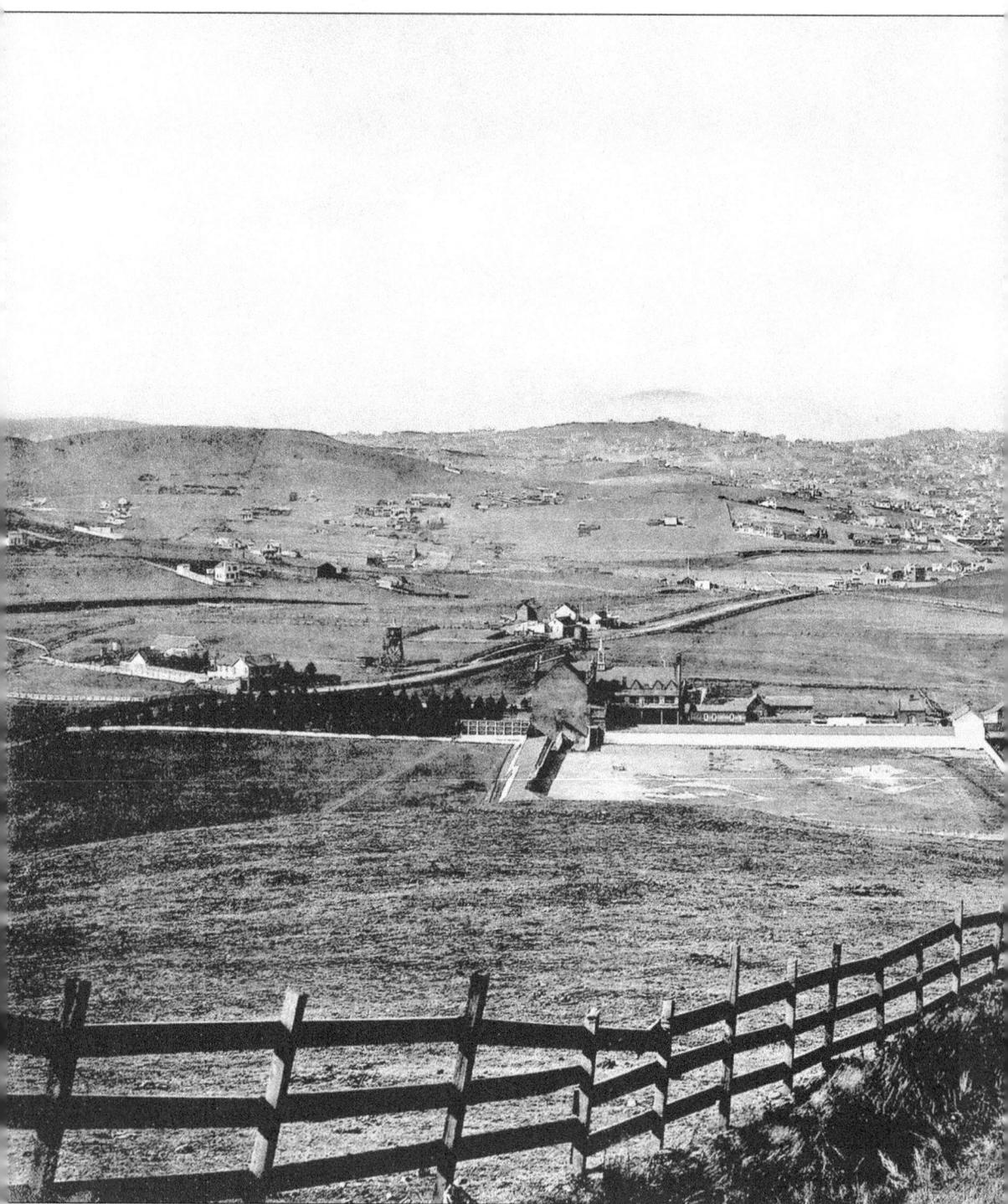

Carleton Watkins (1829–1916) was one of the most famous outdoor photographers of the American West. He also made many pictures of the growing city of San Francisco, such as this one taken in 1875. From around Silver Avenue, looking north to the Mission District and Noe Valley, the bare grasslands of southwest Bernal are revealed. The prominent enclosure nearby is St. Mary's

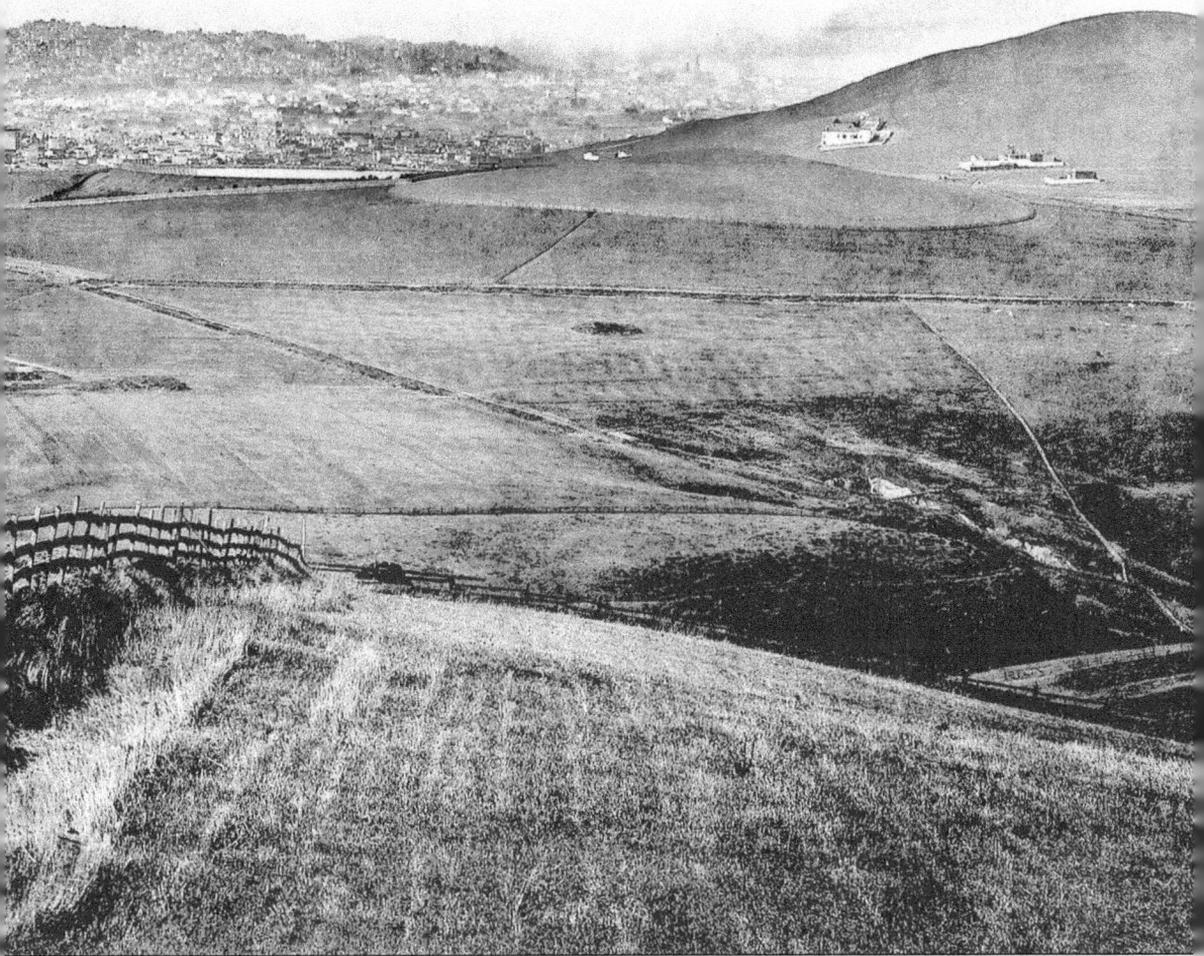

College, long before it ended up in Moraga. It faced Mission Road (now Mission Street), the principal route at the time. College Hill Reservoir is the flat area in the center, with Leese Street angling from Mission Road down to the right. The fenced circle denotes Holly Park, and on the extreme right is the top of Bernal Heights. (Courtesy California State Library.)

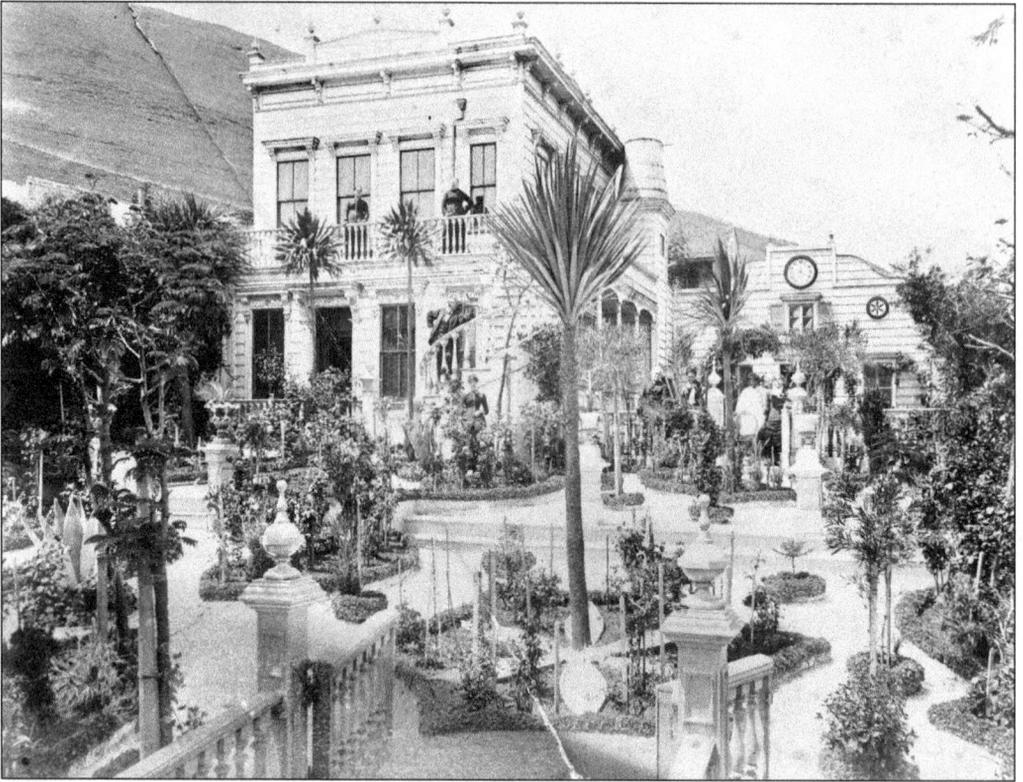

The house at what is now 3340 Folsom Street on Bernal's north slope was built in 1862 for the Prior family, and this 1886 picture shows it in all its ornate Victorian splendor. One of four Bernal buildings featured in *Here Today*, this home has been sympathetically restored. Today this view is hidden behind a fence, and unfortunately the fantastic garden is history.

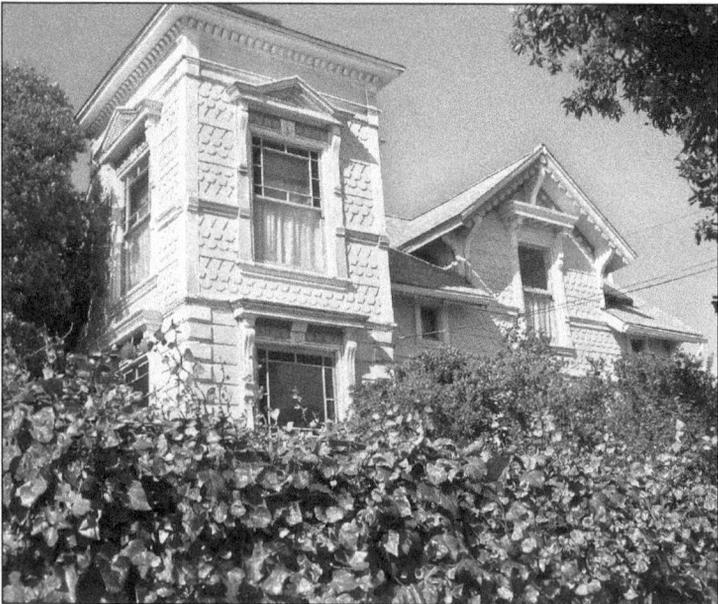

The house at 450 Murray Street was built in 1887 by Francis Kowalkowski, a cabinetmaker and carpenter who arrived from Poland in 1882. Over the years, the Kowalkowskis and their 11 children expanded the house with Italianate, Eastlake, and Queen Anne styles. It is one of four Bernal buildings featured in *Here Today*.

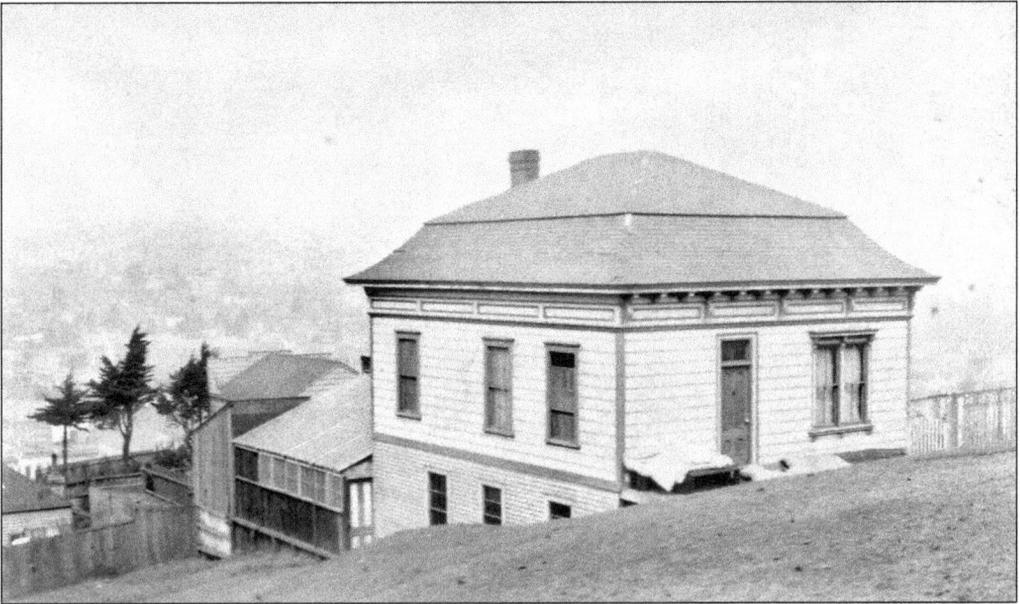

Carpenter Cyrus Packard's house was on Cherubusco Street near Coso Avenue and dates from the 1870s. This September 1890 view of Bernal's west slope illustrates the era when the neighborhood was mostly grassy hillsides with no streets and a few grazing cows. Packard built several other houses in the neighborhood. The house now has the address 12 Elsie Street.

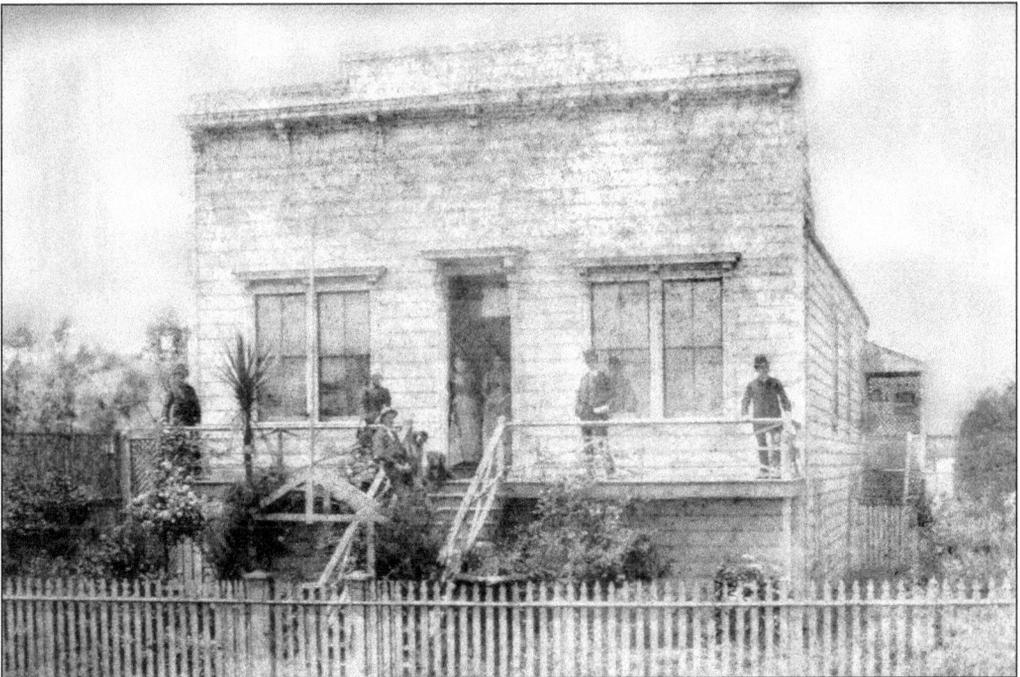

The Litzius family lived in this house at 252 Bocana Street. August Litzius came from Germany and settled in Bernal in the 1860s. Family lore has it that he owned most of the block but lost it in a poker game, and also that he was the first registered voter in Bernal Heights. A descendant, Allen Foy, still lives in the neighborhood on Bonview Street. (Courtesy Allen Foy.)

This 1869 U.S. Coast and Geodetic Survey map shows a lightly populated Bernal Heights with a few fenced-off farms. To the north, Precita Creek (along the line of Cesar Chavez Street) has burgeoning industries. On the right, Islais Creek has yet to be filled. On the left is Mission Road and the railroad winding through the Bernal Cut.

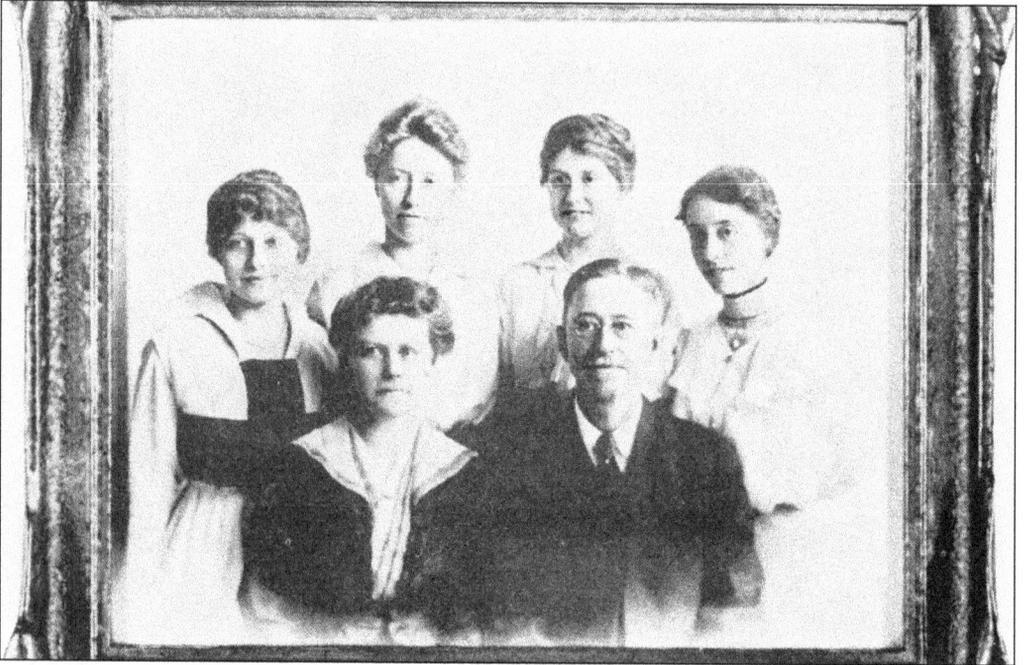

Frank E. Smith was an important electrical engineer in the early days of wiring San Francisco and cities all over California and Nevada. He married Ella Manchester in 1884, and they had four daughters, Ethel, Florence, Hazel, and Olive. The Smiths celebrated their 50th wedding anniversary in their home at 418 Eugenia Avenue. It was built by Manchester's father, who lived next door at 412 Eugenia Avenue, which he also built. (Courtesy Andrea Cochran.)

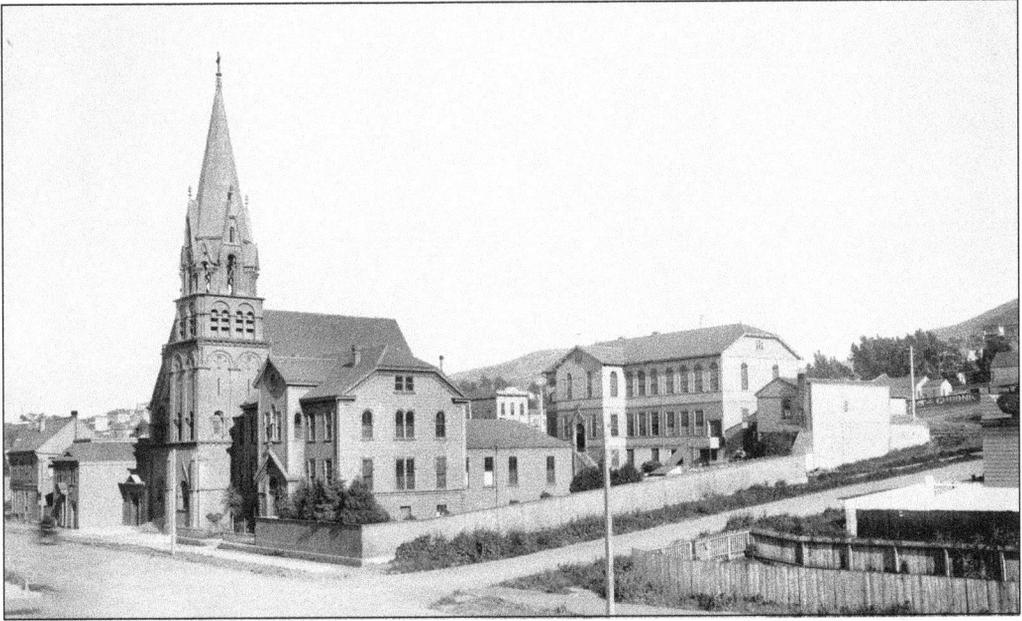

St. Anthony's Catholic Church was built in 1894–1895 on Army Street as a German national church to serve the German-speaking immigrants living in Bernal Heights and the Mission District. Serving the farmers, dairymen, artisans, and other working-class families of the area, the church flourished. The photograph, from about 1906, shows the original rectory and school. St. Anthony's changed to a regular parish in 1947. (Courtesy St. Anthony's archive.)

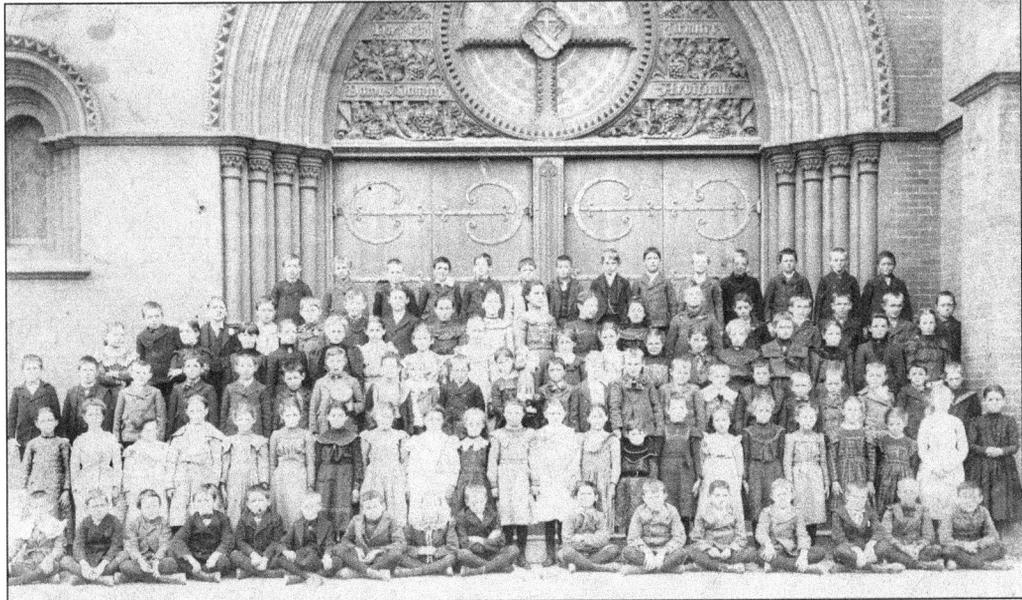

St. Anthony's School started in 1894, the same year the church was dedicated. The class of 1903 is arrayed in front of the church doors. The building's tragedy occurred in June 1975, when the Gothic-style edifice was destroyed by fire. The arch around the doors was rescued and still stands today on Cesar Chavez Street, but the huge doors were lost during the rebuilding when a truck drove up, loaded the doors, and drove away. (Courtesy St. Anthony's archive.)

The board of supervisors established Precita Park in 1894 at the foot of the north slope of Bernal Heights. One supervisor fought for it because other districts had plentiful and spacious "pleasure grounds," and the south end of the city had almost nothing. It was an early example of the neighborhood fighting to keep open space and to preserve rural character. The view east from Folsom Street in 1896 of what was Precita Place shows the tree stakes for the original planting of Blackwood acacias. It was dedicated as Bernal Park, and the name was not officially changed until 1973.

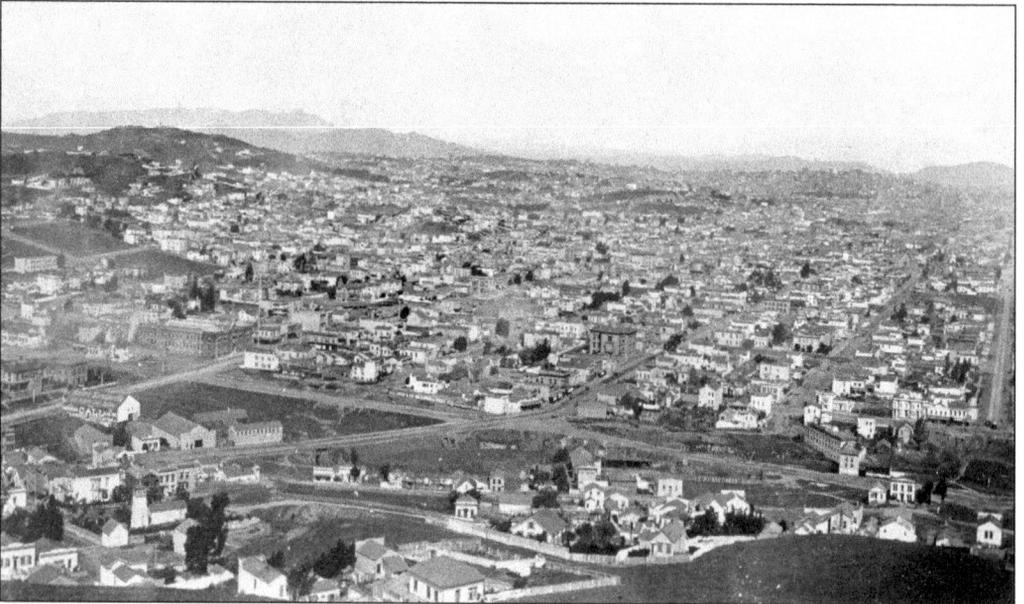

Mission and Army Streets intersect in the middle of this 1888 photograph of the Mission District seen from Bernal Hill. At the bottom edge is the Packard house at 12 Elsie Street. Remnants of Precita Creek (the name derives from Spanish for "little dam") run beside Army Street to the right. Barely visible on the left are St. Luke's Hospital and the Bancroft Library. Other streets in the foreground are Coso Avenue and Precita Avenue.

The ornate Victorian housing the Holly Park Meat Market in 1893 is still there on Cortland Avenue, now stripped of its decoration. Butcher Frank Bleuss got his start working in the shop and eventually bought the business. The market is still in operation next door at 237 Cortland Avenue with its former sign, Bleuss Meats, overhead. It now sells sushi as well as traditional meat cuts. In the 1905 photograph below, the butchers were proud of their wares and ready for business. Owner Henry Hillers is in the dark suit and bowler hat. Arthur Bleuss is the small boy in the doorway. In 1955, the Bleuss family sold the business to Edward "Bud" Cicero, who ran Cicero's Meats. (Courtesy Ed Huson and Lisa Palmer.)

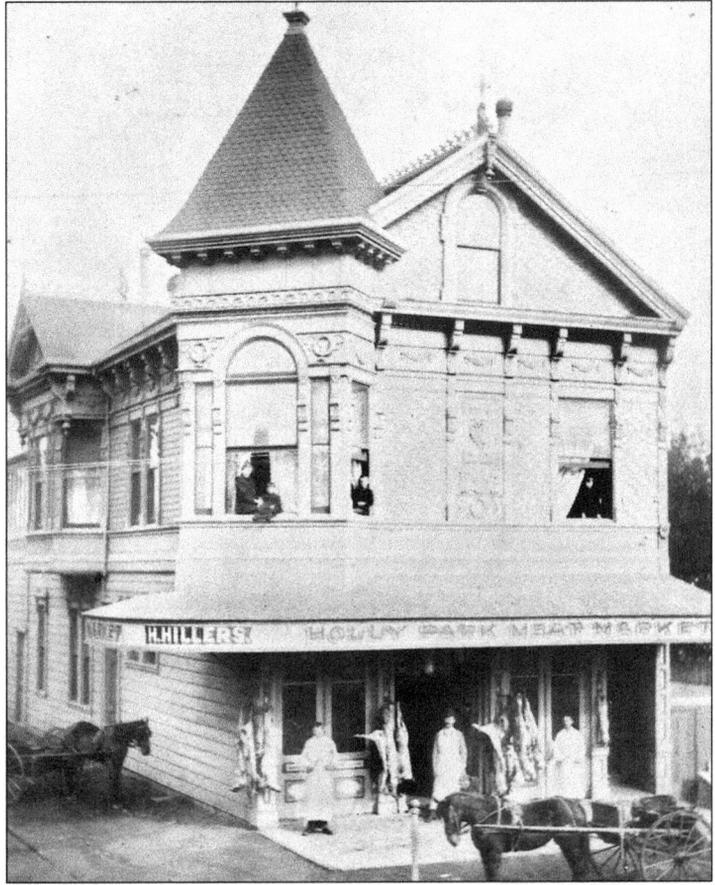

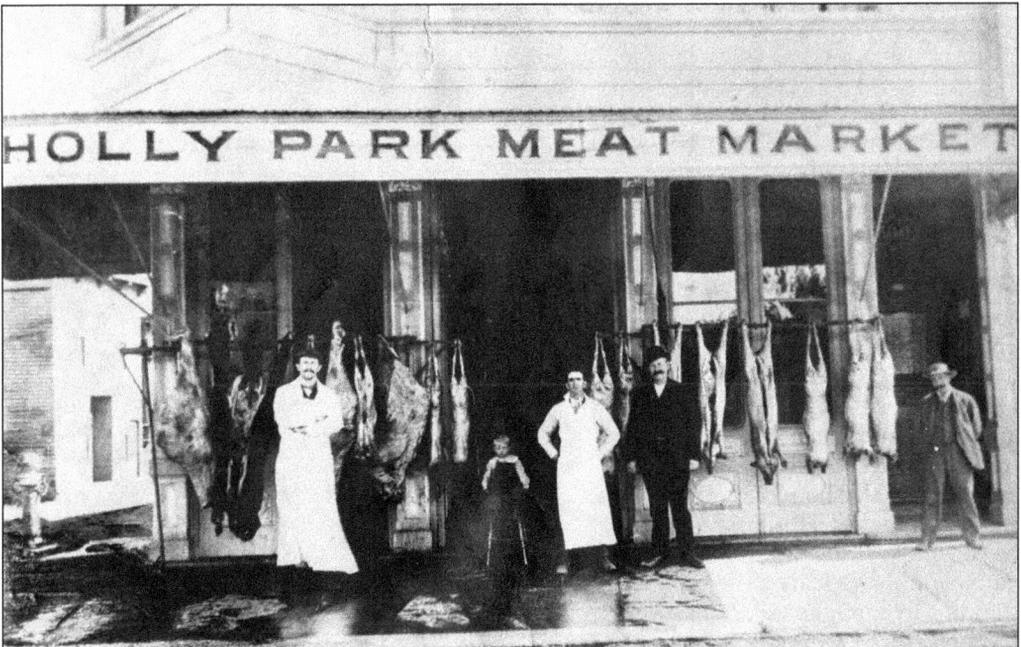

Sue McMahon is shown at the top of Prentiss Street with Mrs. Driscoll's cow in 1913. Several photographs of Bernal show the fenced yards of dairy farms around isolated houses. San Francisco had poundmen, a bit like tow-truck drivers of today, who cruised the city looking for loose animals. They would take them away and charge a fee at the pound for their return. This happened to the widow O'Brien of Cortland Avenue, but she called to her neighbors to help. Men and boys used rocks and clubs in an encounter that drove the poundmen away—never to return to the hill. (Courtesy George Williams.)

Today this house sits at 124 Precita Avenue. It was built by Sivert Peterson, freshly arrived from Norway, in 1866. The dairy farmer and milk dealer lived there until 1902. Bernal Heights was an important dairy area during the 1870s, following its Mexican-era history of cattle ranching. Surviving gabled houses of this time are rare. This may be the oldest of six known dairy farmhouses still standing in San Francisco. (Photograph by Milne.)

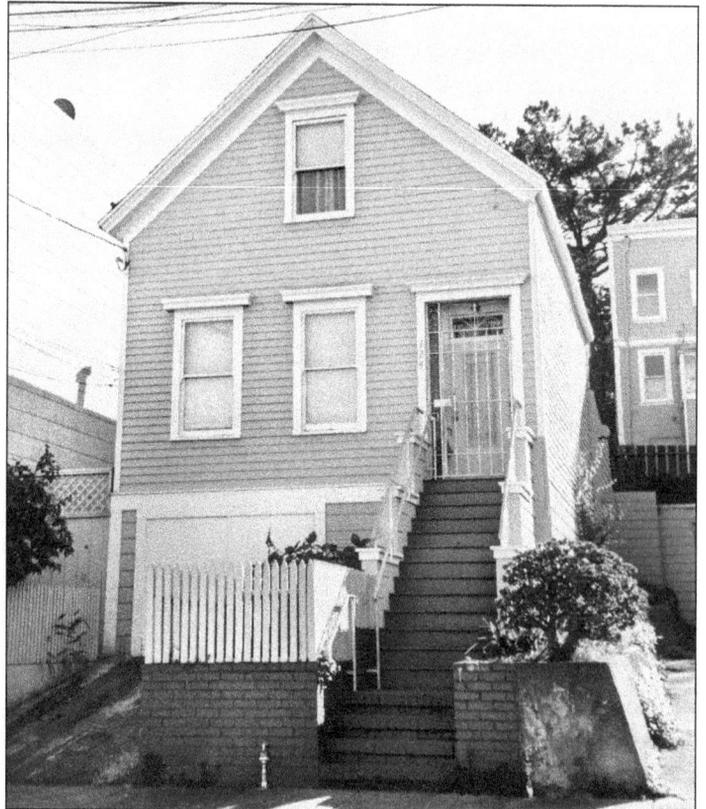

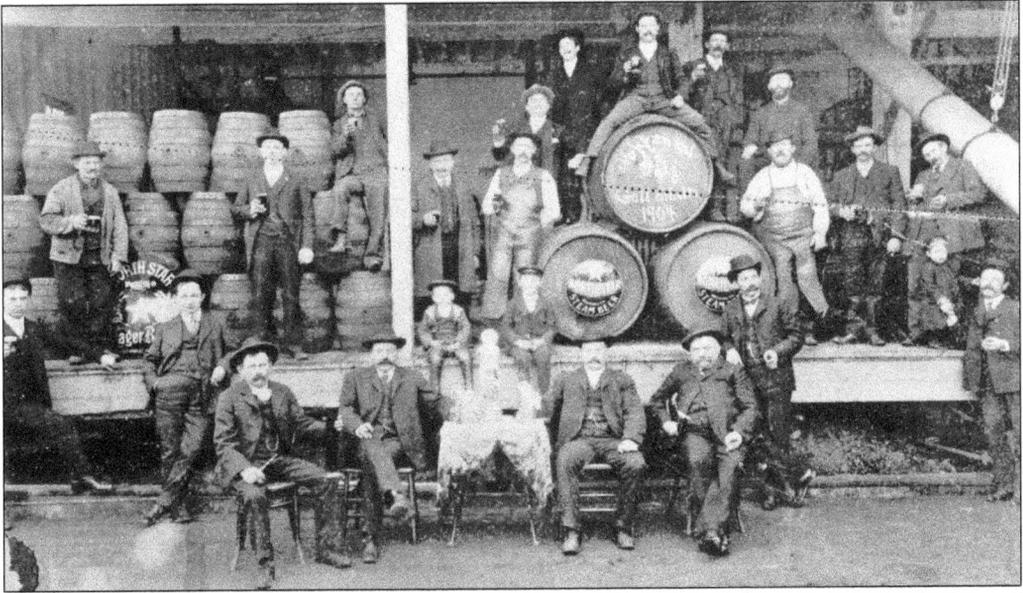

The pugnacious crew at the North Star Brewery at 3310 Army Street celebrates a particularly good brew in 1904. The company made both lager and steam beer, and was one of many breweries in the city at the time. The slogan painted on the barrel in German means something like "hops and malt and God does the rest." North Star was run out of business in January 1920 by the dreaded Volstead Act of Prohibition. (Courtesy San Francisco History Center, San Francisco Public Library.)

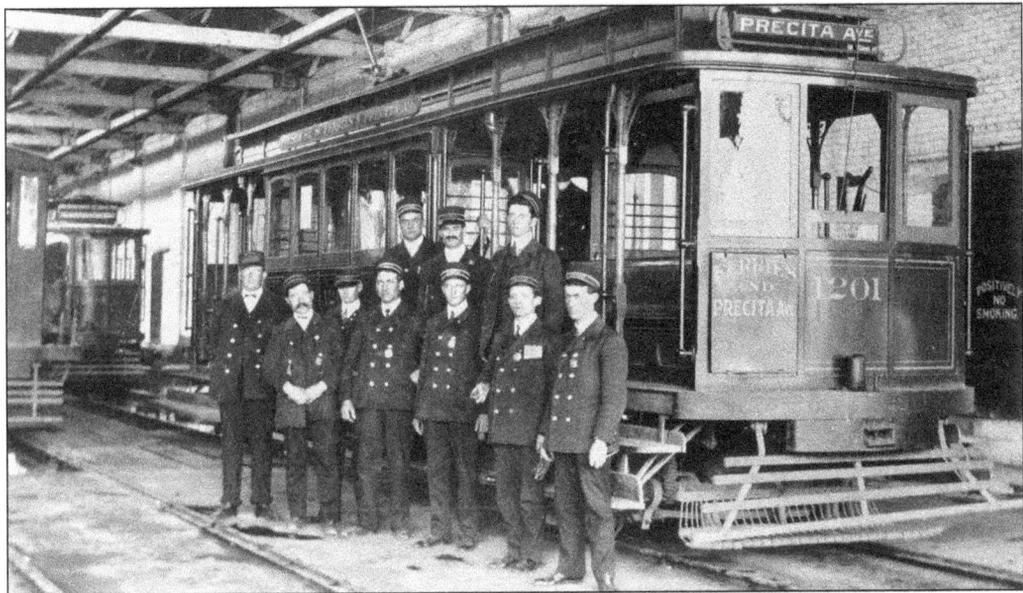

Streetcar men are formally arranged inside the car house at Twenty-ninth and Mission Streets in this pre-1906 photograph. In 1902, the United Railroads consolidated many of the city's streetcar companies. In 1921, they reorganized as the new Market Street Railway and painted the fronts of their cars white. The Precita Avenue line ran from the Ferry Building to a terminus at Precita Avenue near Potrero Avenue, serving the growing population of Precita Valley and Peralta Heights, two of a half-dozen small Bernal Heights neighborhoods. (Courtesy SF Muni Railway.)

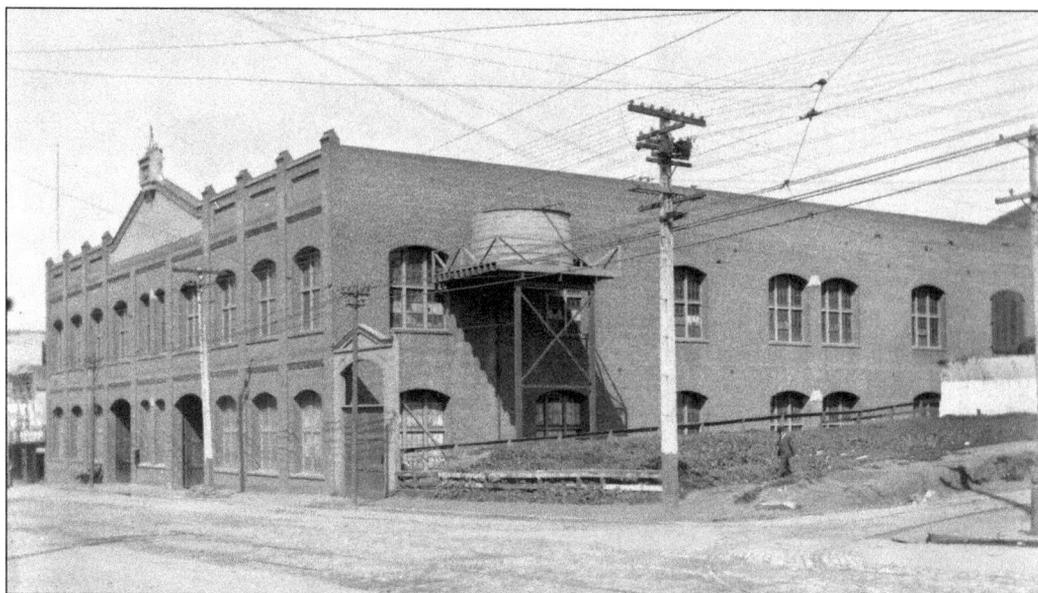

The Twenty-ninth and Mission Streets car house was constructed in 1894 by the United Railroads. Electric streetcars were replacing the cable system, which already came to a car house on Tiffany Street at Valencia Street. Virginia Avenue is the small street on the right in this 1904 photograph, where tracks curve up to reach the Coleridge Street access to the second-floor repair bays. (Courtesy SF Muni Railway.)

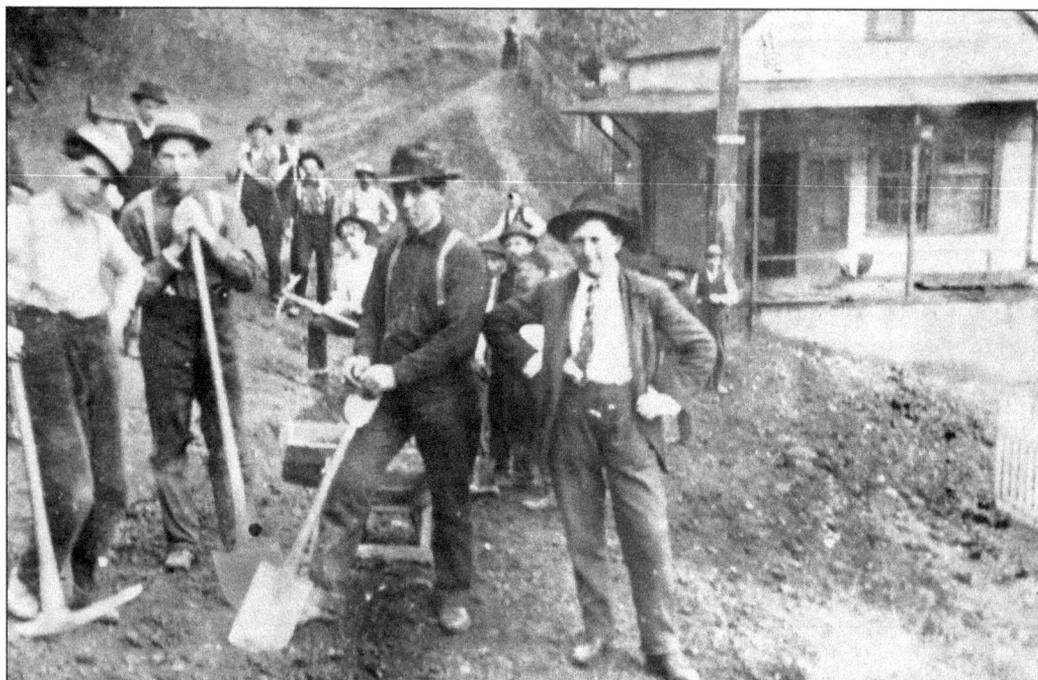

The whole neighborhood turns out to grade a new street on the east slope. These men were digging the intersection of Brewster and Costa Streets in front of Hannah Fitzpatrick's store about 1900. This may be an early example of the Bernal community organizing collective labor to build an infrastructure that the city was unwilling to provide. (Courtesy Don Schaan.)

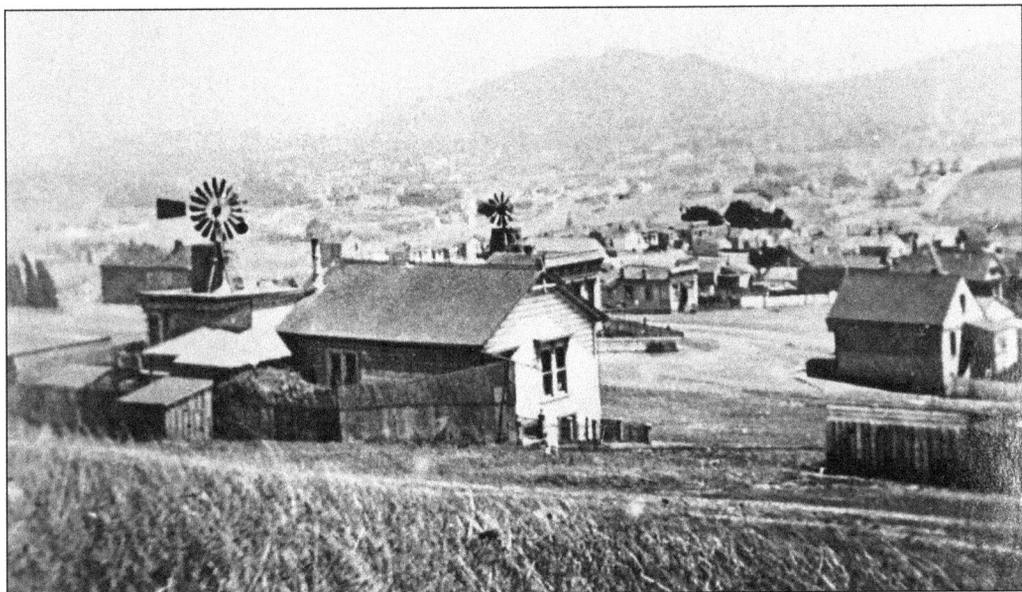

The south slope of Bernal was dotted with windmills in this 1900 photograph looking toward Bayview Hill. Widely spaced houses indicated sparse development and plenty of room for goats and dairy cows. Too remote to use city services, these Bernal residents harnessed the power of the wind to pump water from wells and streams into raised tanks. (Courtesy San Francisco History Center, San Francisco Public Library.)

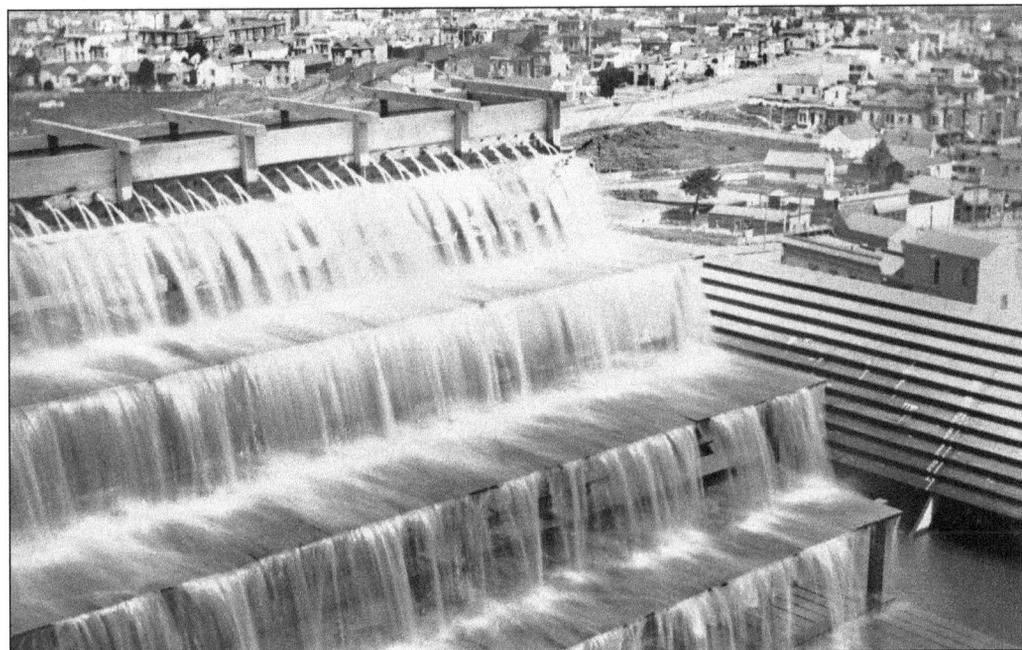

The College Hill Reservoir (commonly known in the neighborhood as Holly Park Reservoir) was constructed by the Spring Valley Water Company in 1870. The aerator contraption was operating in 1896, when this photograph was taken. Mission Street and Cortland Avenue intersect near the right side. The wide street is San Jose Avenue, and barely seen in the back is the railroad line heading toward the Bernal Cut. (Courtesy SFPUC Archive.)

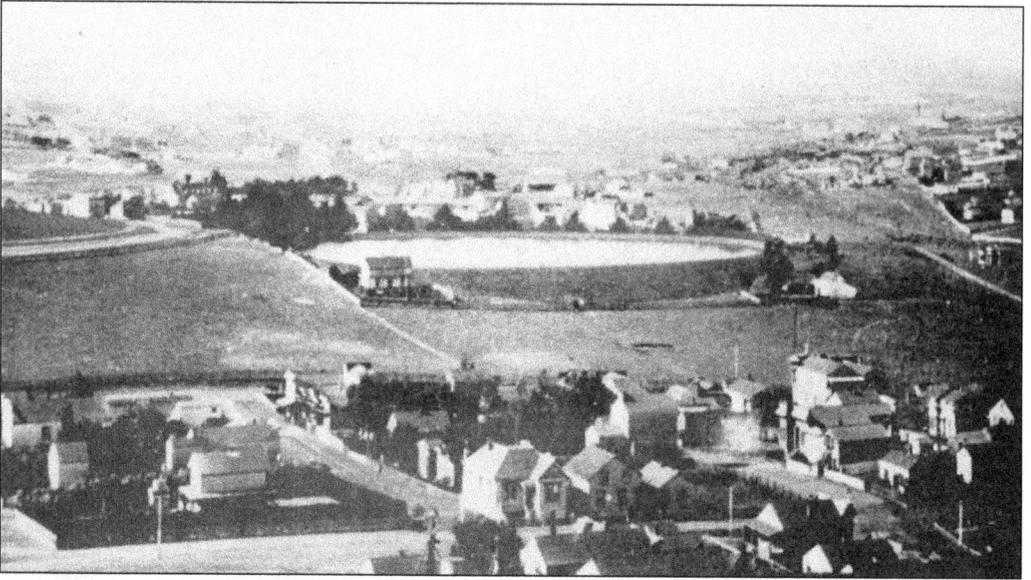

The land surrounding the College Hill Reservoir was mostly vacant in this 1891 view from atop Bernal Hill. In the front are the houses at 418 and 412 Eugenia Avenue. On the left is the familiar circle of Holly Park. The keeper's house is beside the reservoir all by itself. It was built in 1871 and is featured in *Here Today*. The water department demolished this historic structure in 1971. (Courtesy Andrea Cochran.)

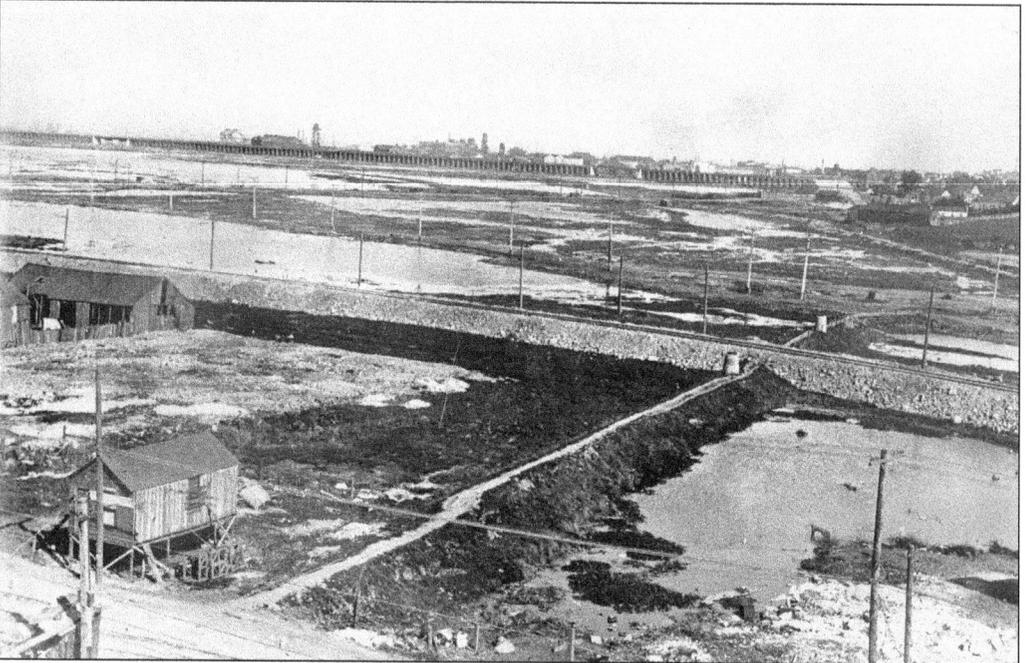

From the time of European settlement, Bernal Heights has appeared separate, solid, and aloof, almost surrounded by creeks, swamps, and marshlands. This enduring characteristic left the hill as pasture with little habitation for a number of years beyond that of nearby neighborhoods. This view east from near Cortland Avenue shows how the early 20th century was a scramble to fill the Islais swamps. Industrial areas Bayview and Butchertown can be seen in the distance.

Clement Richardson and Bridget Mary Sheehan married in 1874 and had six children (later nine) when they moved into the house at 440 Cortland Avenue in 1887. Clement, a roustabout on the docks, was killed in an accident in 1897. Aided by several of her children, Bridget ran a coal yard on Mission Street while taking in boarders. In 1902, her son George opened Bernal Meats at 448 Cortland; later, his younger brother Walter helped with this enterprise, which flourished for 25 years. In the photograph below, dated 1909, son Bill Richardson can be seen with two of Bridget's grandchildren, Florence and Melvin Wiegner. The bunting was for the citywide Portola Festival, celebrating San Francisco's renaissance from ruin after the earthquake. (Courtesy Gloria Wiegner Lane.)

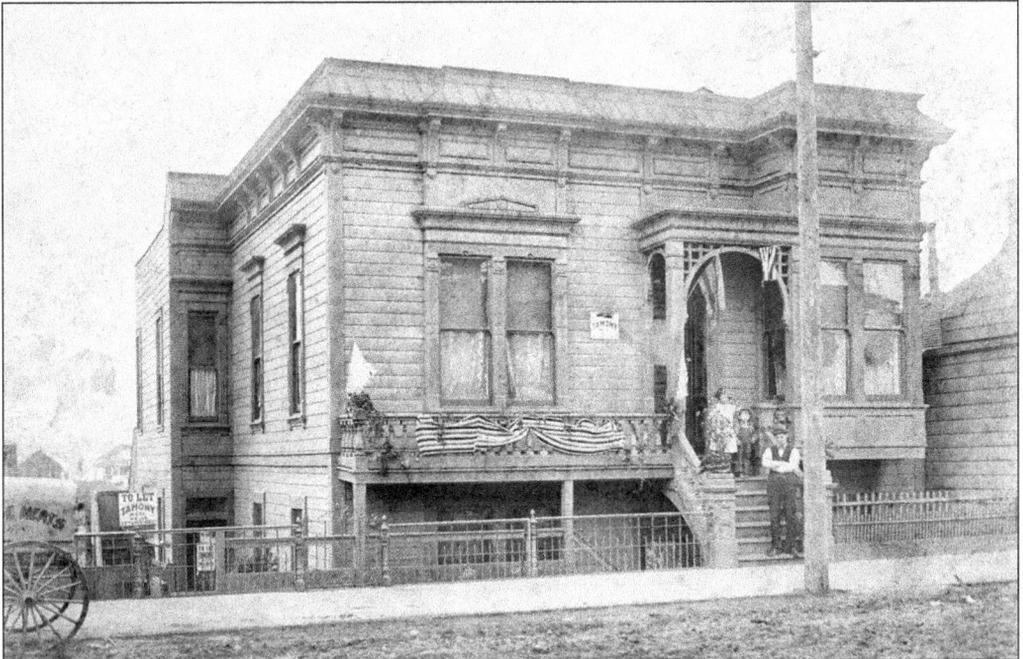

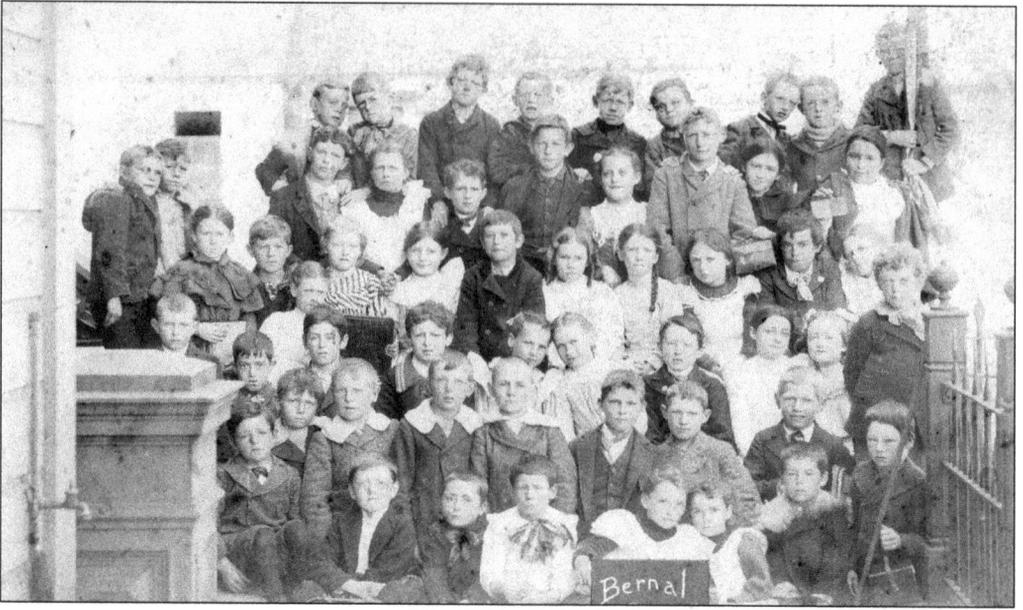

Bernal Grammar School was built in 1886 to educate the growing population of children in the neighborhood. Smaller buildings on Cortland Avenue were rented before its construction. The playground and auditorium were transferred to the recreation commission in 1932, and the recreation center is still in use. The school was replaced when the Bernal Heights Branch Library was constructed in 1939–1940. The school photograph above shows a class picture c. 1900. Most of the children on the hill at the time were of German, Irish, or Scandinavian descent. Bill Richardson is the tall boy in the double-breasted jacket, third from the right, second row from the top. (Above courtesy Gloria Wiegner Lane; below courtesy San Francisco History Center, San Francisco Public Library.)

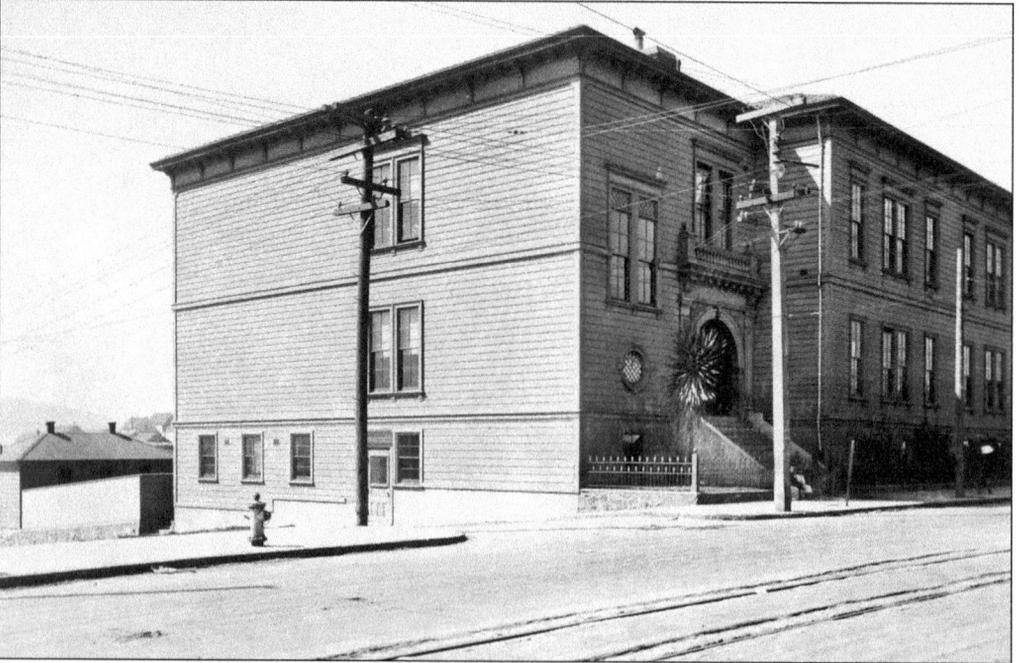

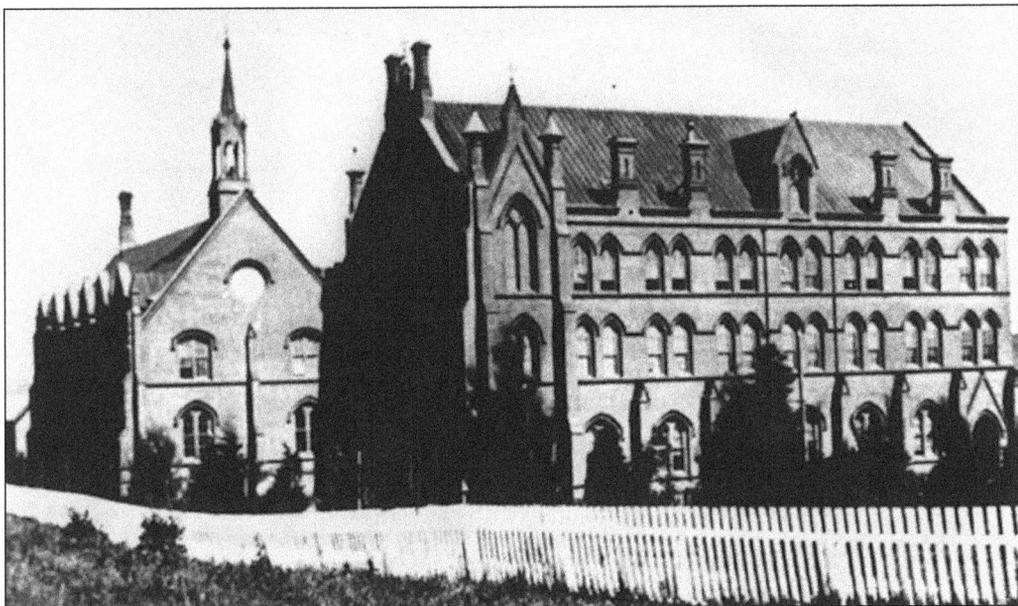

St. Mary's College began in 1863 as a diocesan college for boys established by Joseph Sadoc Alemany, O. P., archbishop of San Francisco. It was handed over to the De La Salle Christian Brothers in 1868. In 1889, the college moved east to Oakland, and then to Moraga in 1928. After the college moved away, it leased the land to local farmers who grew vegetables that they sold in the area. Neighbors called the terraced farm the Italian Gardens. (Courtesy St. Mary's College.)

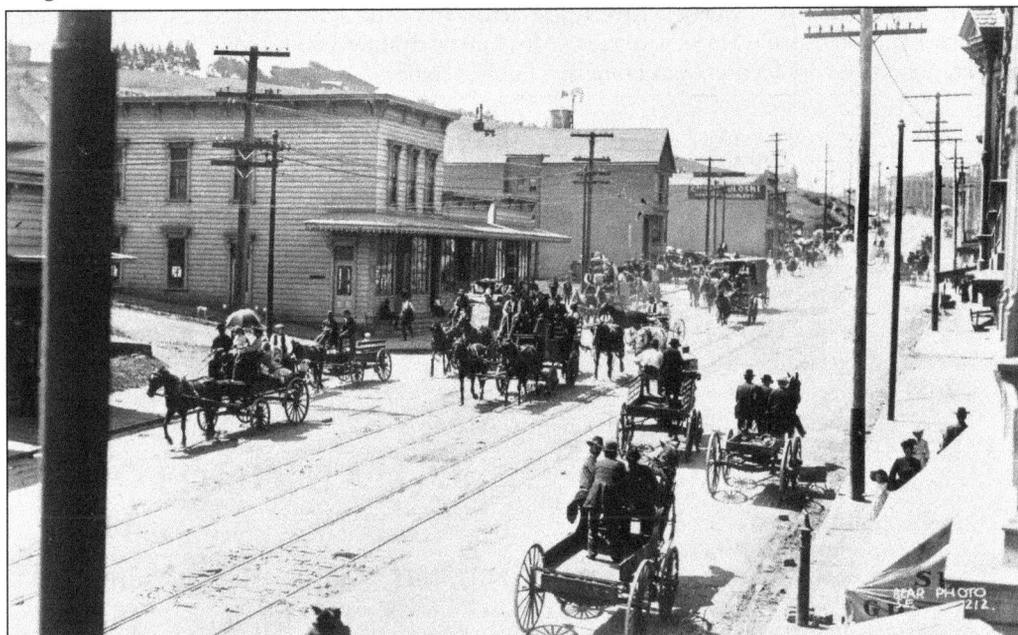

Mission Street was the major route in and out of San Francisco. Railroad and streetcar tracks followed the path of least resistance and circled Bernal Hill. This 1906 photograph of a bustling Mission Street looking south at Kingston Street shows people going about their business in wagons and carriages, possibly during one of several streetcar strikes of the era. (Courtesy California Historical Society, FN-36465.)

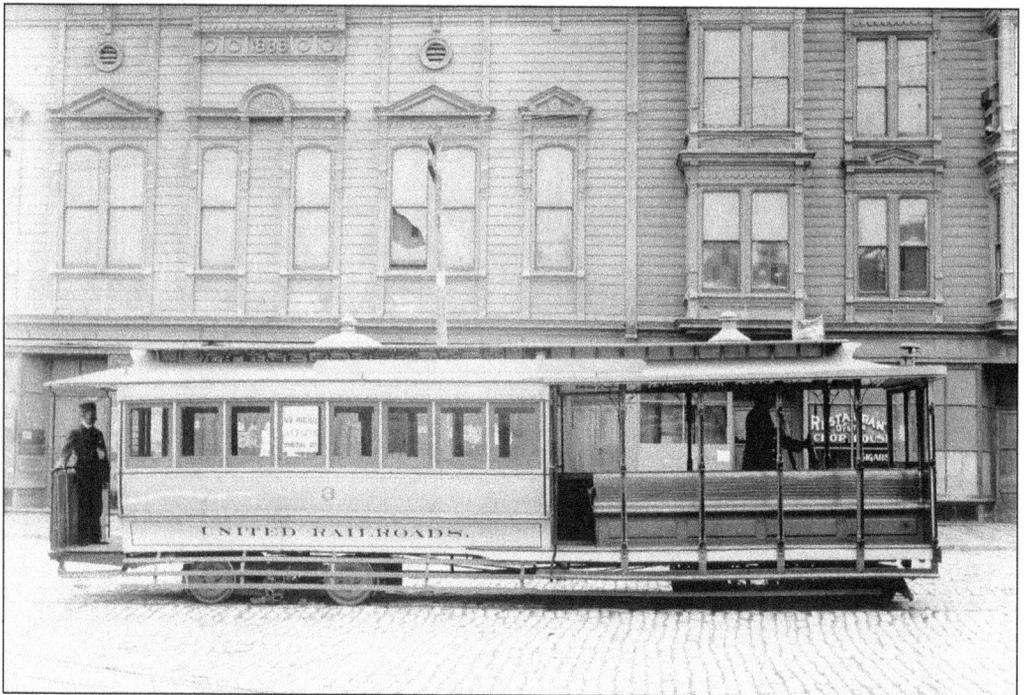

Development effectively came to the neighborhood in 1883 with a new cable car line running from Mission and Valencia Streets all the way downtown. In 1903, this cable car was photographed in front of Stanford Hall on Valencia Street, just across from the Tiffany Street car barn. Around the corner at 3236 Mission Street was one of Mrs. Leland Stanford's free kindergartens. (Courtesy San Francisco History Center, San Francisco Public Library.)

Phone Capp 914.

JOHN CATTO

Manufacturer and Importer of

...Marble and Granite...

MONUMENTS, STATUES, ALTARS, VAULTS, COPINGS, ETC.

COR. 29th and MISSION STREETS, San Francisco, Cal.

Designs and Estimates Furnished on Application. Carving, Floral and Draping a Specialty.

NEW

PRECITA VALLEY MEAT MARKET

BAIREUTHER BROS., Proprietors

Dealers in

Choice Stall=Fed Beef, Mutton, Lamb, Veal and Pork.

All Kinds of Salt Meats, Sausages, Hams, Bacon, Lard, Etc.

PRECITA STREET

Between Mission and California Ave.

RED TRADING STAMPS GIVEN SAN FRANCISCO

30

.Modern Restaurant.

J. S. MASON, Proprietor

Meals at All Hours

Oysters in Every Style

Regular Dinner, 25c

3289 Mission Street

OPEN ALL NIGHT.

Highest Prices Paid Cheapest Store in Town

J. HARRINGTON

...DEALER IN...

NEW AND SECOND HAND

Furniture, Stoves, Ranges, Crockery Carpets, Etc.

3405 Mission Street

On earthquake-era Mission Street, there were stables, harness stores, and grain and feedlots. T. H. Cummins shoed horses at 3247, and Toloski Saddlery sold equipment at 3515. Other local businesses touted their wares in the advertisements from a 1905 Carmen's Union pamphlet.

30

Two

EARTHQUAKE, FIRE, AND AFTERMATH

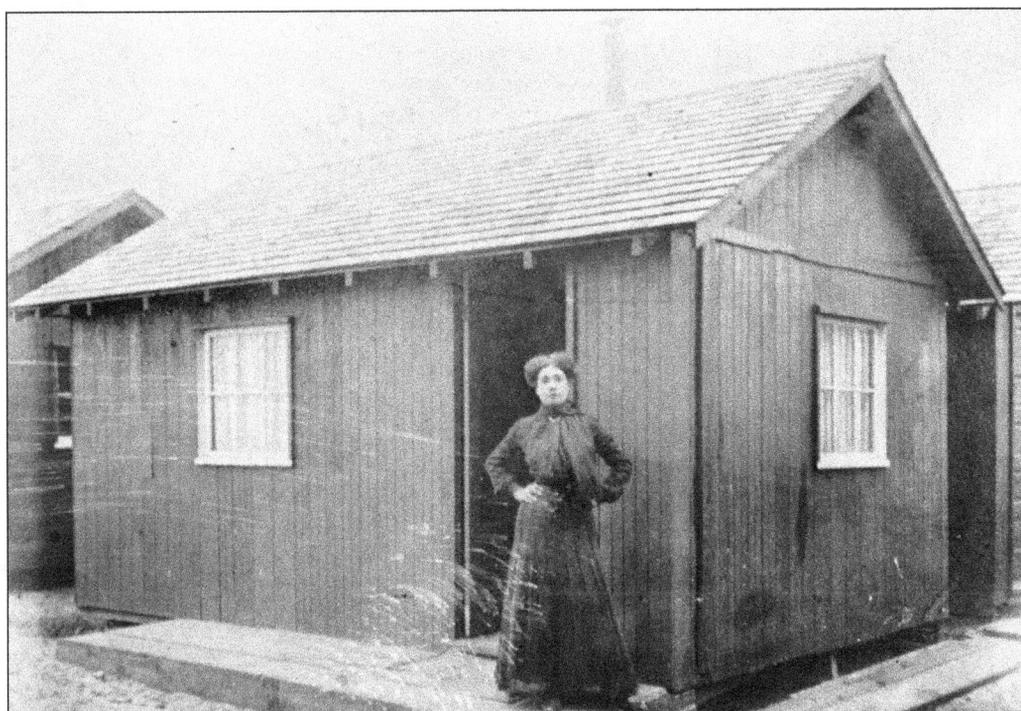

Miss Esther Chelim of 81 Crescent Avenue was one of 250,000 city residents displaced by the 1906 earthquake and fire. The San Francisco Relief Corporation contracted with union carpenters to build 5,600 refugee shacks in 1906 and 1907. Precita Park was one of the official camps and was where 250 shacks were built as Camp 23. They rented for $2 per month. (Courtesy San Francisco History Center, San Francisco Public Library.)

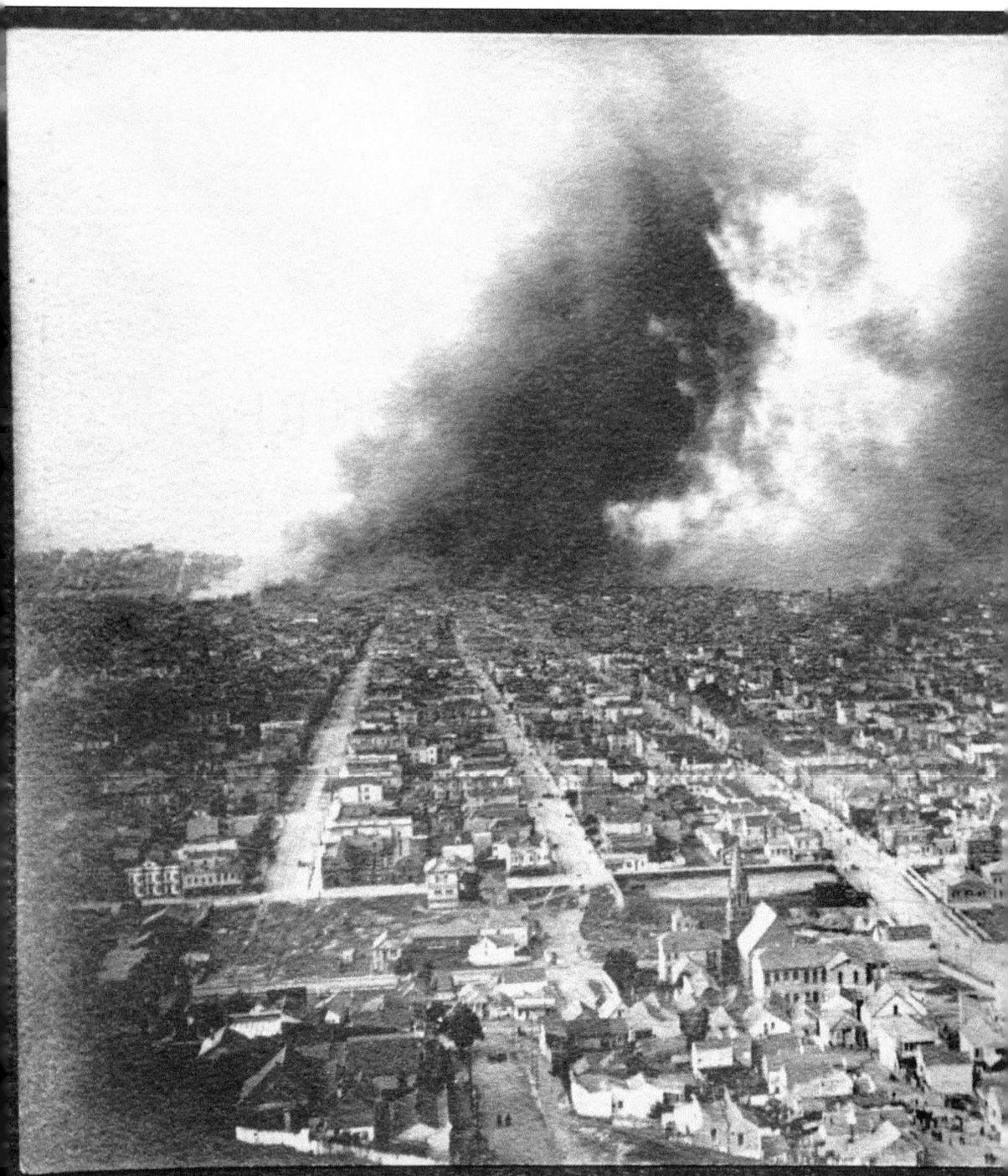

Taken from Bernal H[e]

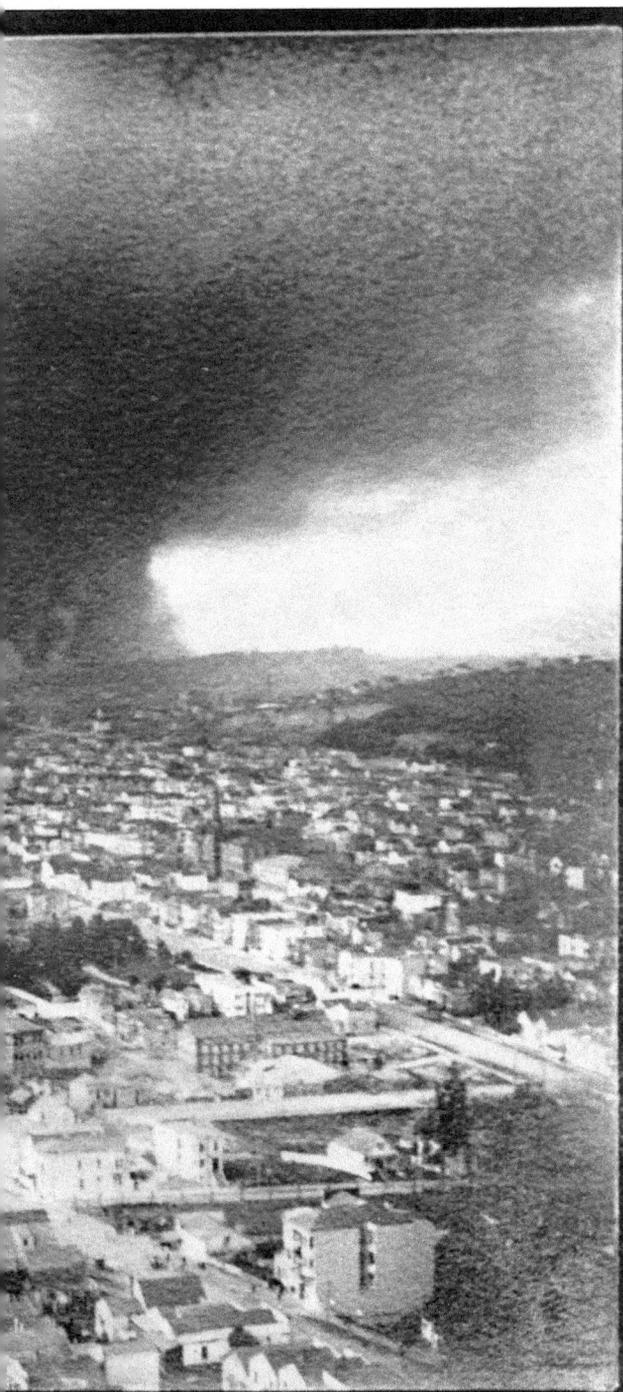

ts Apr. 18 1906

The 1906 earthquake and fire that devastated the city of San Francisco is viewed from the north slope of Bernal Heights. At several locations downtown, fires started that burned for three days and nights. The conflagration was finally stopped at Twentieth Street in the Mission District. Downtown was obliterated, and surrounding neighborhoods were heavily damaged. St. Anthony's Church steeple and Cogswell College are recognizable in the foreground on either side of Army Street, which crosses the photograph. Folsom Street comes uphill to the right, passing what is now Precita Park. The photograph is a rarity, perhaps because Bernal was shaken but not stirred, and there was almost no damage on the hill. Some residents did not even feel the shake.

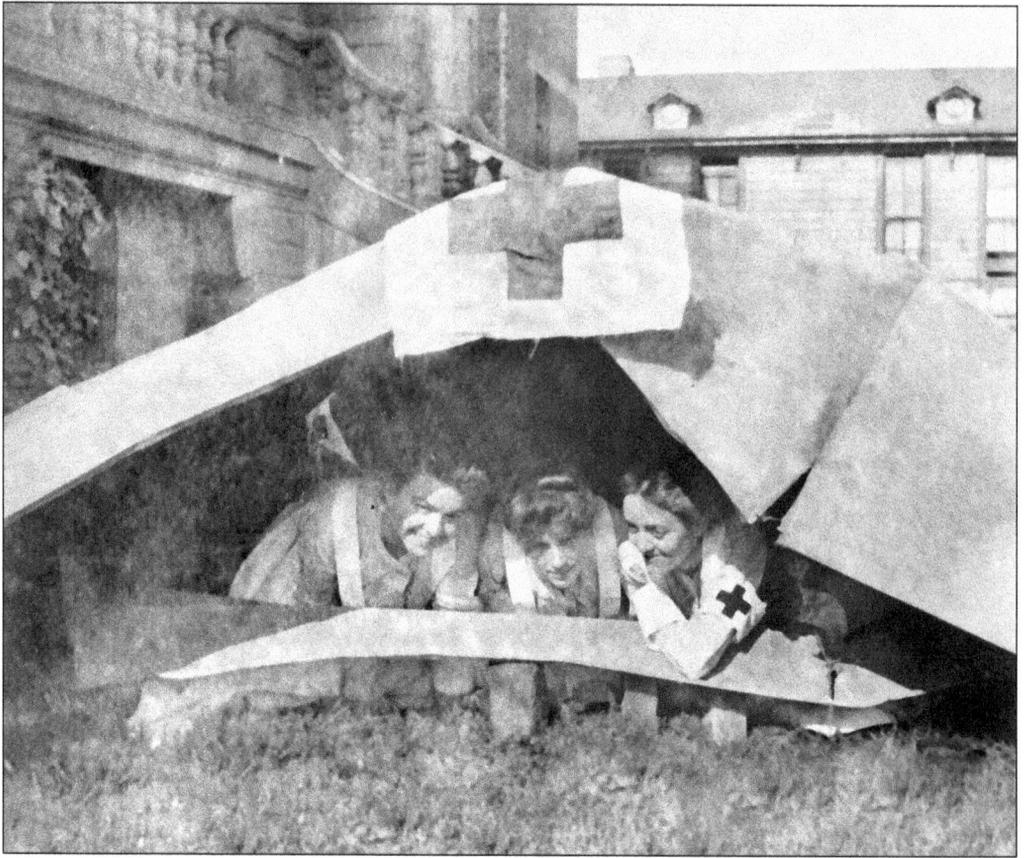

Although the earthquake left the just-completed Gibbs Surgical Pavilion practically destroyed, St. Luke's was the first hospital in the city to hang out the Red Cross flag. Initially the wounded were treated in tents by doctors and the nurses pictured above, identified only as the 1906 St. Luke's Red Cross Surgery Unit. Quake refugees on the hospital grounds gathered to watch the city burn and later to eat hot meals. By that time, the operating tables had been moved from the tents into three flats on San Jose Avenue. (Courtesy California Pacific Medical Center/Archives.)

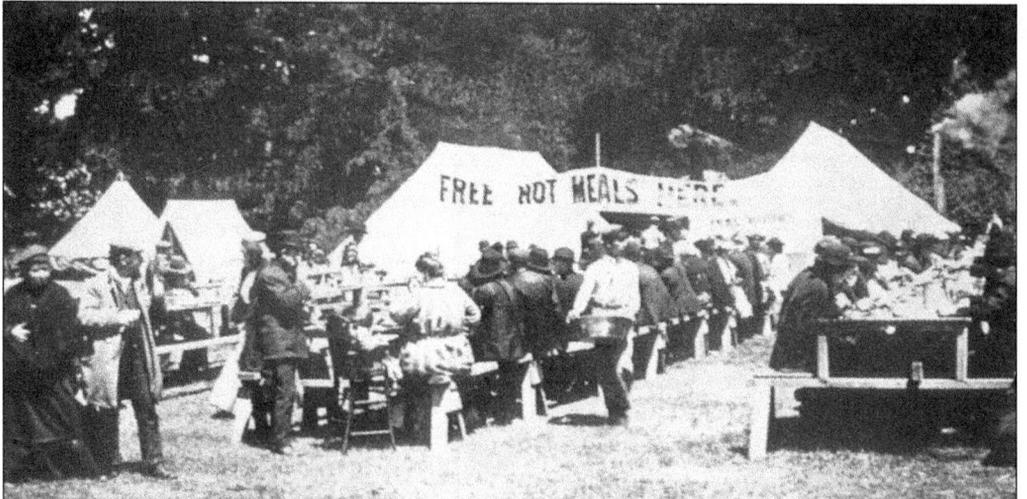

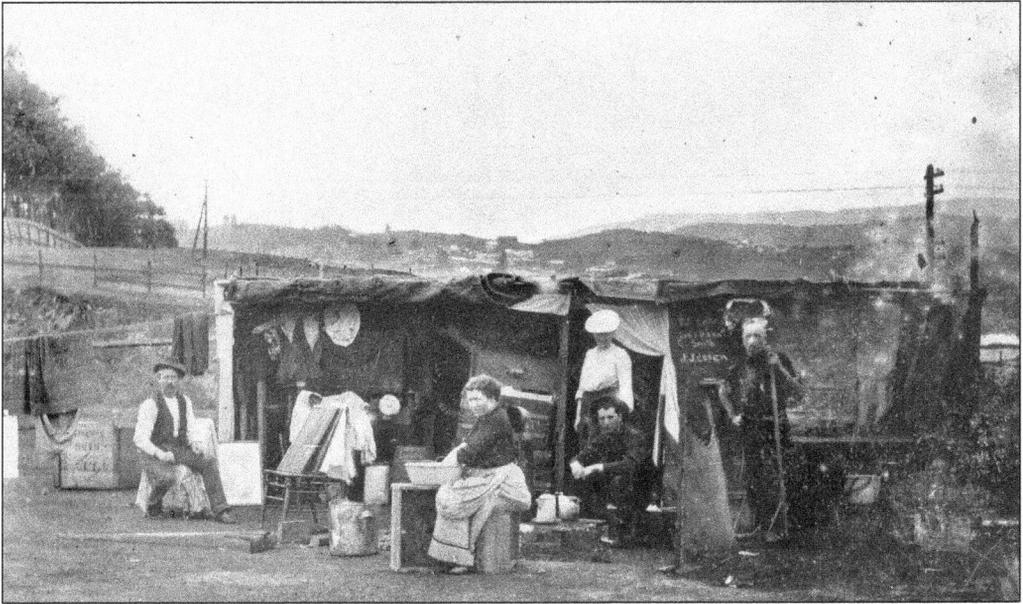

Will and Lottie Hahn were descended from Germans who immigrated to California. After the earthquake, they camped in a doorway for three days, eating canned fish. They salvaged some belongings and set up a makeshift tent in Holly Park with Will's father, Henry, and Lottie's mother and her husband, the Jessens. Pictured from left to right are Henry Hahn, Lottie Hahn, Will Hahn, Mrs. Jessen (standing), and Mr. Jessen. Their names are written on the outside of the tent, perhaps to receive mail. (Courtesy Jo Bailey.)

As the refugee camps began to close in the late summer of 1907, the Relief Corporation sold off the shacks for $100 or less. This view of Precita Park close to the Alabama Street end shows the beginning of the camp's clear out with the hauling away of shacks. Most of the shacks have not survived.

Helene Ferenz Critler, left, was a little girl living at Twelfth and Market Streets when the earthquake struck. She remembered the plaster being knocked off the walls and later the embers falling from the sky. Once safely in the street, she was charged with guarding the family sewing machine. The Ferenzes camped in Franklin Square for eight months before moving to two refugee shacks put together on Carver Street at the top of Bernal Heights. Helene lived to be 104 and to see the 2006 earthquake centennial, although she was modest about her memories of the disaster. Domicella Ferenz, Helene's mother, is shown at right outside the family home on Carver Street, some time in the 1930s. (Courtesy the Ferenz family.)

Bernal Heights has the largest collection of remaining earthquake refugee shacks in any one San Francisco neighborhood. Jacque Phillips, the current owner of the Carver Street cottages, proudly shows off her home, which she bought from the original Ferenz family in 1973. (Photograph by Molly Martin.)

Carl and Sophia Lund, Swedish immigrants, were married in San Francisco in 1896. At the time of this c. 1905 picture, they were living on Elsie Street with their four children. On the morning of the quake, Carl left home around 6:00 a.m. and walked to Mission Street to take a streetcar to the docks where he worked. After an unusually long wait, he finally asked some strangers why. One replied, "Haven't you heard that a great earthquake just occurred downtown?" (Courtesy Erik and Carolyn Lund.)

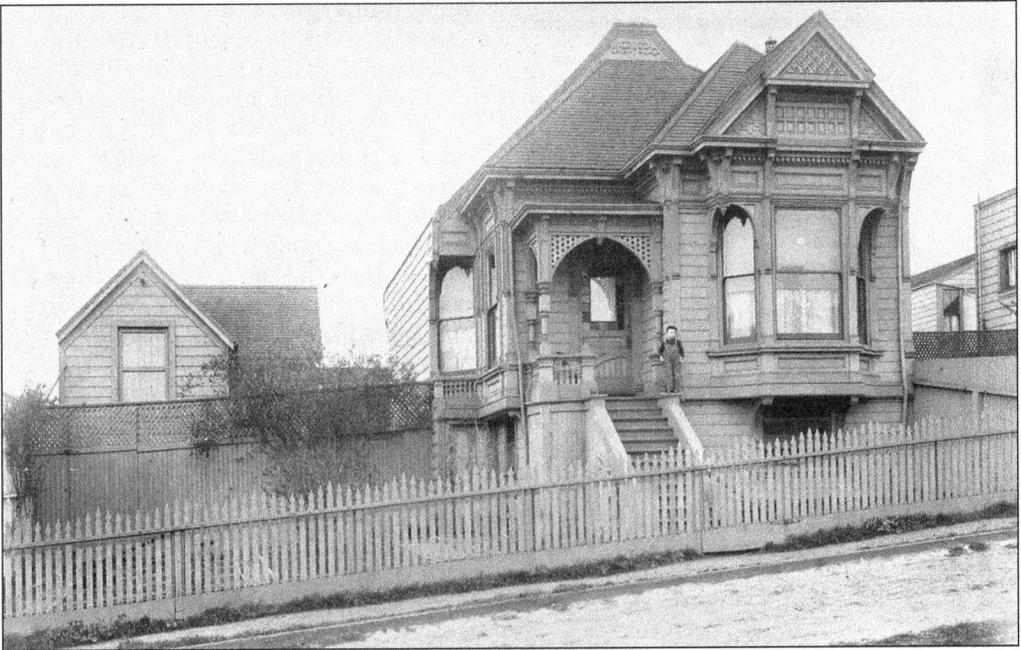

The Feyling family bought this house at 274 Andover Street in 1902. It was built in 1895, and in this photograph, a vegetable garden and a carriage house are visible on the left. Ludvig Feyling, a Norwegian rigger, worked on a state fireboat. On the morning of the earthquake, he walked to the top of the hill to see where the smoke was coming from, and then went to work, not returning for two weeks because there was so much to clean up in the city. This c. 1905 photograph shows Norbert, Feyling's oldest son, standing on the porch. (Courtesy Walter and Fern Feyling.)

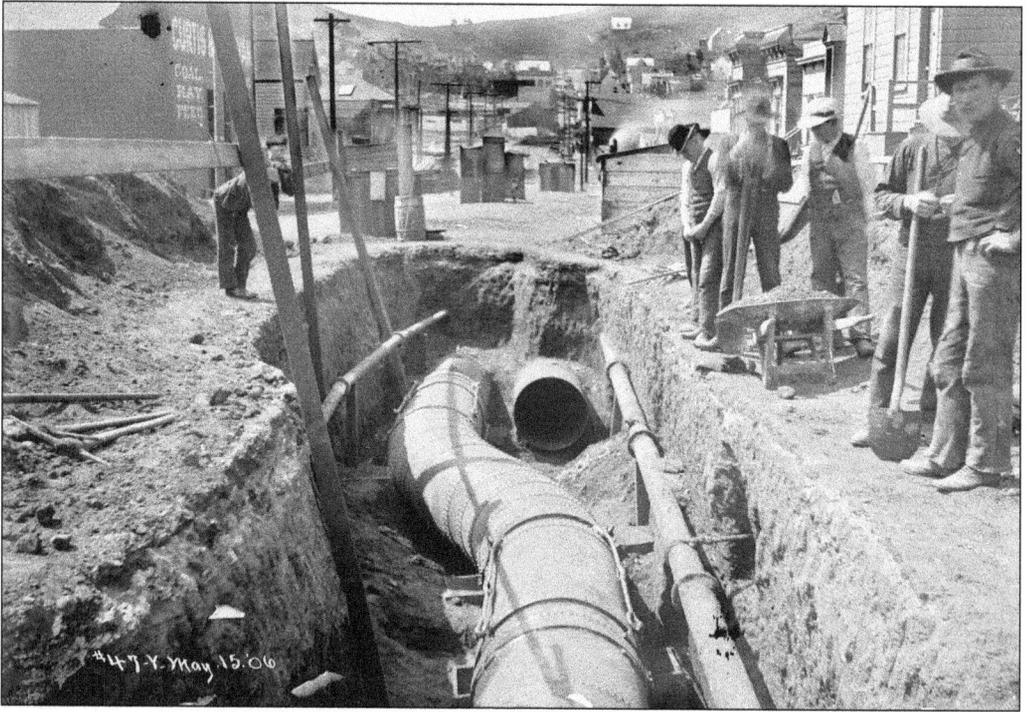

Rapid recovery from the fire and earthquake was the aim of all civic endeavors at the time. This May 1906 photograph shows men replacing water pipes on Alabama Street at Twenty-sixth Street looking south toward Bernal Hill. The street trenching meanders around the earthquake kitchens; by edict, only open-air cooking was allowed. On the left of the picture is the hay and grain business and grocery store operated by Peter Curtis and James Donovan until 1910. (Courtesy SFPUC Archive.)

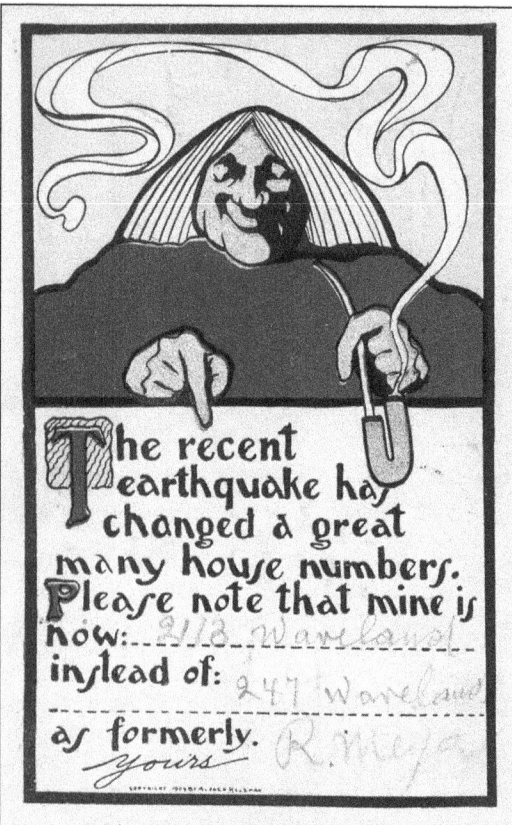

The recent earthquake has changed a great many house numbers. Please note that mine is now: 218 Waveland instead of: 247 Waveland as formerly. yours R. Mega

After the horrors and difficulties of the earthquake subsided, San Franciscans rediscovered their sense of humor and were able to laugh again. For a while, comic postcards were common, sent by the city's residents to their far-flung relatives and friends. This benign-looking witchy character with a pipe was used on a change-of-address card. (Courtesy the collection of Glenn Koch.)

Three

A NEIGHBORHOOD GROWS UP

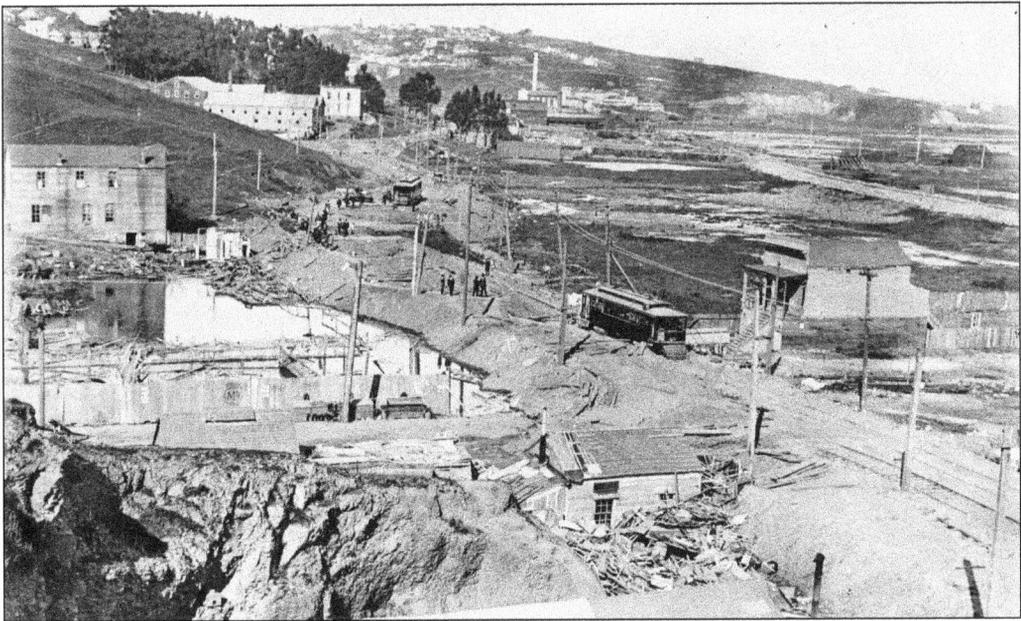

The post-earthquake period catapulted Bernal Heights from cow pastures to a dense urban neighborhood. In this 1915 photograph, taken at San Bruno Road (now Bayshore Boulevard) and Cortland Avenue, construction of raised streetcar tracks forces passengers to transfer. This photograph looks north with Bernal Heights rising to the immediate left and Potrero Hill in the distance. Just to the south of Cortland is a rock quarry. To the north on San Bruno Road is a machine shop and farther north are tanneries and the Pacific Curled Hair Works, a mattress factory with a stable in the basement. The Islais Creek wetlands occupy today's Bayshore industrial zone. These wetlands also drained Precita Creek, which was eventually buried by Army Street on the north side of Bernal Heights.

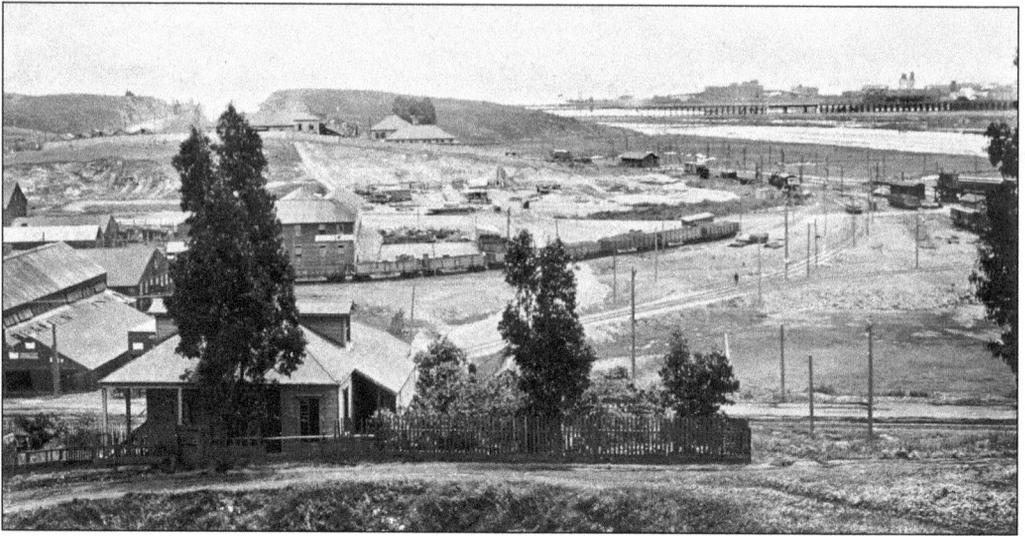

Bernal Hill was still a bucolic backwater at the time of this 1910 photograph (top), taken from its northeast slope. In the foreground is the Ocean Shore Railroad yard at the intersection of Army, Kansas, and San Bruno Streets. The railroad, which was intended to connect the city with Santa Cruz, operated on the east side of Bernal Heights from 1905 to 1920. The Islais Creek wetlands flow on the south side, crossed by the Southern Pacific trestle in the distance. In May 1906, the board of supervisors ordered the Ocean Shore Railroad to fill in the Precita Valley swamp, which they called a "public nuisance for many years past." Virtually all of the flatlands east of Bernal Heights were filled with rubble and debris. Below, a 1912 view of Bernal's east slope shows the same railroad yard and early "twin peaks" aspect of the hill. Some of the buildings in this photograph still exist, but many were razed to make way for the 101 Freeway.

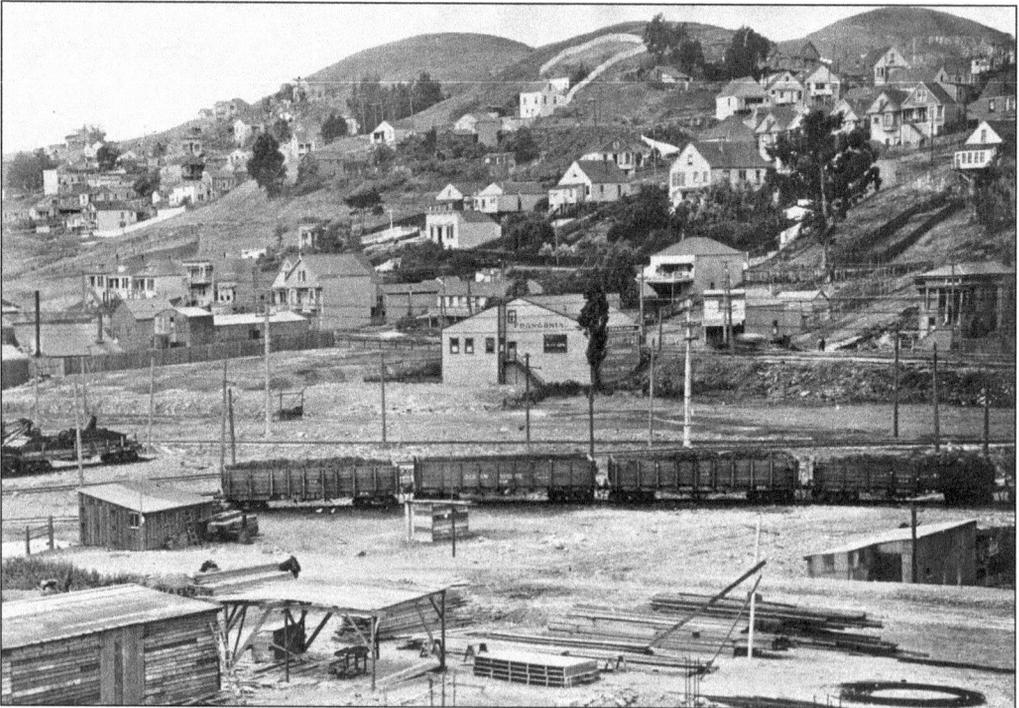

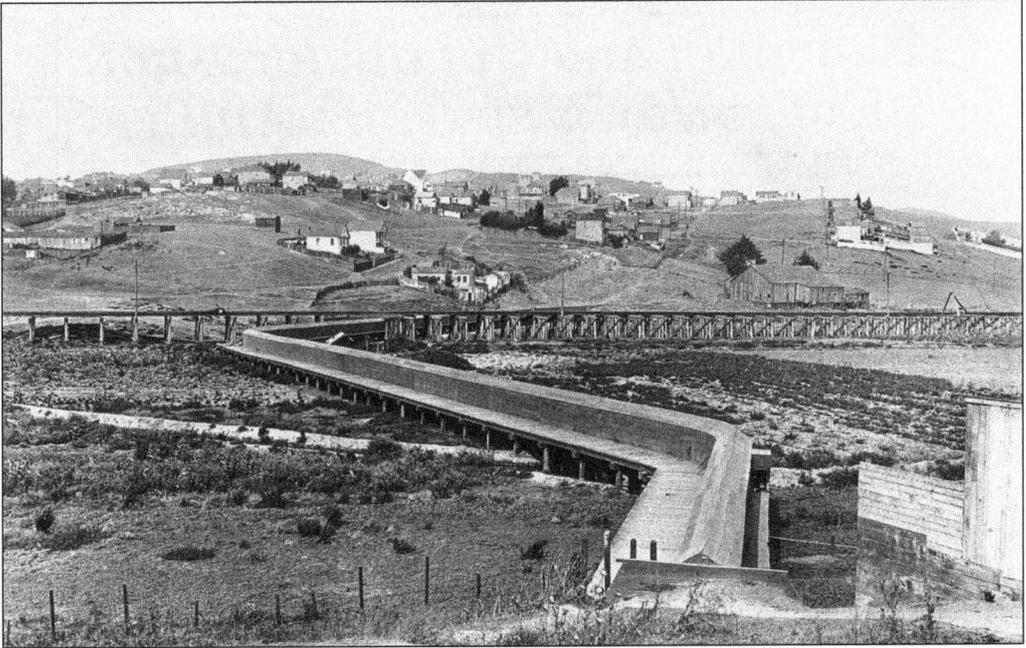

This 1912 photograph of Bernal's south slope shows an intersection of the Ocean Shore Railroad and the Alemany water flume. The flume carried water from Islais Creek near Glen Park around the south and east slopes of Bernal Hill to a reservoir at Sixteenth and Brannan Streets. It was constructed in 1860. Owned by the private company Spring Valley Water Works, it was an important part of the city's early water system.

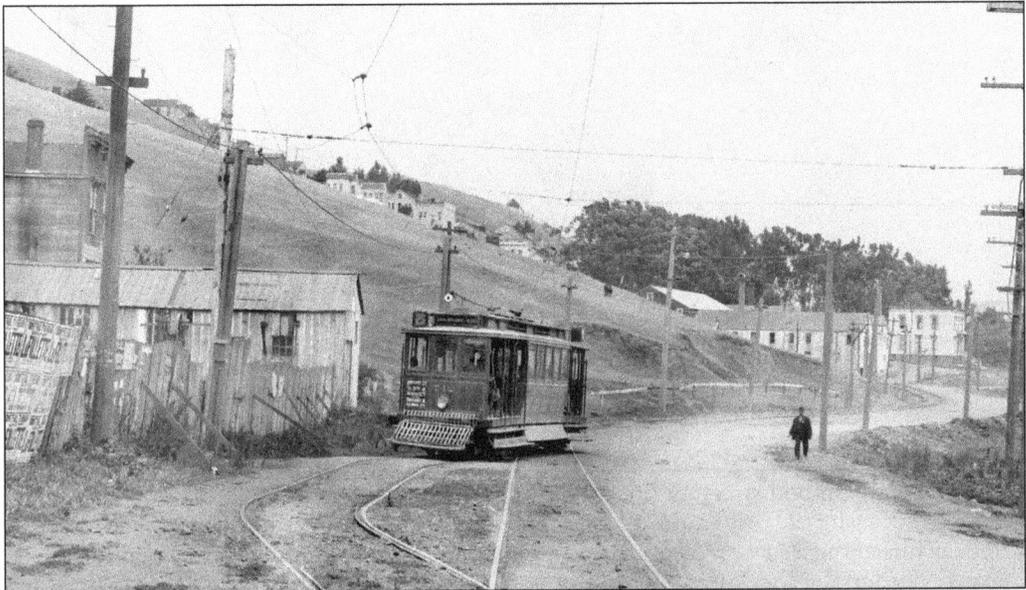

In 1912, the east slope of Bernal Heights at San Bruno and Cortland Avenues still looked like the country—with streetcar service. Note the campaign signs plastered on the fence on the left. William Howard Taft and Robert M. LaFollette sought the GOP nomination. When the Republicans renominated Taft, Roosevelt left the party to lead the Progressives, thus guaranteeing the election of Woodrow Wilson that year. Uphill the row of houses on Joy Street is still there.

Motorman and Conductor Shot: Big Trolley Car Runs Amuck!

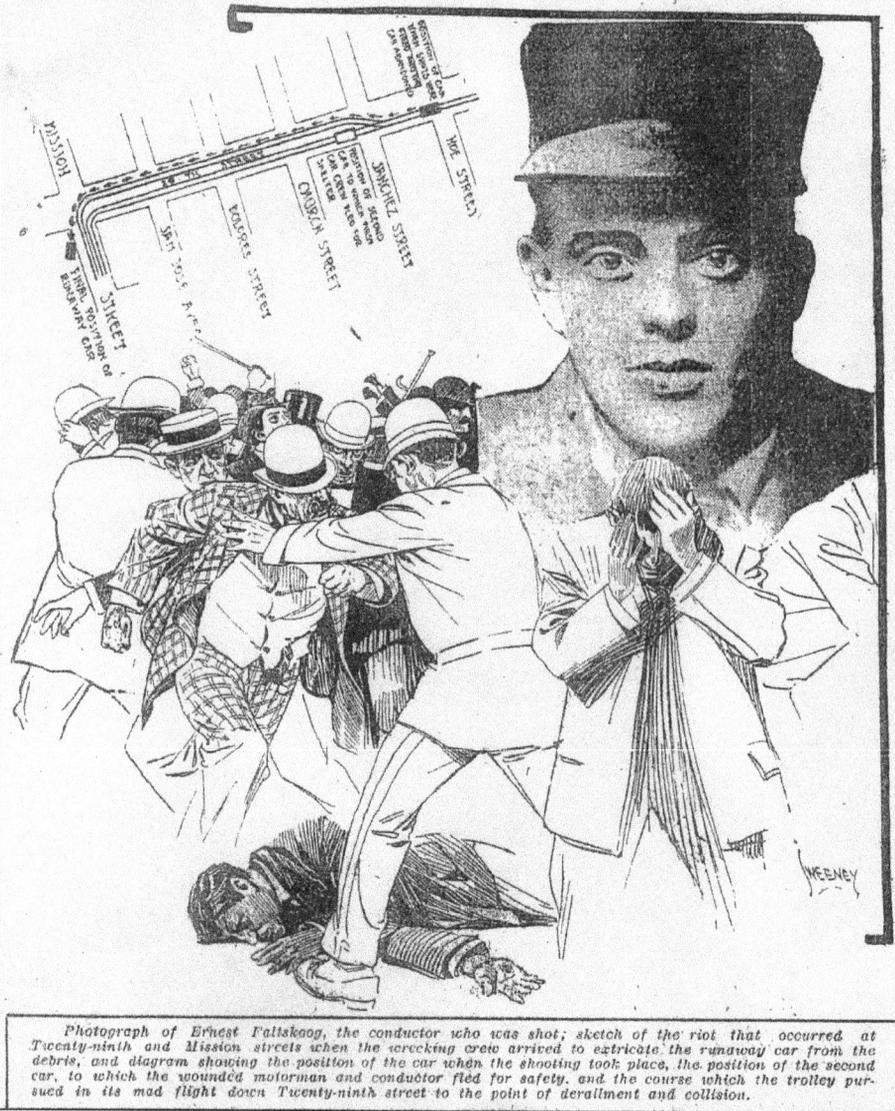

Photograph of Ernest Faltskoog, the conductor who was shot; sketch of the riot that occurred at Twenty-ninth and Mission streets when the wrecking crew arrived to extricate the runaway car from the debris, and diagram showing the position of the car when the shooting took place, the position of the second car, to which the wounded motorman and conductor fled for safety, and the course which the trolley pursued in its mad flight down Twenty-ninth street to the point of derailment and collision.

The two neighborhood streetcar houses on Valencia Street and Mission Street were sites of intense conflict in 1907 when the Carmen's union was forcedto strike. The private streetcar company hired armed strikebreakers to operate the cars. In one notorious incident on July 21, an inexperienced strikebreaker tried to run the No. 9 line car back to the barn. He lost control and the car hurtled back down Twenty-ninth Street, leapt the tracks at the Mission Street turn, and smashed through stores on the east side of the street. Several people were badly injured. This incident caused another night of rioting at the car house in the city's deadliest strike. Over the course of nearly a year, 31 people were killed and more than 1,000 injured. The strike was lost, and the Carmen's Union was dissolved in 1908.

Built for the Buren P. Kelley family in 1884, the house at 161 Coleridge Street typified early residential buildings on Bernal's west slope. Like many residents, Kelley worked for a streetcar company. The house was designed and constructed by Richard Hurlburt, who built at least four other homes on Coleridge Street. It was originally built as a single-story structure in the Eastlake style, then was raised and expanded to two stories, and later was raised again to make way for a garage. (Courtesy Yvette Kay.)

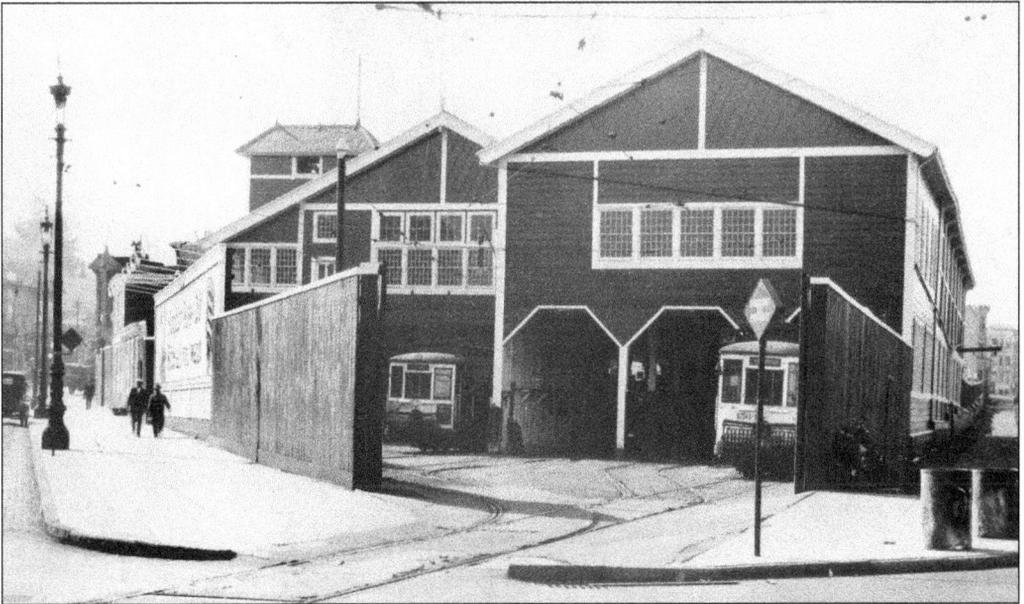

The growing transportation grid, privately owned and developed, often by real-estate interests, encouraged working-class families to move to the area. By 1883, cable car lines reached south of Army Street, with a Market Street Cable Railway car barn on Tiffany Street at Valencia Street shown here in a 1928 photograph. In the 1890s, the first electric line in the city ran out through the Mission on Guerrero Street to San Jose Avenue. (Courtesy Philip Hoffman.)

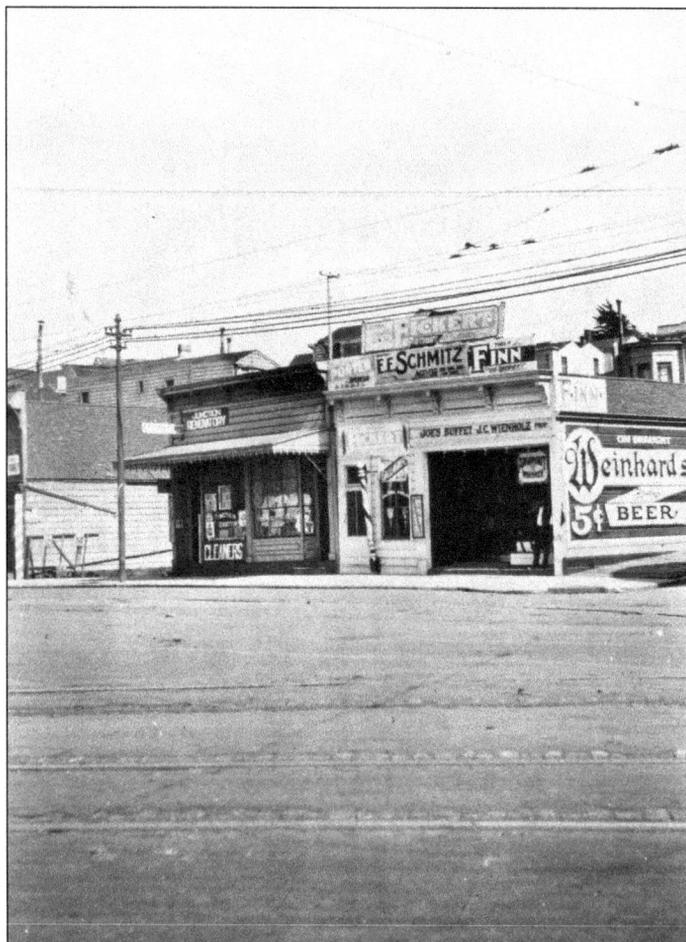

When these photographs were taken, between 1911 and 1915, Mission Street south of Army Street was a bustling commercial strip serving its working-class neighbors. Many locals either owned a small business or worked for one. Single men lived in rooming houses, such as the El Trocadero Hotel at 3437 Mission Street, and ate in storefront restaurants, such as Joe's Buffet at Fair and Mission Streets. There were drinking establishments on every corner and then some. Back then one could find just about anything one wanted on Mission Street between Army Street and Cortland Avenue. (Courtesy California Historical Society, FN-36464 and FN-36463.)

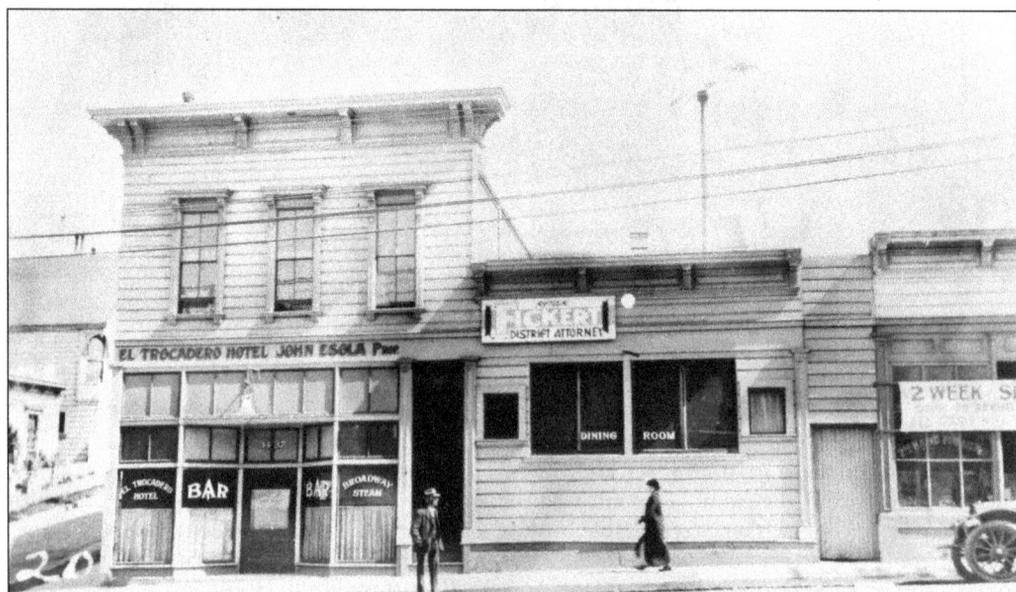

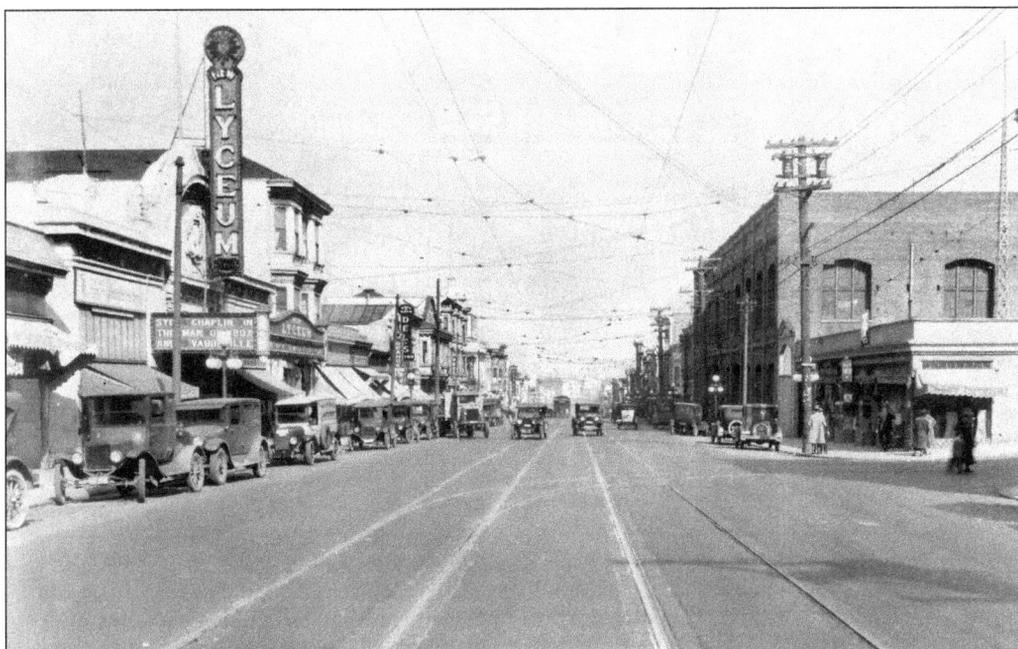

One of the first substantial theaters to be built in the Mission District, the Lyceum Theater was built in 1907 with 1,400 seats. This 1926 picture shows the New Lyceum, which was playing a comedy starring Syd Chaplin, brother of the more famous Charlie. It was demolished in 1964 to make way for the Safeway parking lot. (Courtesy Jack Tillmany.)

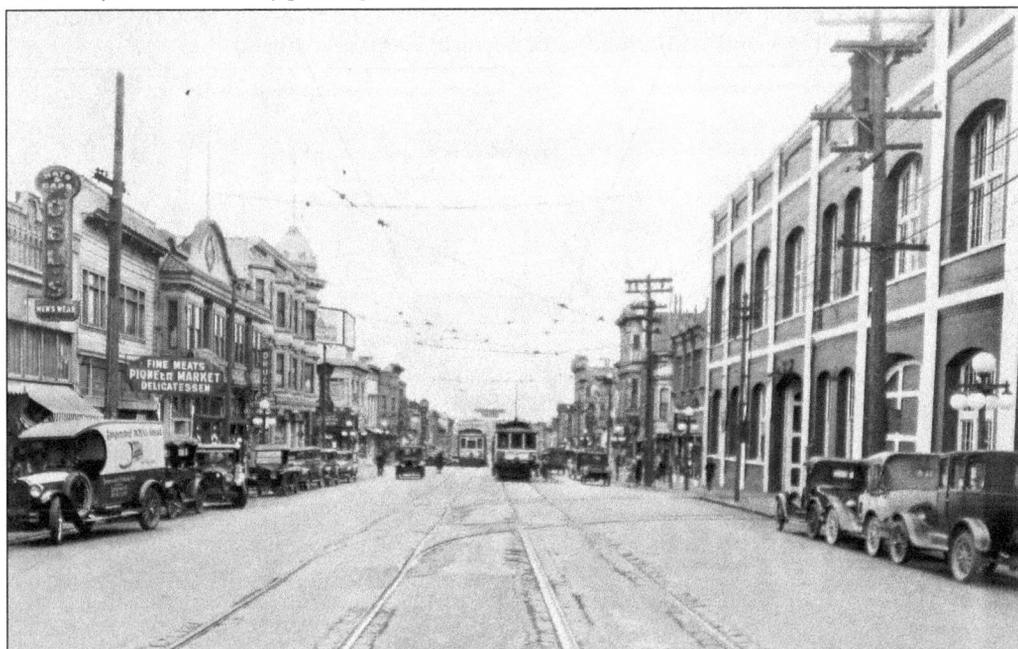

By the 1920s, Mission Street had entered the automobile age. On the right is the electric-streetcar barn at Virginia Avenue, now the site of senior housing and Big Lots. On the left is the Graywood Hotel at 3300 Mission Street. Its great turret was removed in the 1940s and donated for scrap metal to help the war effort.

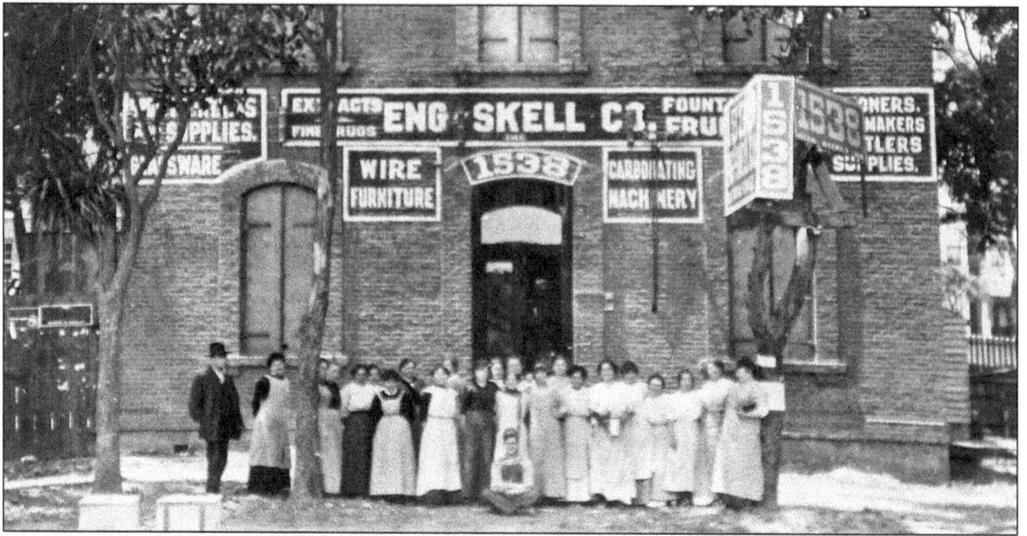

In 1881, Hubert Howe Bancroft built his library next to St. Luke's Hospital to protect his research materials and 43,000 volumes from downtown fires. It was the only major library in the city to escape damage in the 1906 earthquake and fire. By the end of May 1906, University of California students moved his entire collection to Berkeley. The Eng-Skell Company, purveyors of essential oils and fruit extracts and soda fountains and supplies, occupied the building until St. Luke's took over the entire block in 1910. It became an outpatient clinic in 1920. The 1926 photograph below shows nurses parked in front of the clinic in a subscription car used for follow-up home visits. From 1890 to 1989, St. Luke's Nursing School graduated more than 2,500 nurses. The hospital demolished the Bancroft Building in 1956. (Above courtesy San Francisco History Center, San Francisco Public Library and California Pacific Medical Center/Archives.)

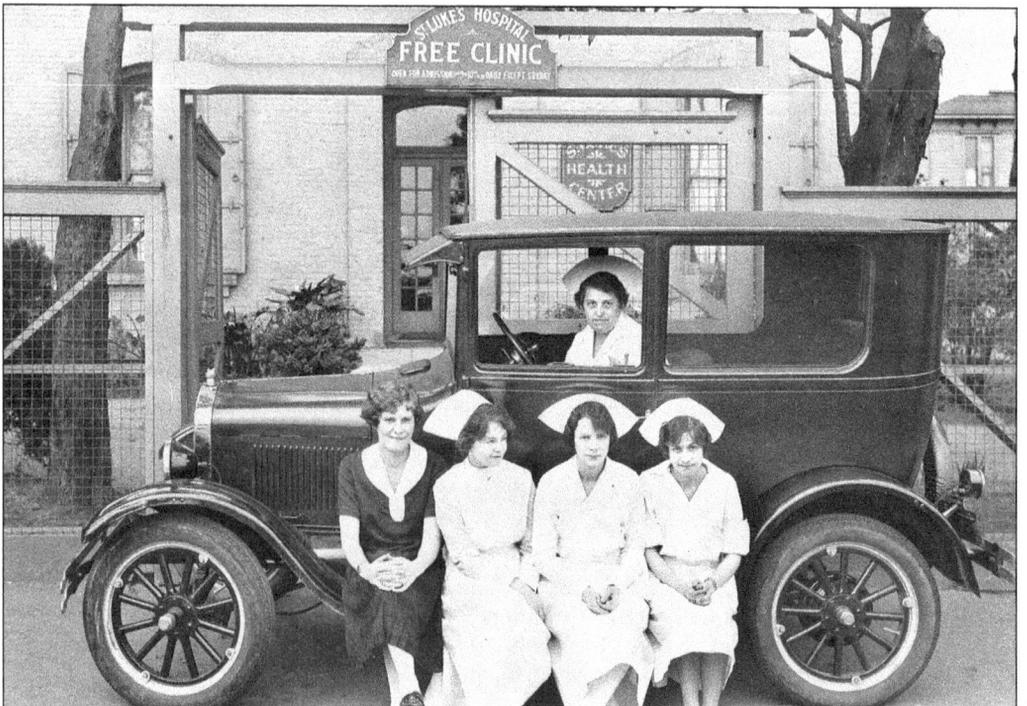

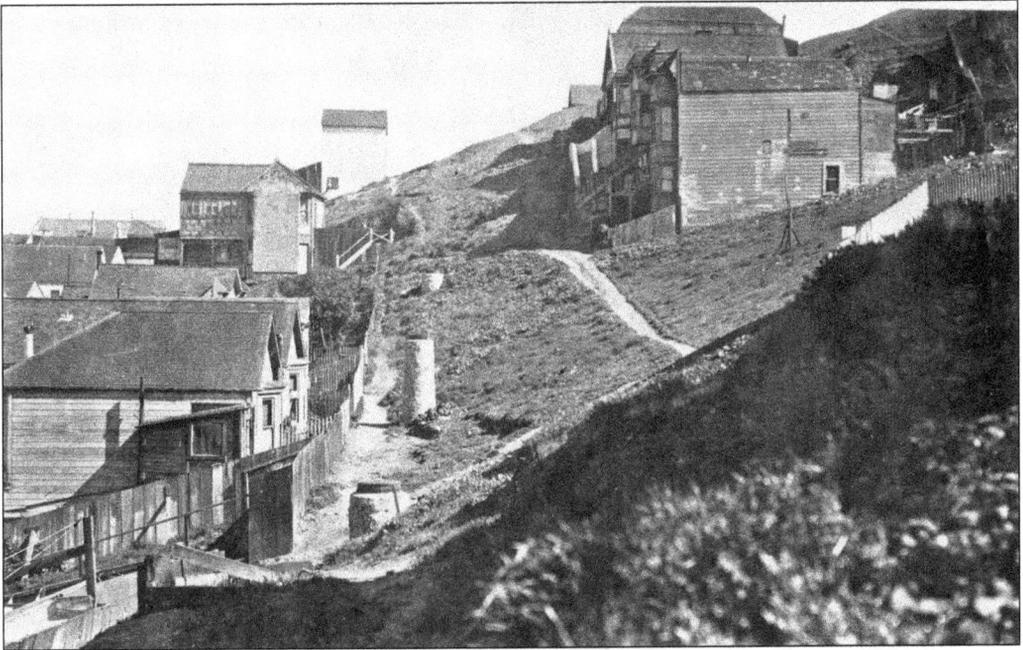

Elsie Street still lacked paving in the mid-1920s. In this view north from the middle of the 100 block, most of the houses are now gone, victims of various calamities over the years. The two houses on the lower left, 150 and 148 Elsie Street, are still there. The white columns are sewer manholes set at the proposed street grade. The street was not actually constructed until the 1980s.

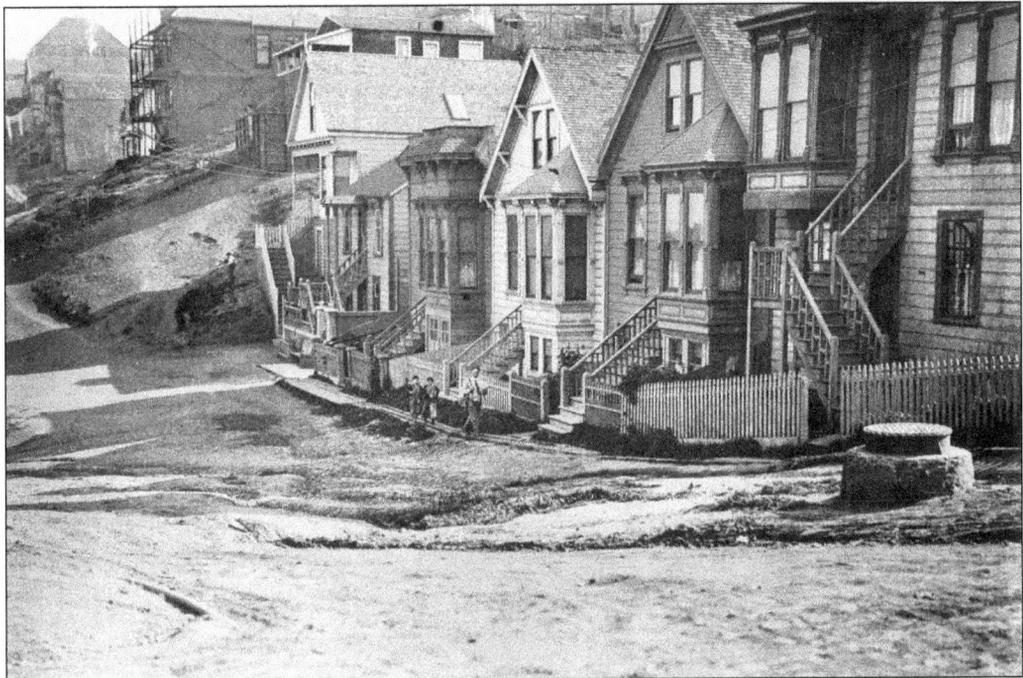

The postman is delivering mail to 183, 185, 187, 191, 193, and 195/197 Elsie Street in this 1920s view, looking north from Eugenia Avenue. The houses beyond are now gone, having been replaced by much newer buildings when the street was finally constructed.

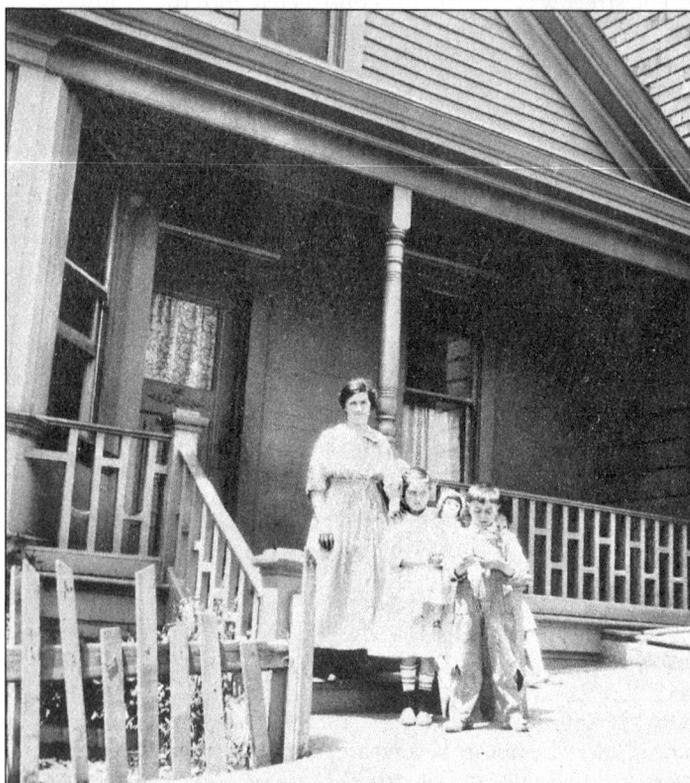

Dominic and Cecilia Gualco's family typified working-class settlers on the west slope of Bernal at the beginning of the 20th century. Dominic's uncle, Fr. Paul Michael Gualco, was sent to California by the Italian Catholic Church. Dominic followed him, working for Southern Pacific and selling tamales from a pushcart in Chico before coming to San Francisco in 1900. Dominic married Cecilia Vaca in 1906, 10 days before the big quake. Above standing on the steps at 112 Winfield Street in 1920, are Dominic Gualco and his son Frank. At left, c. 1915, are Cecilia and their children Catherine and Frank. (Courtesy Jacalyn Morri.)

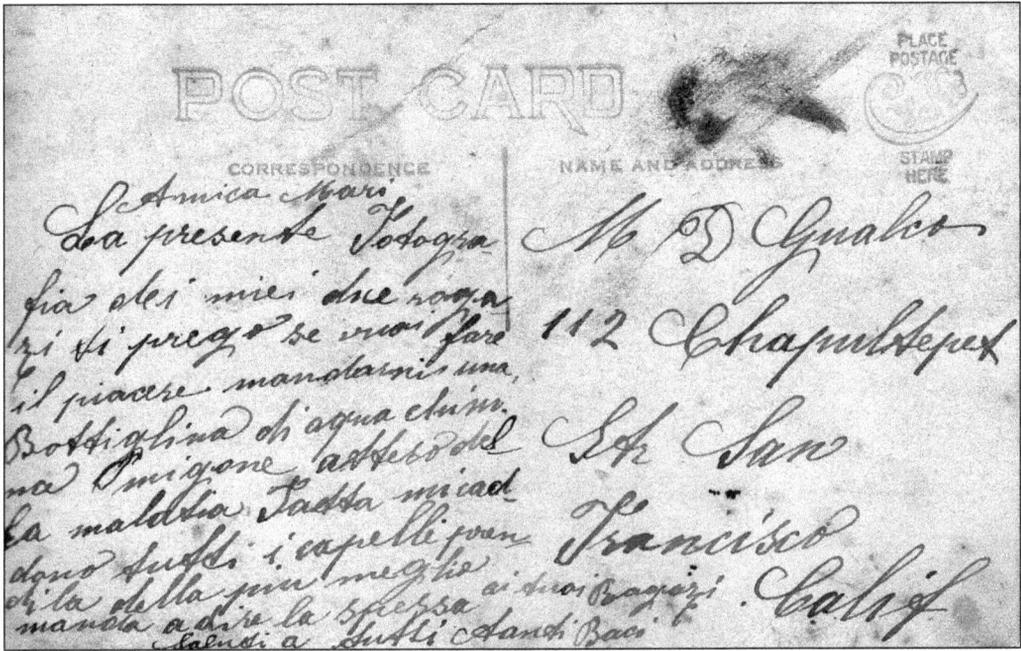

In 1909, a postcard from Italy was addressed to Dominic Gualco at 112 Chapultepec Street before Bernal Heights's street names were changed. In 1909, a street-renaming commission was appointed by Mayor Edward Robeson Taylor to clear up the long-standing confusion from similar or duplicate street names. By 1919, when the postcard below was sent, the street name had been changed to Winfield. Many Bernal street names were changed at that time. On the west slope, California Avenue became Coleridge Street, Buena Vista Street became Bonview Street, and Lizzie Street became Kingston Street. (Courtesy Jacalyn Morri.)

Natale John Gualco, seen here as an innocent in 1908, was a bookie in the 1930s and early 1940s. He kept his money, as much as $10,000, in a barrel in the sub-basement at the family home on Winfield Street. In the 1940s, he became a co-owner of Cavanaugh's Bar at 3301 Mission Street, tending bar there until his death in 1970. He was considered a great "Irish" bartender and was praised by Herb Caen. (Courtesy Jacalyn Morri.)

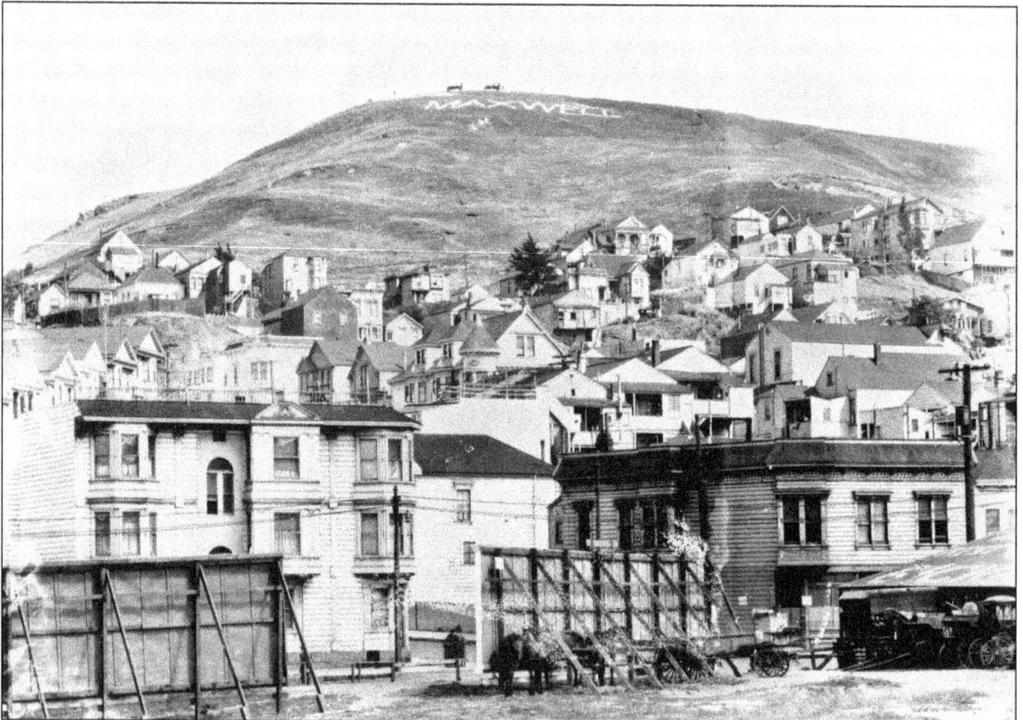

By the mid-1920s, when this photograph was taken of the northwest slope, the west side of Bernal Hill was fairly well developed. Horses in the foreground indicate there was a livery stable on the west side of Mission Street, the site of the soon-to-be-developed Sears and Roebuck department store. The turret in the center of the photograph is 1 Coleridge Street. The Maxwell automobile, advertised on the hilltop, was manufactured from 1903 to 1925.

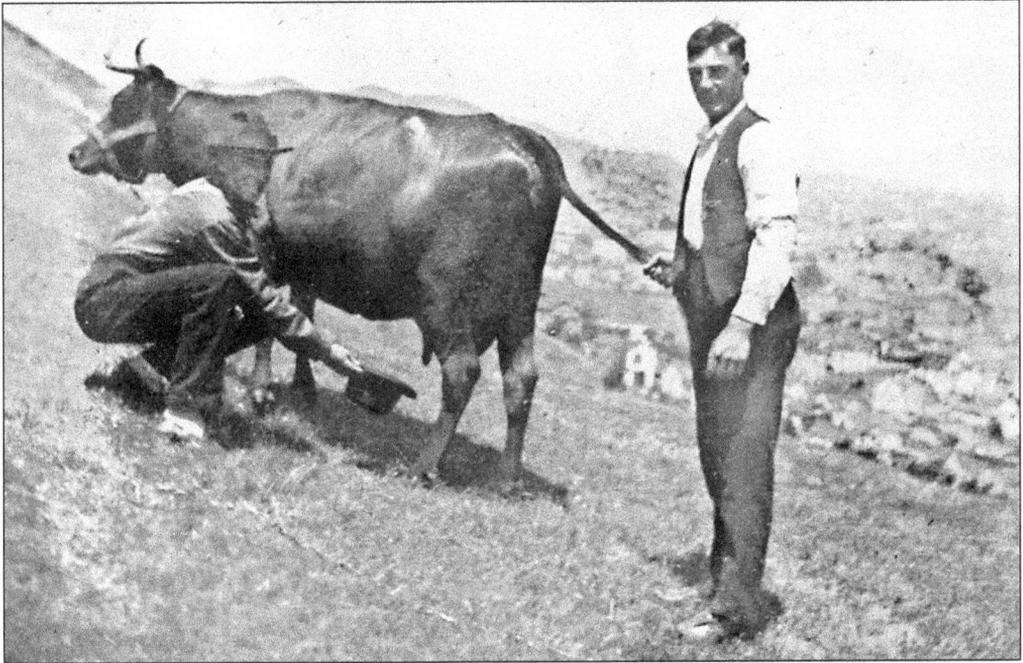

Lawrence Aarreberg and Edmond Mayers (standing) illustrate an unusual method of getting milk from a patient-looking cow at the top of Bradford Street. In 1920, many residents of Bernal Heights kept cows and goats, and the hilltop grasslands were freely used as pasture. (Courtesy Elaine Mayers.)

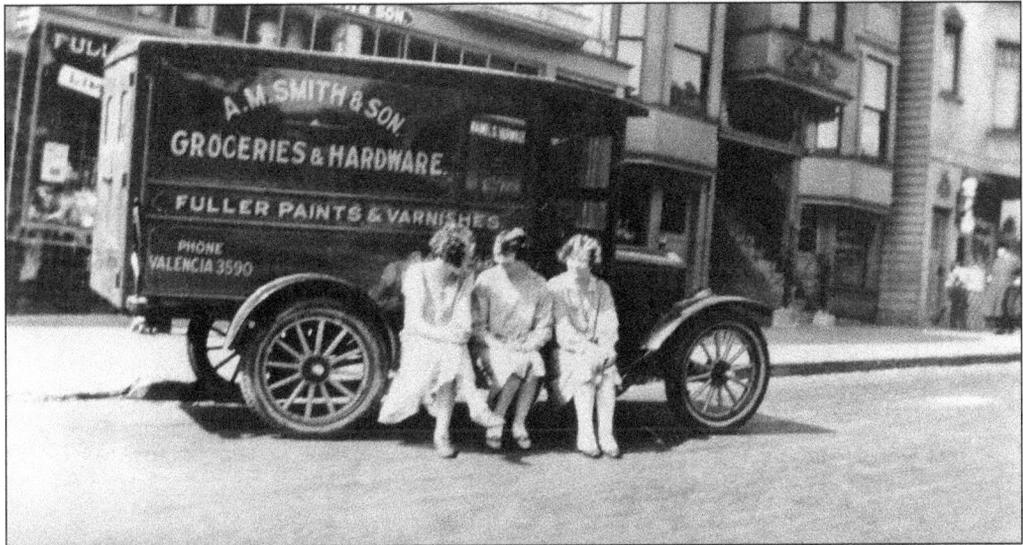

August M. Smith operated a grocery store (along with paint and hardware) at 340–342 Precita Avenue. In this 1926 photograph, his daughters pose with the colorful delivery truck in front of the store. The family lived above the business, then moved to the house next door. At the far right is the striped pole announcing Joseph Guardino's barbershop, which was in business for decades. (Courtesy Mona Tong.)

At left, the Caruso family moved into this house at 3220 Folsom Street in 1907. Matriarch Rose Tarantino Caruso (front) was born in Palermo in 1856; her children Joseph, Jlia, Jake, Henry, and Jennie were born in New Orleans. The Carusos came to San Francisco via New Orleans, where they sold fruit and vegetables. The ground floor of the house was converted to the family's grocery store before World War I. Like many Italian families in Bernal, the Carusos made their own wine and traded some with their neighbors. The below photograph from the early 1920s shows the extended family in the backyard of 3220 Folsom Street. Pictured from left to right are Julia Caruso; her mother, Rose; neighbor Louis; Henry; Julia's son Sam; Jennie's husband, Antonis; and Julia's husband, Salvatore. In the foreground are Jennie Caruso with Julia's children Rose, Petrina, and John. (Courtesy Petrina Caruso Paton and Patricia Paton Cavagnaro.)

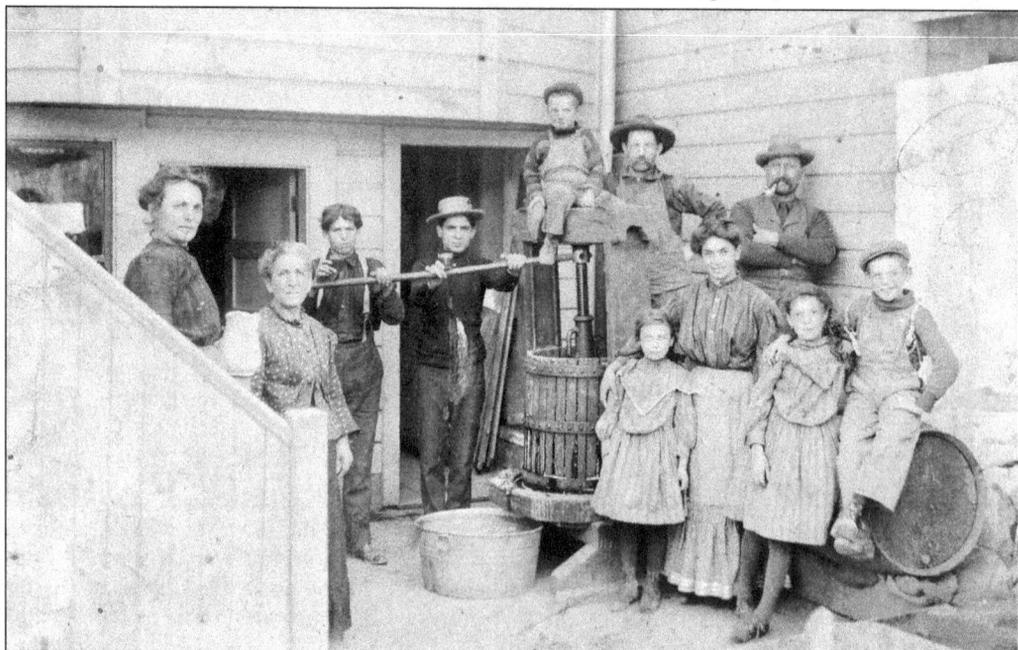

Three of Jennie and Antonio Caruso's children, Petrina ("Baby Pete"), Salvatore ("Toots"), and Joseph, pose in their Sunday finest at (right) on a sunny day outside the family grocery store at Folsom Street and Precita Avenue in the early 1930s. The awning of the store shelters a little girl in a frilly dress and apron—perhaps another family member drafted into service. The Carusos' grocery store (below) sold the basic staples alongside fresh pasta, bread, and vegetables. In this *c.* 1918 photograph, Jennie Caruso and her children John, Joseph, and Salvatore pose alongside Nana Rose Caruso. Rose ran the grocery store with her daughter Jennie after Jennie's husband, Antonis, died in 1925. They made tomato paste by drying tomatoes in the backyard. The store had a chicken coop out front; Rose would wring the chickens' necks for customers. (Courtesy Petrina Caruso Paton and Patricia Paton Cavagnaro.)

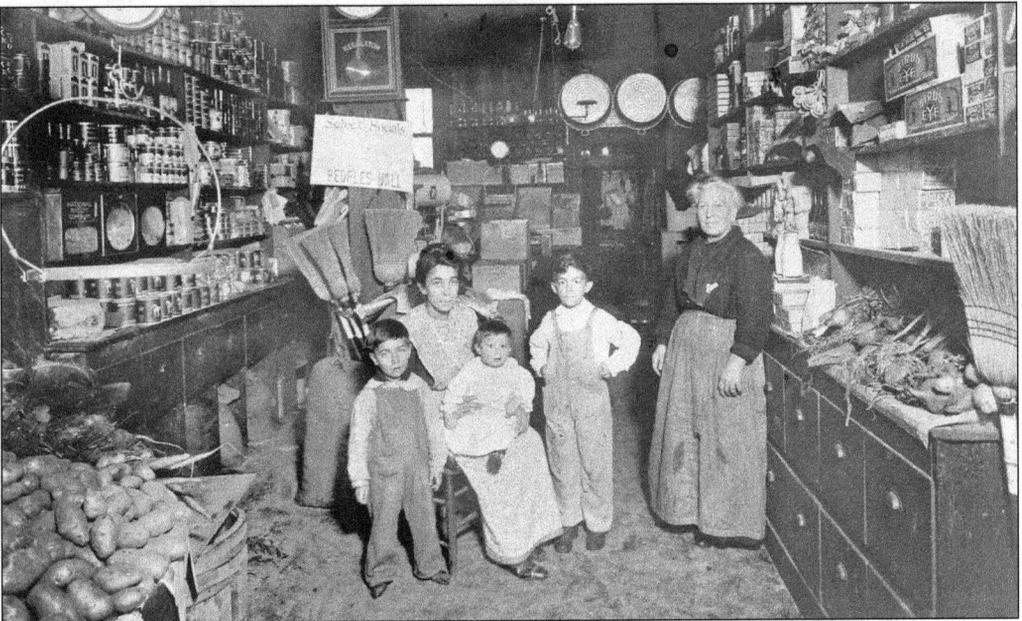

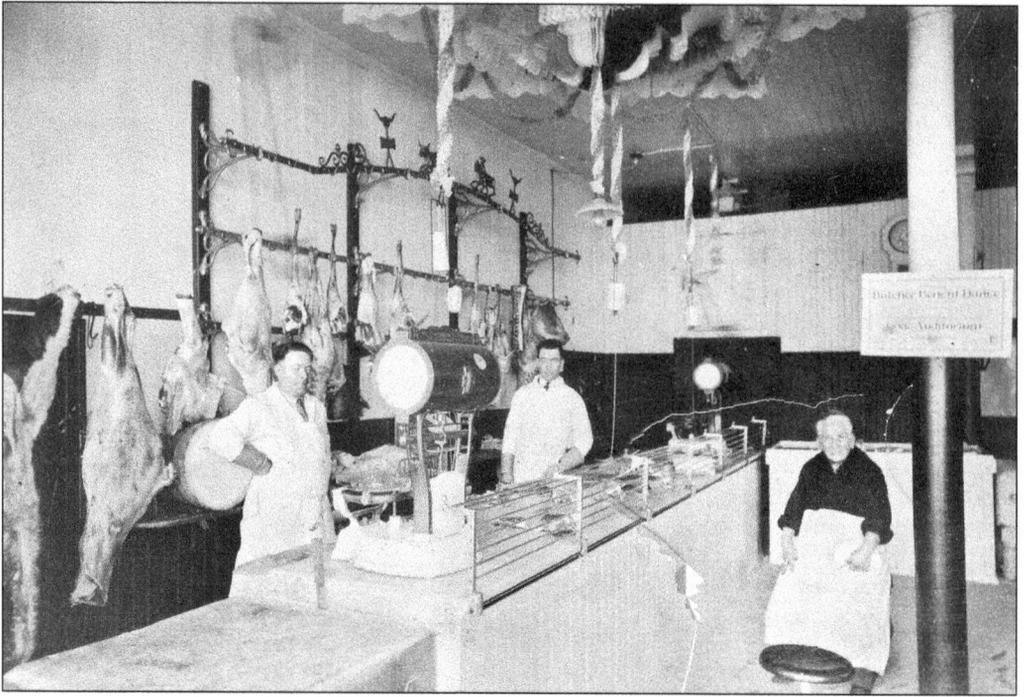

Red McCaffrey and Joe Campbell ran the Yosemite Meat Market at 3202 Folsom Street, with neighbor Rose Caruso (seated) dropping by for a visit. The building has been owned by the Cozzo family since the 1920s. Rumor has it that when a young woman was hit by a streetcar on Folsom Street, Joe used a chopping knife to amputate her leg. The store continued as a butcher's until the 1990s. (Courtesy Petrina Caruso Paton and Patricia Paton Cavagnaro.)

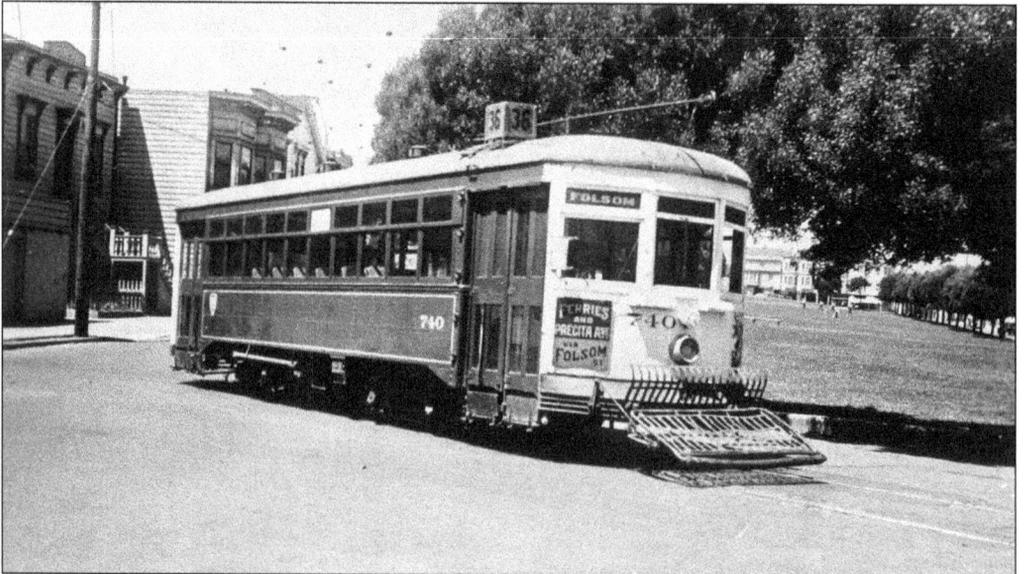

The No. 36 Folsom streetcar turns the corner at Precita Avenue and Alabama Street at the east end of Precita Park. Cars ran along the park until 1948. Looking west from Alabama Street, 418 Precita Avenue can be seen above the back of the streetcar. (Courtesy Philip Hoffman.)

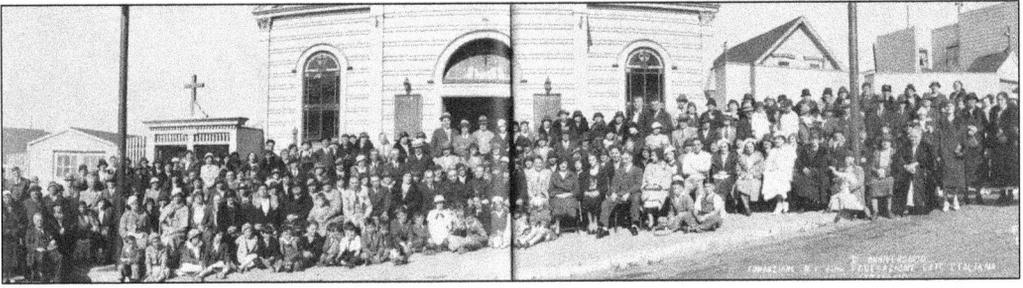

The Immaculate Conception Church on Folsom Street was constructed in 1912 as an Italian national church to serve Italians living in the community, many of whom moved to Bernal Heights after the 1906 earthquake and fire. A special mass was held in 1934 at Immaculate Conception Church to celebrate the 10th anniversary of the Italian-American Catholic Federation. In the 1917 picture below, parishioners celebrate the Feast of St. Joseph. Immaculate Conception Church was the subject of media attention in the summer of 1996, when several parishioners saw what they thought was the image of the Virgin Mary on a gable of the church. Some connected it to the recent murders of two teenagers in Precita Park, although the initial sighting predated the murders by two days. Crowds gathered in the evening to pray and sing, but the purported apparition was not accepted as a miracle by the Archdiocese of San Francisco and interest eventually waned.

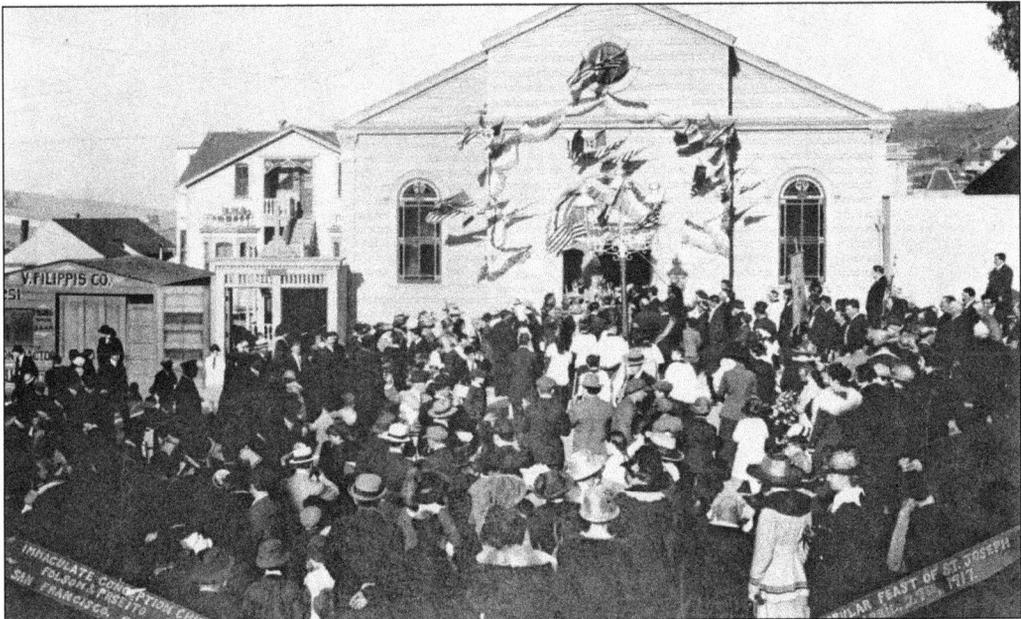

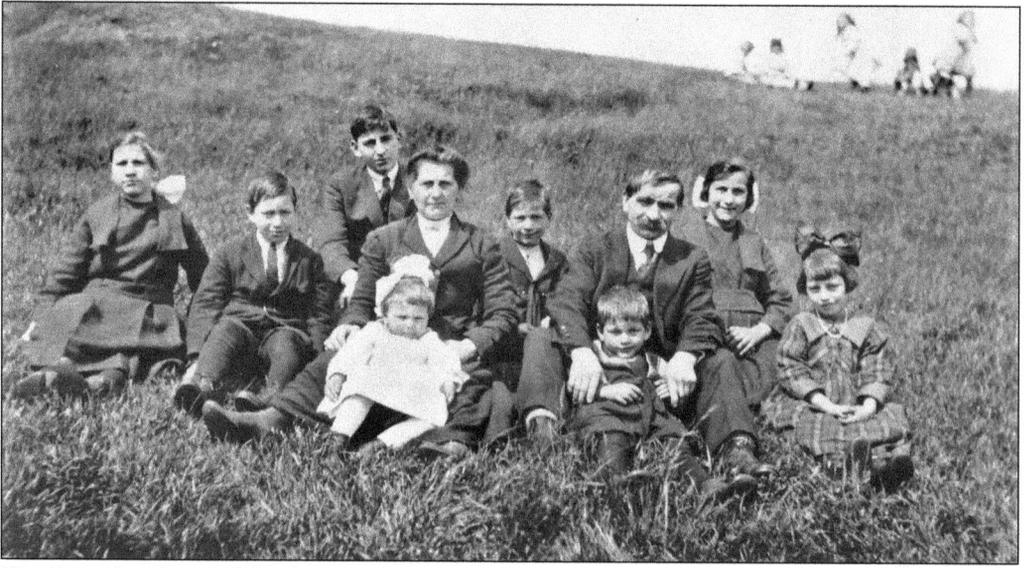

The Egger family posed for this 1920 family photograph in Holly Park. From left to right are Anna, Theodore, Eugene, mother Anna, Frank, father Eugene, Katherine "Kay," and Elizabeth "Lee" (age seven), with baby Rose and Joe in front. The parents and a couple of the kids emigrated from Austria. In 1907, they moved to Wolfe Street (now Mullen Avenue), and later to Waltham Street. In 1999, an Open Space memorial at the top of the Harrison Street stairway was dedicated to the family. Lee Egger served as the unofficial Bernal Heights historian for many years. (Courtesy the Egger family.)

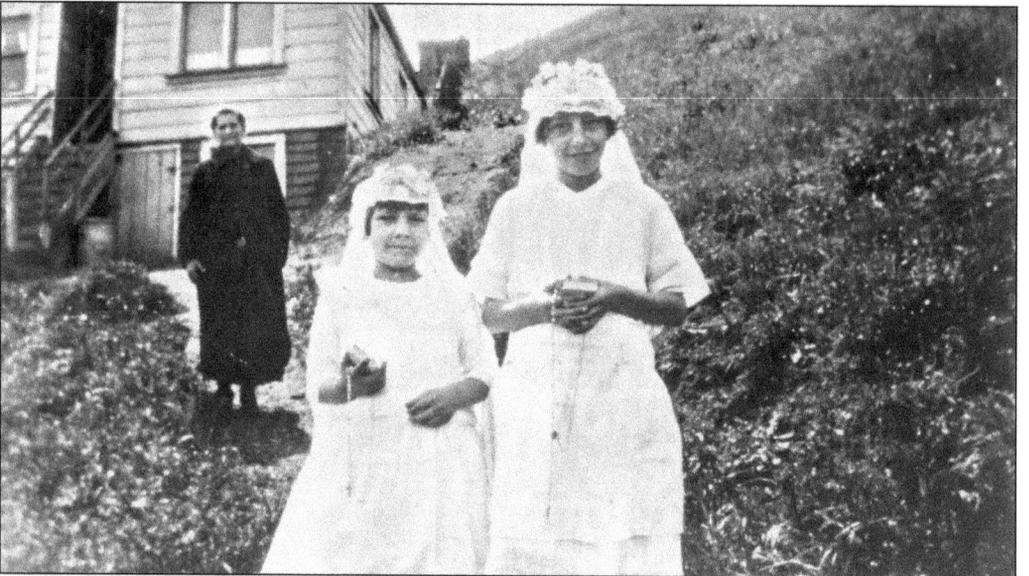

Dressed for first communion in 1925, Rose and Elizabeth "Lee" Egger proudly show off their outfits before going down the hill to celebrate mass at St. Anthony's Church. Their mother, Anna, is in the background. The Egger home sits on the north slope of Bernal Hill. A few years later, it was moved downhill to make way for the construction of Bernal Heights Boulevard. (Courtesy the Egger family.)

Mary Stack McNabola and daughter Jane are pictured facing their house at 88 Lundys Lane around 1909; they were photographed by Mary's husband, Michael. Jane was two weeks old when the family was made homeless by the earthquake and fire. They made their way to the Presidio and then to Precita Park. Jane was baptized at St. Anthony's on April 22, 1906. Jane McNabola married Frank Marchetti and lived in San Francisco until her death in 1993. (Courtesy Mary Marchetti.)

This house at 57 Mirabel Street on the north side of the hill was built by Mr. Schatz in 1908; he is seen in the picture with his wife. Mr. Schatz worked in Butchertown and also built the house next door. (Courtesy Verena Lukas and Peter Rengsdorf.)

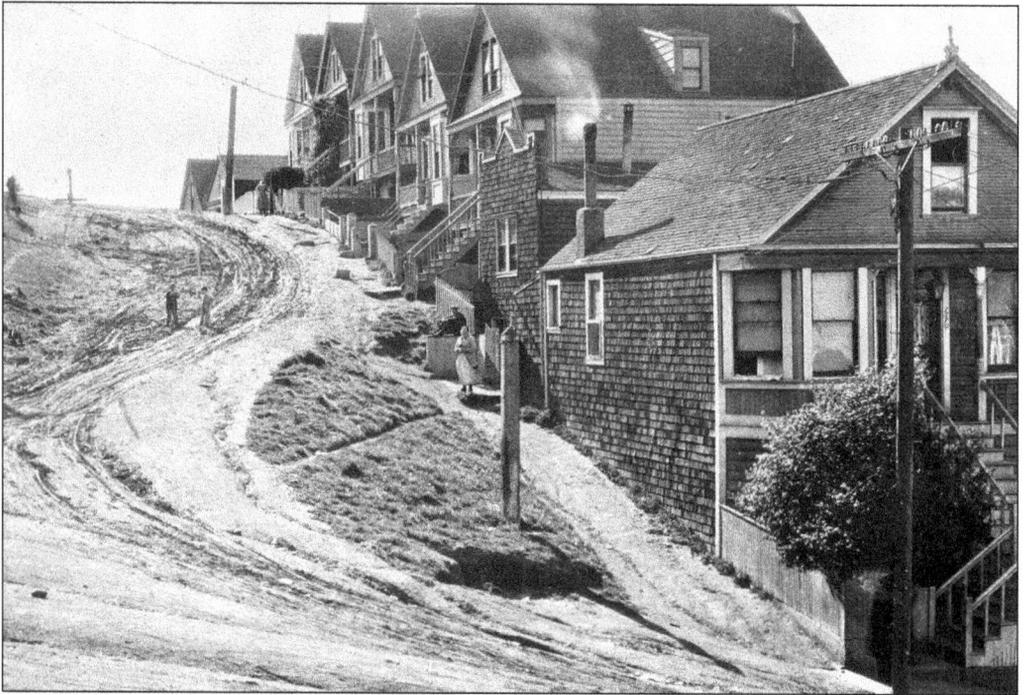

In March 1920, the streets at Peralta Avenue and Hampshire Street were still unpaved. Marching up the hill is a row of houses built in 1907; their addresses are 76, 78, 80, 82, 84, and 86 Peralta Avenue. More than 600 homes were built in Bernal Heights in the year after the 1906 earthquake and fire. Downhill on the corner is 1570 Hampshire Street.

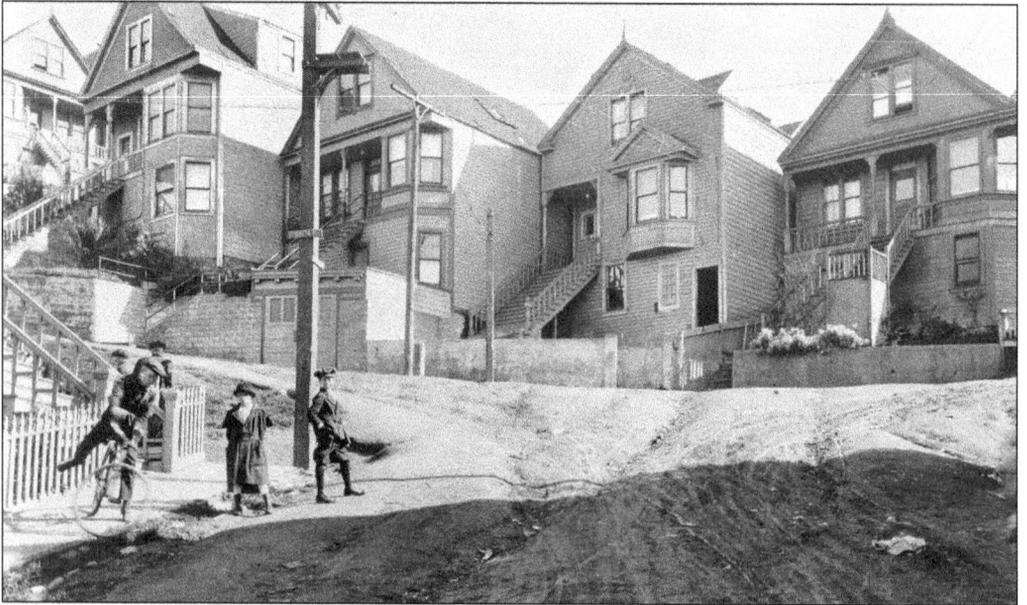

The unpaved streets were a kids' playground long before the construction of a retaining wall, seen here on Hampshire Street looking south at Peralta Avenue in 1920. The neat row of Victorian houses is 51, 53, 59 and 65 Peralta Avenue, all built before 1900. This part of the neighborhood was known as Peralta Heights.

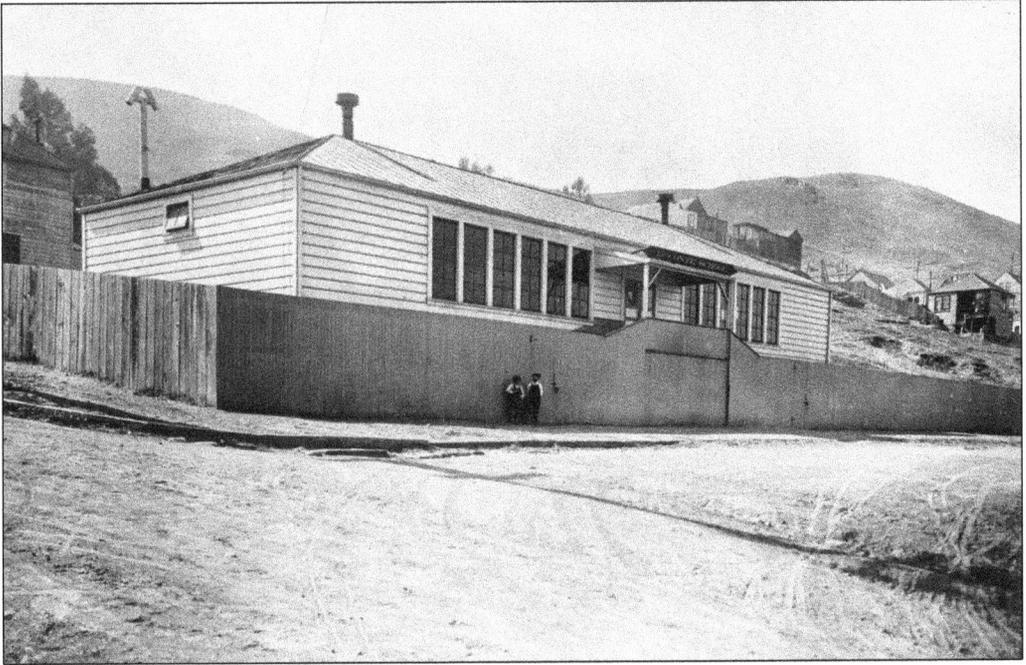

Land was acquired for the original Le Conte School by purchase and condemnation in late 1911. It was built in 1912 at Norwich and Alabama Streets and is shown above in 1915. The later school, shown below, was built on land acquired from 1923 to 1925 at the corner of Harrison and Army Streets. It was designed by the architect John Galen Howard in classical style with monumental windows, an auditorium, library, and 28 classrooms. Built of reinforced concrete in 1924–1925, it was one of only two public schools designed by Howard, and the only one still standing. Howard also designed the campus of UC Berkeley. Le Conte was renamed Leonard Flynn Elementary in 1981. (Below photograph courtesy San Francisco History Center, San Francisco Public Library.)

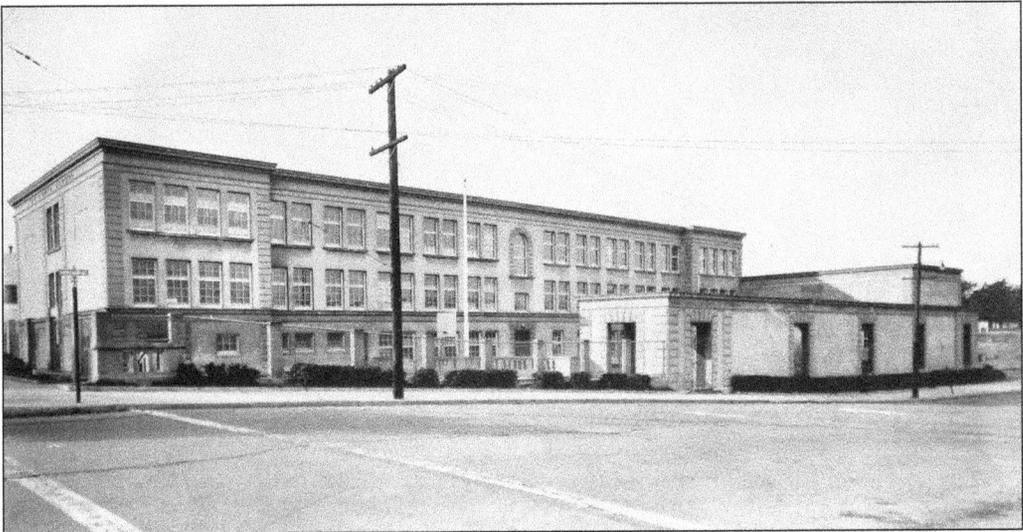

John Bogue, his best friend, Joe, and their pals pose outside a house on Bennington Street in their Sunday best, perhaps before an outing. John, who served in the San Francisco Fire Department for 43 years, was born in San Francisco in 1901; his father was a bartender who ran Johnny Bogue's Tavern at 3001 Mission Street. Two other brothers also served in the SFFD. (Courtesy Georgia Bogue Carrozzi.)

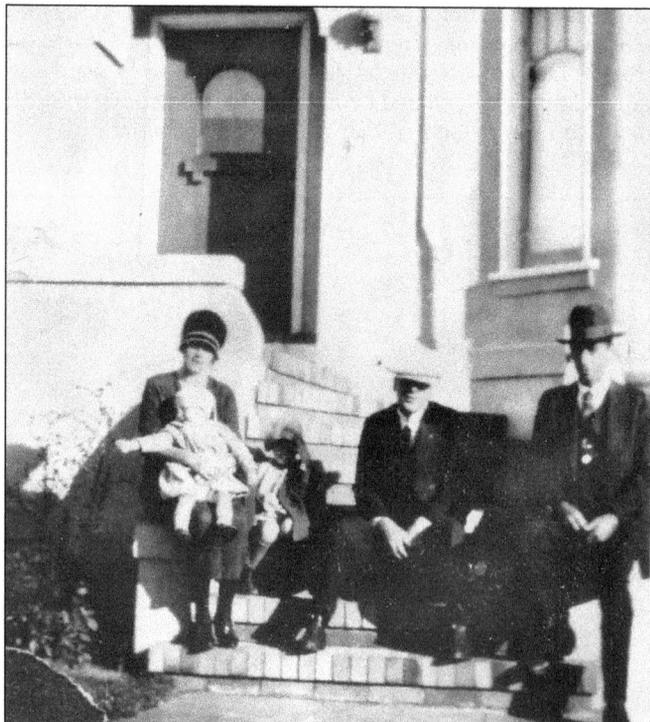

Sam McKay's parents, Henry and Annie, met after the 1906 quake when Annie was fetching a pail of water. They bought the house at 47 Genebern Way in St. Mary's Park in 1926 when it was built. Sam grew up in the house, where he and his wife Gloria still live. Pictured from left to right are Annie, children Sam and Jewel, Jim Lee, and Henry. (Courtesy Gloria McKay.)

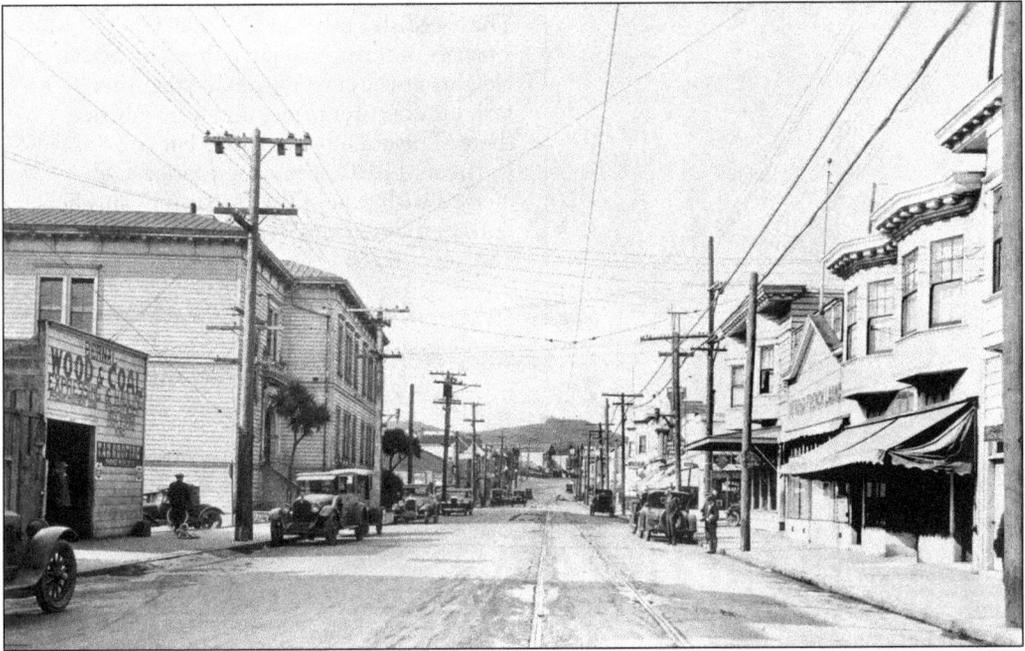

Cortland Avenue is seen from the east between Anderson and Moultrie Streets in 1926. Bernal School, on the left, was active from 1886 to about 1930 and is now the site of the library. On the right, 615 Cortland Avenue is now Moki's sushi restaurant; the French Laundry at 605 is now Unlimited Hair Care; and 601 was converted to a private residence. The wood and coal yard at 600 has been replaced by a laundromat and apartments.

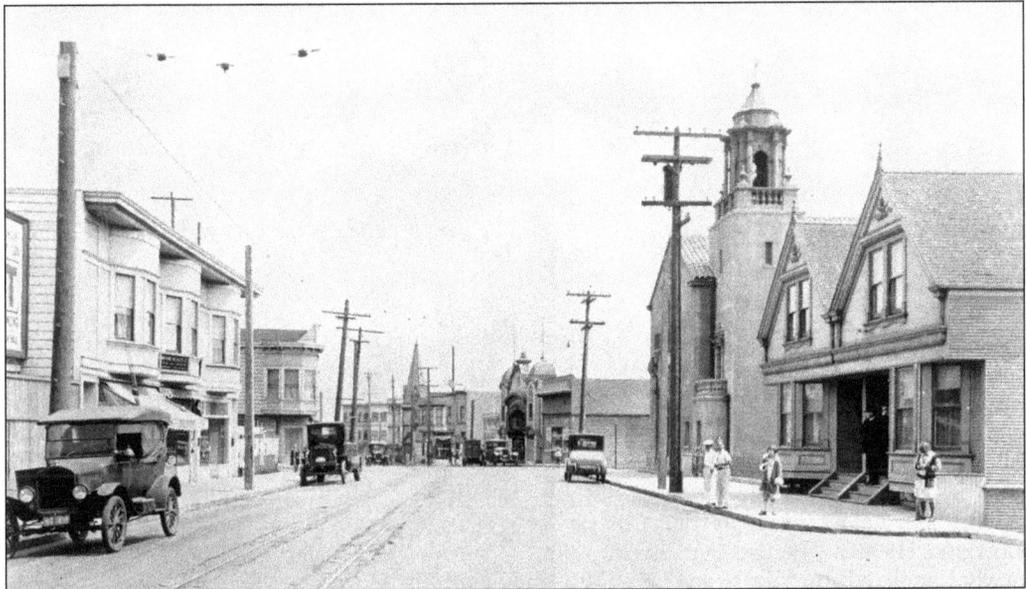

Cortland Avenue at Anderson Street in 1926 was at a loss for traffic. The building on the left, 733–737 Cortland, now houses Tacos Los Altos. A vacant lot at the corner of Ellsworth Street is now Martha and Brothers coffeehouse. The Lutheran church in the distance burned in 1979. Straight ahead, the Cortland Theater operated until 1969. St. Kevin's Church is on the right; the rectory replaced the adjoining houses in 1953.

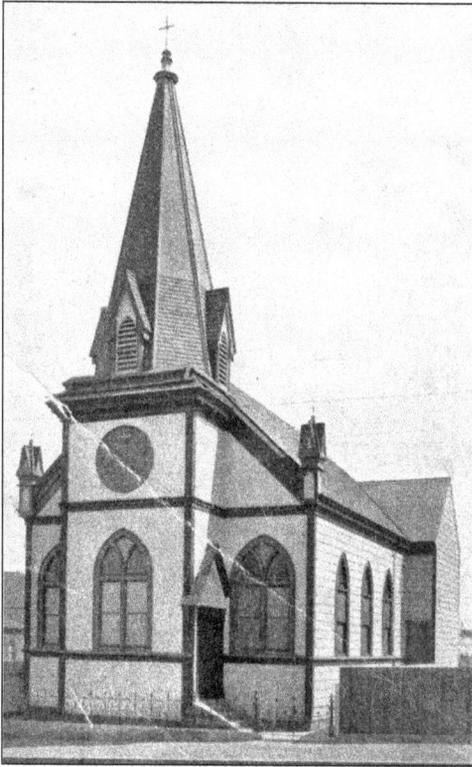

The Swedish Lutheran Emanuel Church was a center of Scandinavian culture in Bernal Heights at the start of the 20th century. Erik Lund's parents met and were married there. The church was active but poor, and by the mid-1920s, the congregation had merged with that of the Swedish Evangelical Lutheran Ebenezer Church at Fifteenth and Dolores Streets.

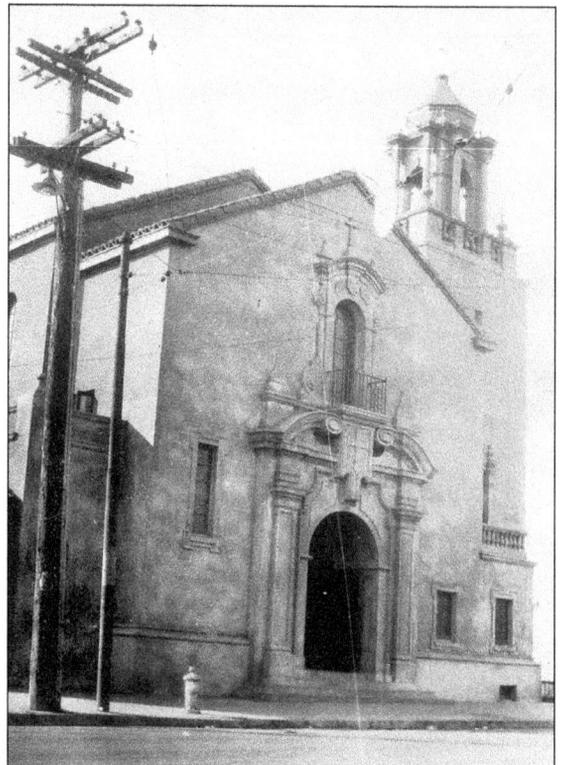

St. Kevin's Church was built at the corner of Cortland Avenue and Ellsworth Street in 1924. St. Kevin's parish was founded in 1922, when the first services were held in the Cortland Theater. The first mass in the newly completed church was given in December 1925 by Father Holahan. The Richardsons (see page 27) were among the local families who donated money for the church's stained-glass windows. (Courtesy George Williams.)

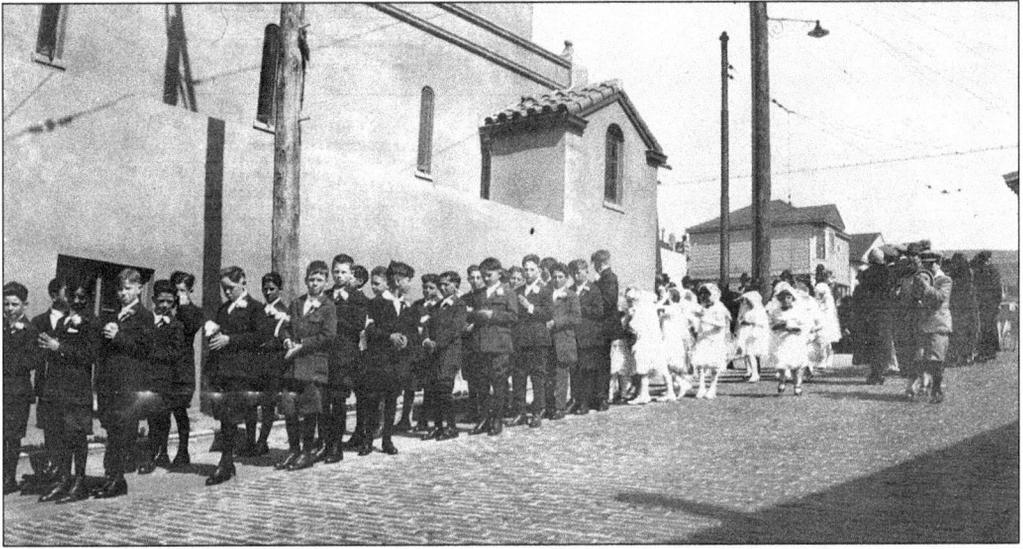

After celebrating their first communion at St. Kevin's, boys and girls line up at the side of the church on Ellsworth Street, perhaps to enjoy lunch in the church hall. Young sisters Helen and Vivian Salcido are in the line; they lived with their parents Joseph Salcido and Antonia Sagoria Salcido on Ellert Street. The Salcido family came from Mexico before the Gold Rush. (Courtesy Virginia Sventek.)

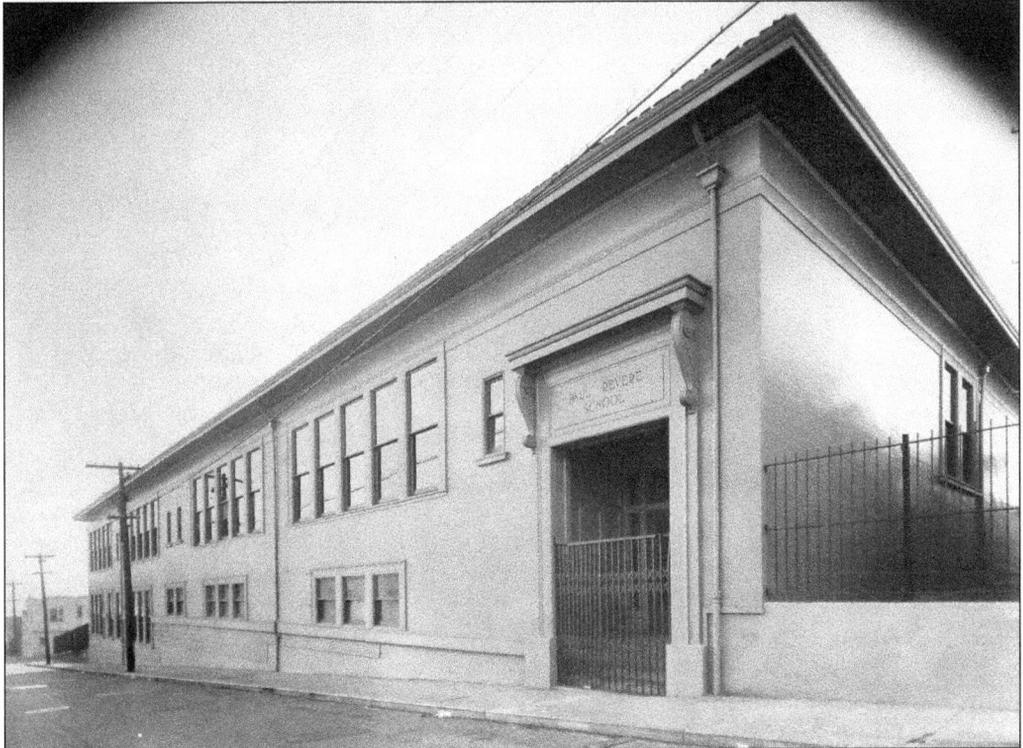

Paul Revere Elementary School was built around 1917. The old building stood at the north end of the lot toward Jarboe Street, where the playground is today. A second building, which still stands at the corner of Banks and Tompkins Streets, was constructed in 1928 and remains in use.

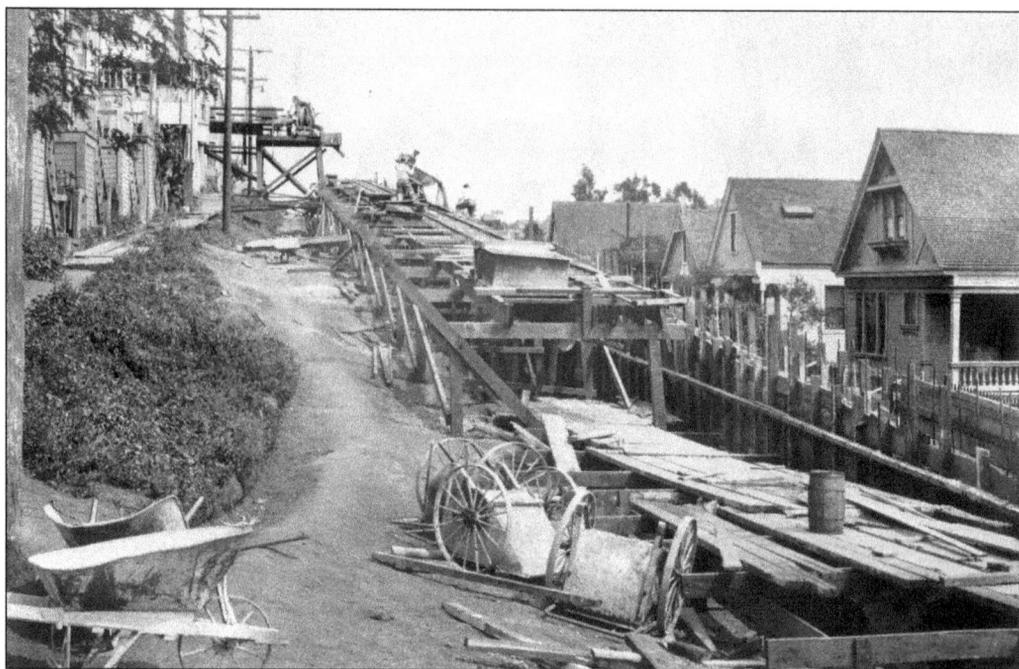

Construction of the split-street retaining wall on the 100 block of Holladay Avenue began in April 1928. This section of the neighborhood was known at the time as Peralta Heights. This photograph was taken looking north from Tomasa Street (now York Street). All the houses on the right were swept away for subsequent freeway construction.

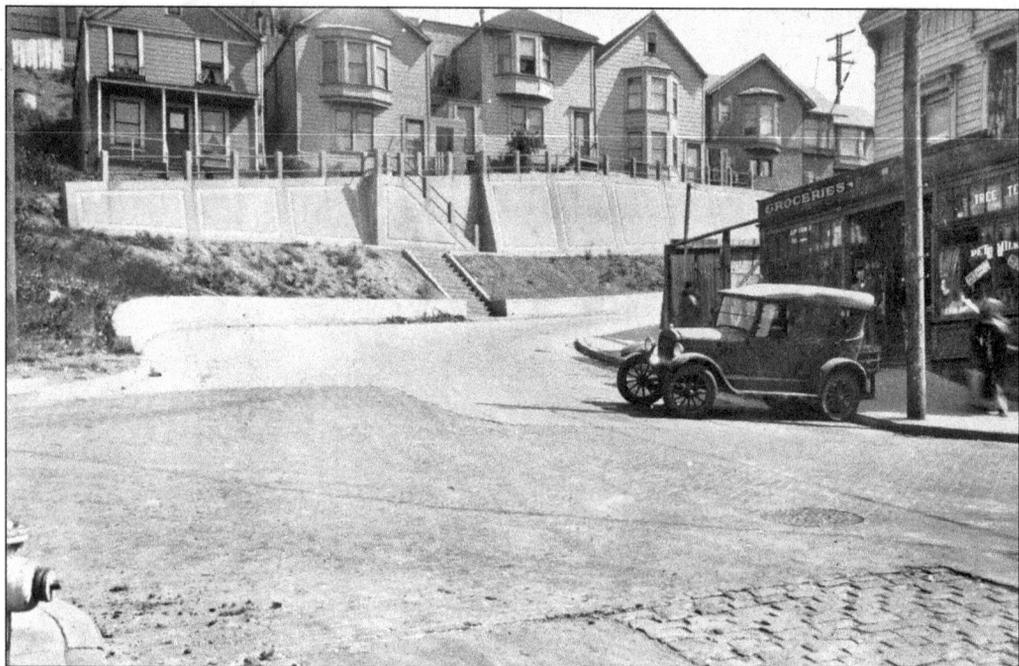

By 1927, Virginia Avenue had a new retaining wall and stairs. Today this space has been turned into a landscaped garden by enthusiastic neighbors. Above the wall are 311, 313, 315, 317, and 319 Virginia. The grocery store on the corner is 300–302 Virginia.

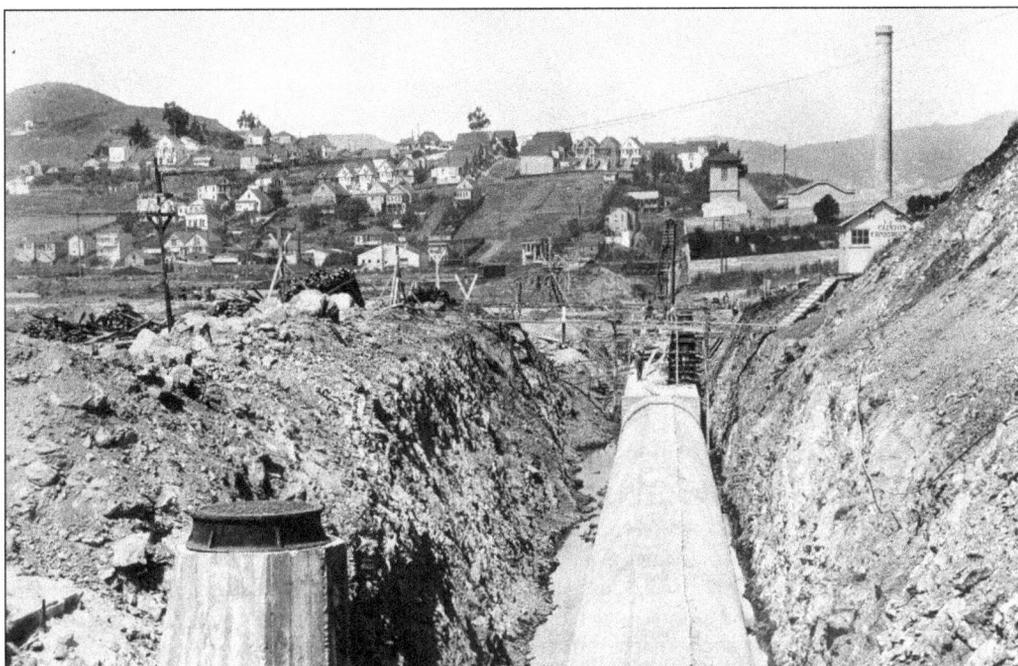

In July 1923, construction of the Army Street sewer marked the final burial of Precita Creek, which originally ran on the north side of Bernal Heights. In this view of Bernal Hill from the northeast, houses on Holladay Avenue and Wright Street can be clearly seen uphill in the middle of the photograph.

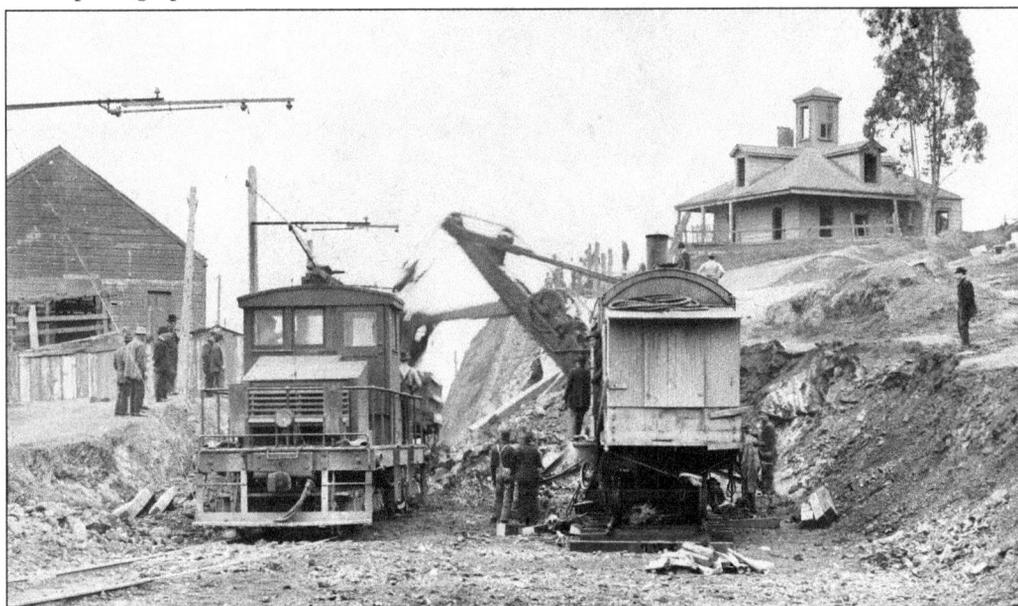

San Bruno Road was for decades the major arterial route along the foot of Bernal Hill's east slope between the hill and the swamp. This 1914 photograph, taken at Holladay and San Bruno Avenues, shows the slope from the north. The Ocean Shore Railroad yard would be just down the hill to the left at what was Army Street. Construction projects required building a railroad line so cars could remove the material excavated by steam shovels.

In 1862, colorful mining baron James Fair bought the land that became Holly Park and deeded it to the city. By 1889, two hundred houses had sprung up in the area. Under persistent pressure from the Holly Park Improvement Club, Holly Park Circle (then Avenue) was built and opened in 1874. This 1920 picture shows the southeast side at Park Street. The house straight ahead is 315 Holly Park Circle. On the right edge of the photograph are 411 and 415.

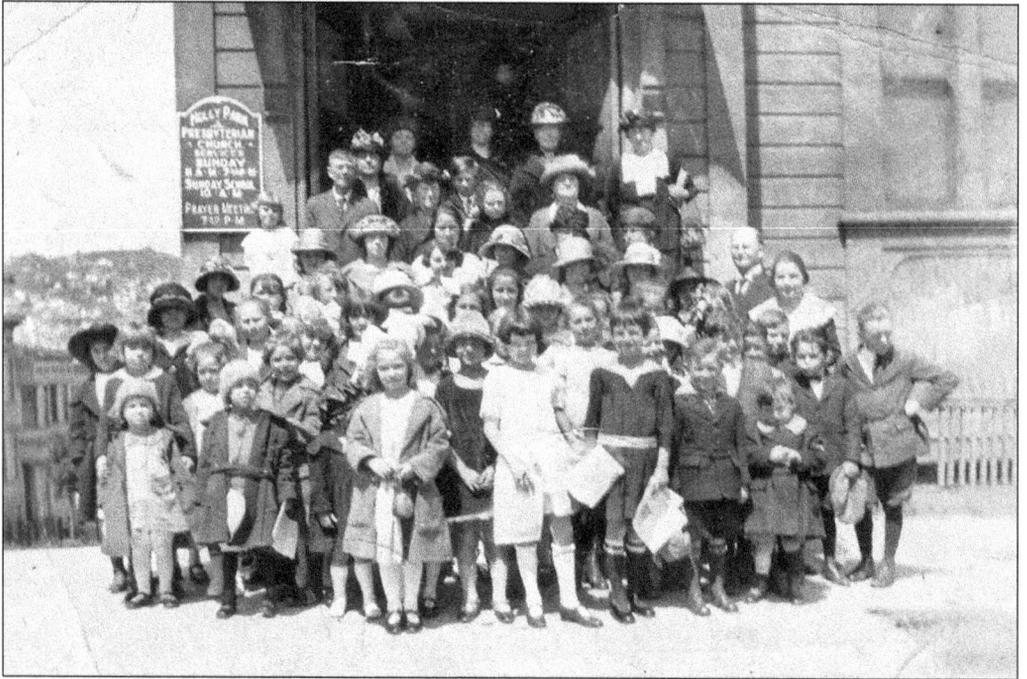

The Holly Park Presbyterian Church was one of the first religious buildings in Bernal Heights. It was constructed in the 1880s at the corner of California Avenue and Lizzie Street (now Coleridge and Kingston Streets). The Reverend James McIlhenney was a long-serving pastor. In the 1920s, kids were still lining up for Sunday school. The church is gone now, destroyed by fire some time in the 1930s. Elizabeth Hird is the blonde girl at the front; her sister Anna is the full-faced blonde girl in the third row to the left. (Courtesy Elizabeth Hird Mikulas.)

The Williams family has lived in the same house on Banks Street for almost a century. George Williams is seen here as a young boy standing near his home; there were hardly any houses on the street then. George's grandfather, James McMahon, dandles George's brother Morris Williams on his lap in 1918. The houses at the very top of the hill were moved or demolished to make way for Bernal Heights Boulevard. (Courtesy George Williams.)

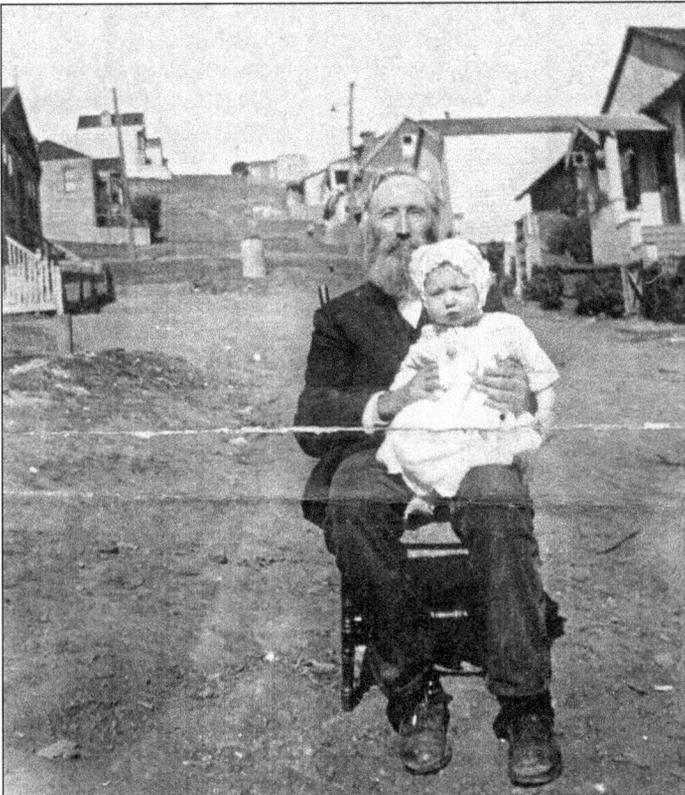

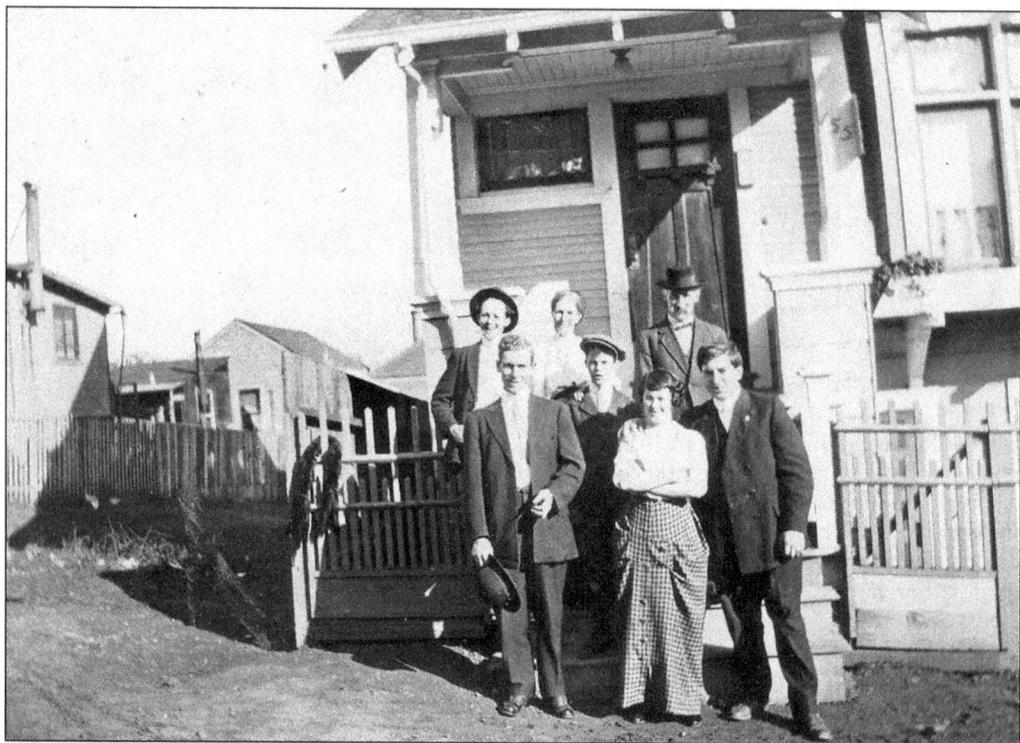

The extended McMahon family also lived on Banks Street, across from the Williamses. The above photograph was taken in 1916. In the 1941 picture at left, George Williams's sister Lauretta stands in the same spot her grandfather was photographed on in the 100 block of Banks Street. The siblings lived in the same house all their lives; George lives there still. (Courtesy George Williams.)

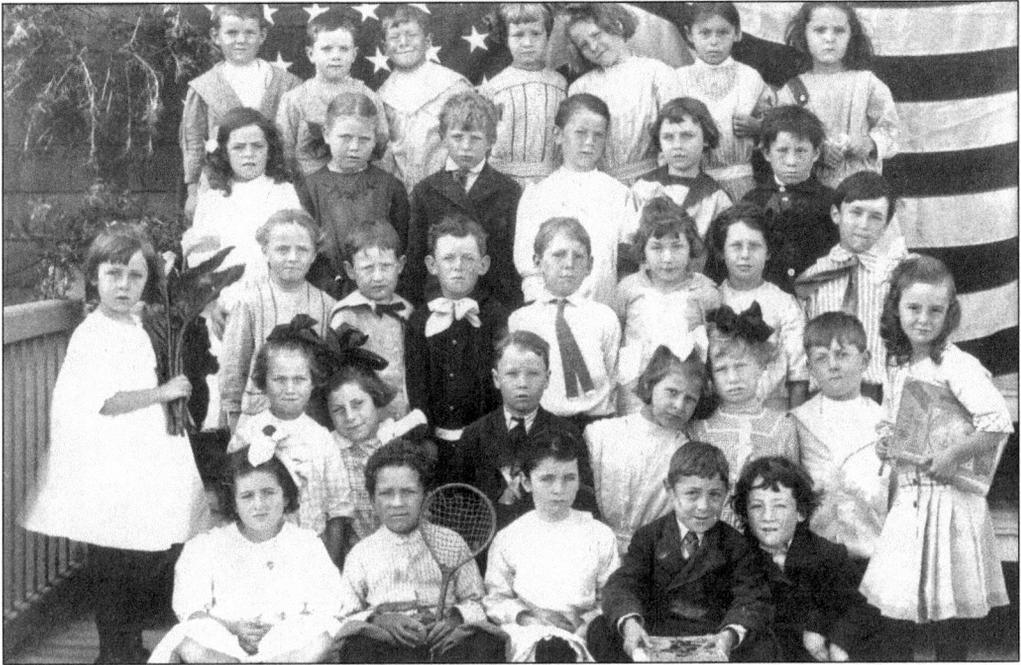

Melvin Wiegner was born at 440 Cortland Avenue on August 25, 1906, and attended the newly opened Junipero Serra Elementary School nearby. In this 1912 first-grade picture, he is second from right in the second row. He later learned the butcher business from his uncles at Bernal Meats and worked for the family every day, sweeping up the sawdust and making deliveries with a donkey cart. (Courtesy Gloria Wiegner Lane.)

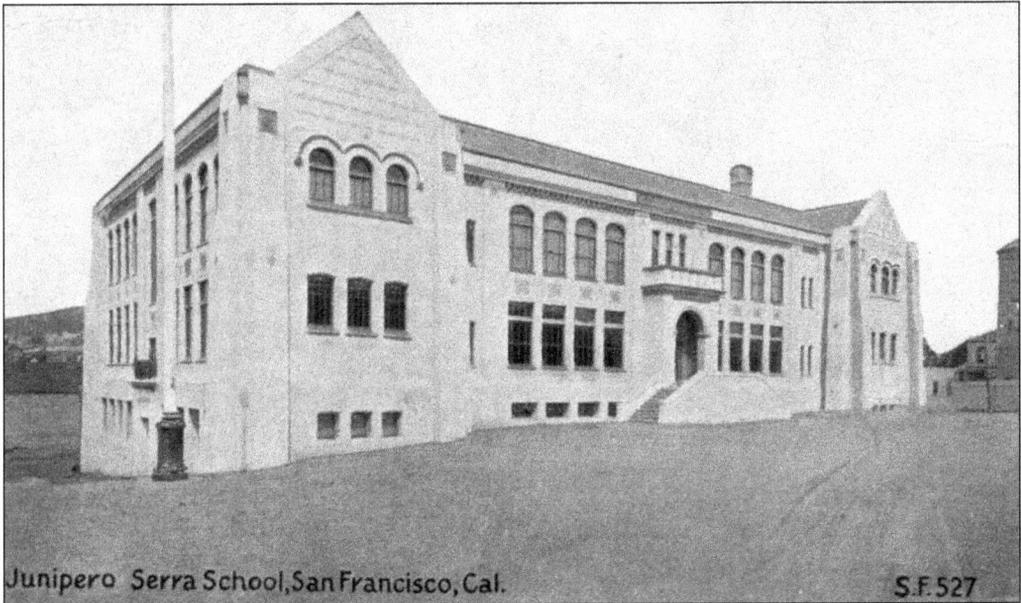

Junipero Serra School, San Francisco, Cal. S.F. 527

Junipero Serra Elementary School was built in 1911, named for the 18th-century Franciscan friar who founded the missions in Alta California. The old wood-frame structure was demolished and rebuilt in 1976 on the old playground on the north side of the lot just across the street from Holly Park. (Courtesy Junipero Serra School.)

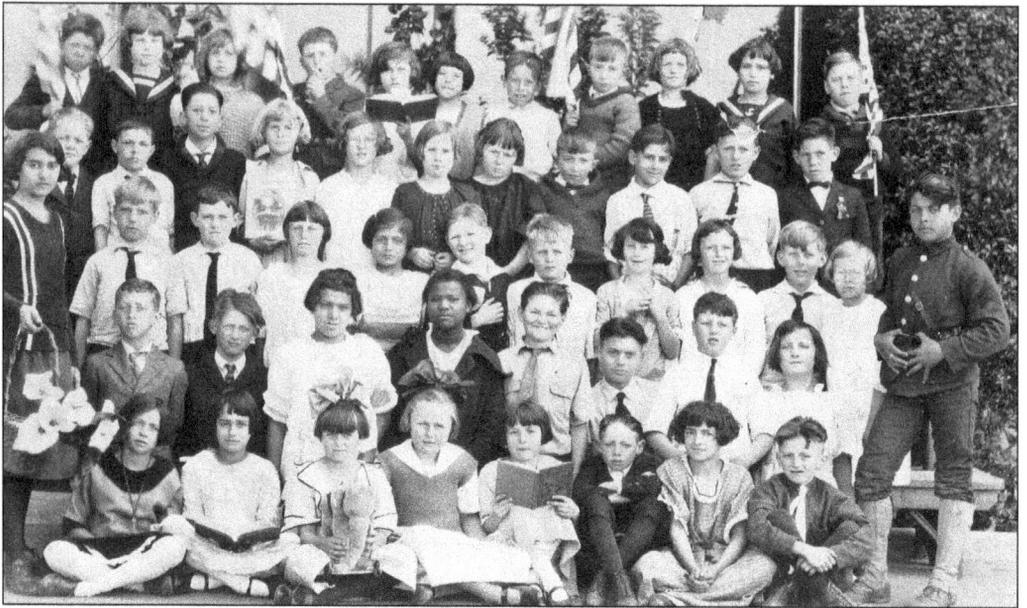

Walter Feyling grew up on Andover Street, the youngest son of Norwegian immigrants. He attended Junipero Serra and is the blond-haired boy fifth from the right in the third row in this 1924 picture. At that time, most Bernal families were of Irish, German, Italian, or Scandinavian origin. (Courtesy Fern and Walter Feyling.)

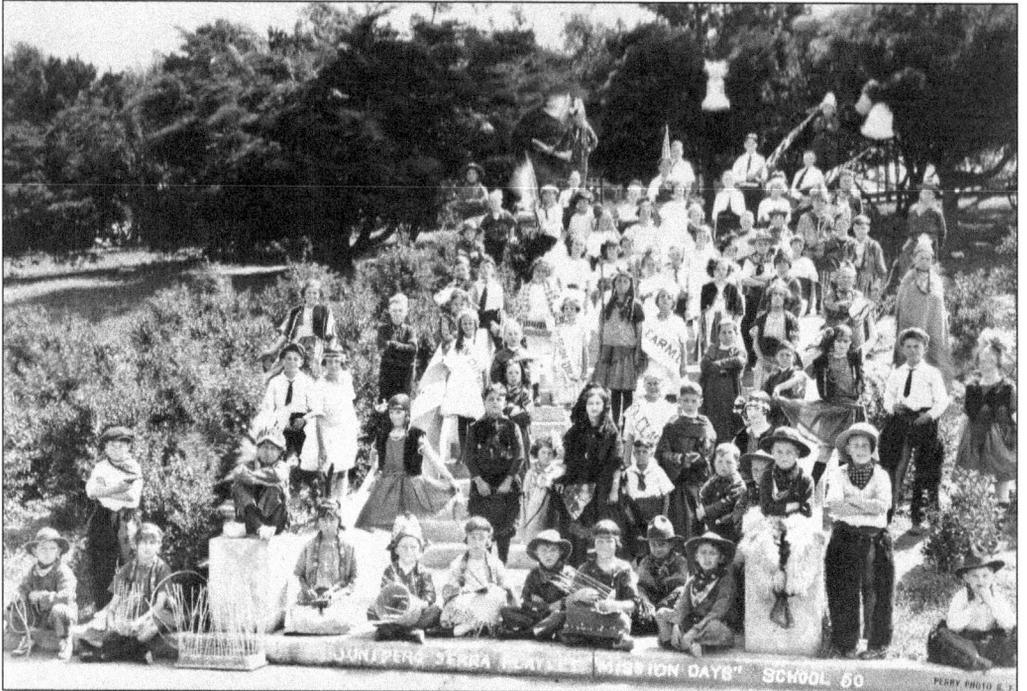

In the late 1920s, the pupils of Junipero Serra staged a playlet, *Mission Days*, on the edge of Holly Park. Children took on the roles of California characters, from the original Native Americans and Spanish to the "cowboys and Indians" of popular culture. Elizabeth Hird's sister Anna is in the center of the picture, wearing a sash labeled "Santa Clara." (Courtesy Elizabeth Hird Mikulas.)

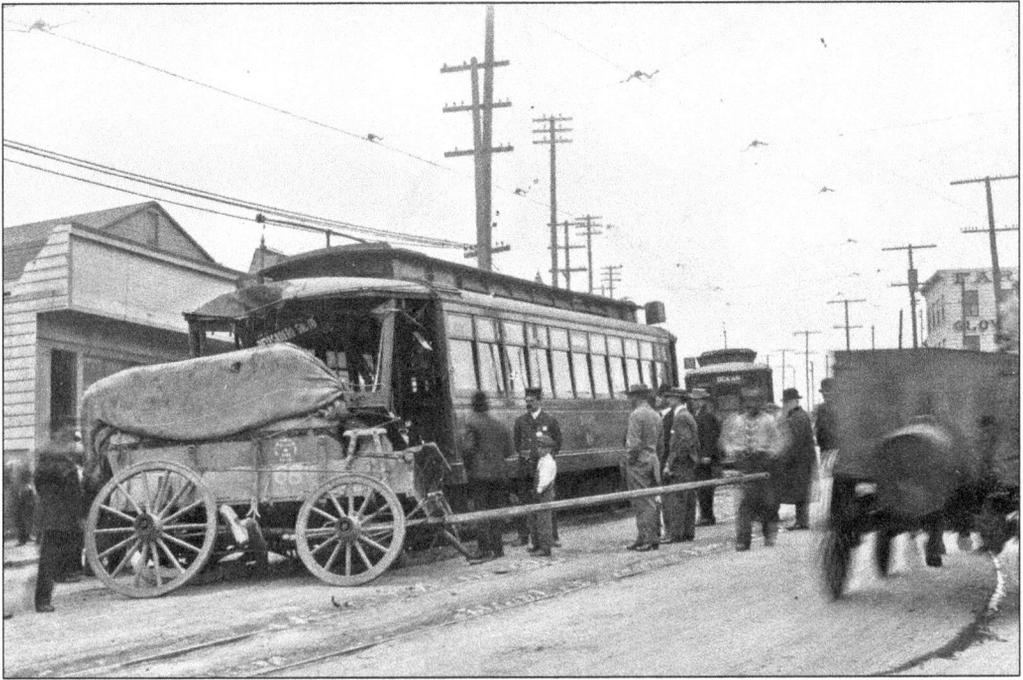

A streetcar and a cart collided at Mission and Randall Streets in July 1911, perfectly capturing the collision between rural and modern life. (Courtesy Philip Hoffman.)

Buildings on the 3500 block of Mission Street looked much the same in this 1920s photograph as they do today. Looking east from Randall Street, Bernal Hill can be seen in the distance on the left. The residential buildings on the left have been replaced by a gas station. The single Southern Pacific Railroad track is gone, replaced by streetcar tracks for the J-Church line. (Courtesy San Francisco History Center, San Francisco Public Library.)

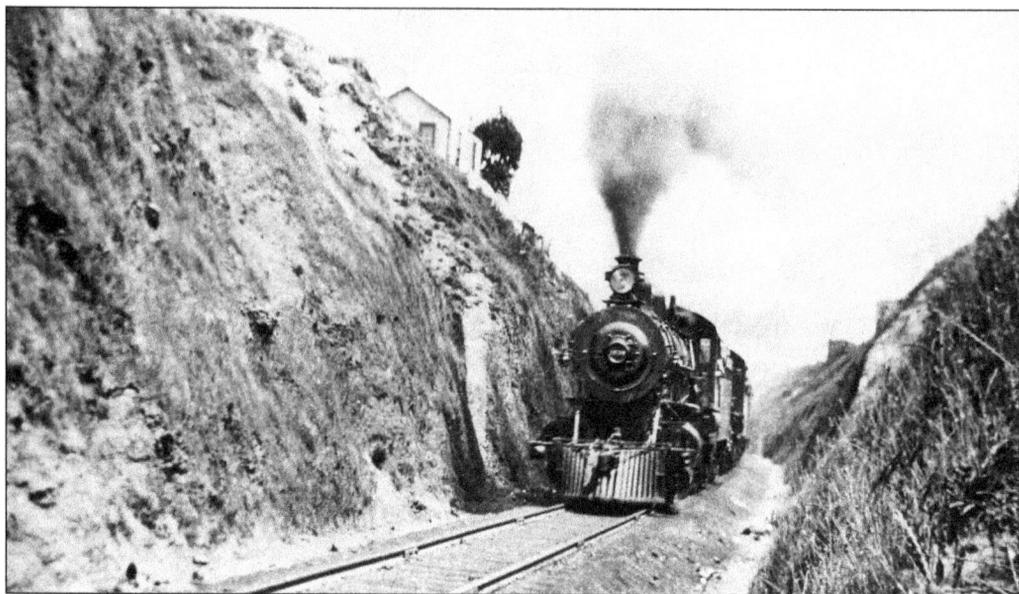

In the 1860s, construction of the Southern Pacific Railroad tracks followed the path of El Camino Real, as did subsequent trolley lines and present-day Interstate 280. The railroads also created the Bernal Cut, leveling the land to railroad-acceptable grades along what is now San Jose Avenue. The narrow cut is pictured here in 1905 looking north near Milton Street.

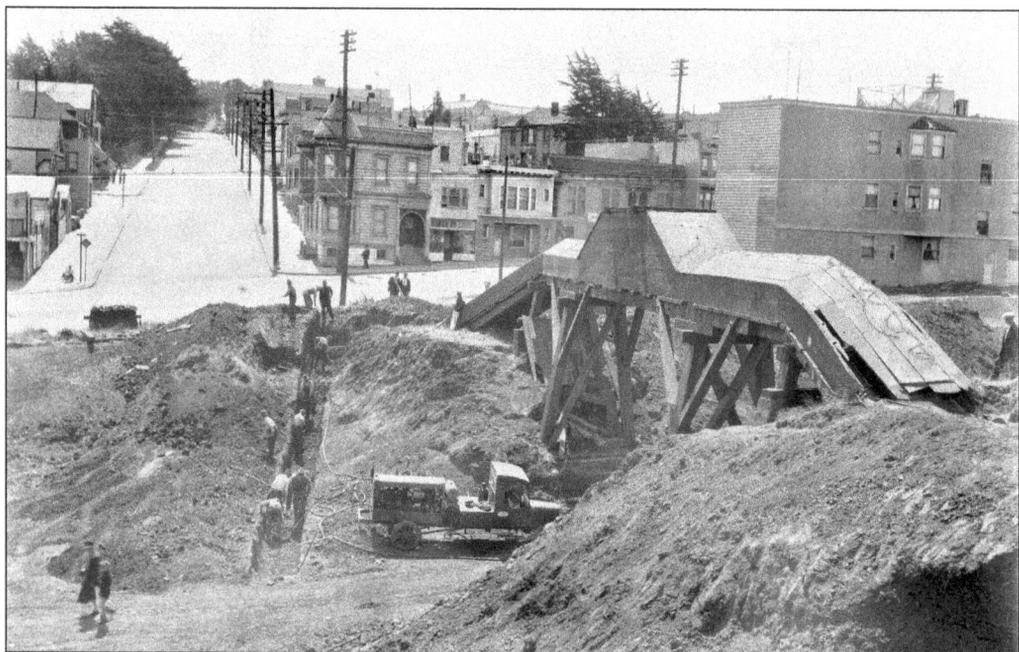

Mayor "Sunny Jim" Rolph operated a steam shovel to take out the first load of dirt from College Hill to widen the Bernal Cut, now used by San Jose Avenue and the J-line extension of Muni. Construction is well underway in this 1920s photograph looking east across Mission Street and up Appleton Avenue. Vehicular access improved in 1929 with the widening of the Bernal Cut and construction of two bridges at Miguel and Highland Streets to connect Glen Park with Bernal Heights.

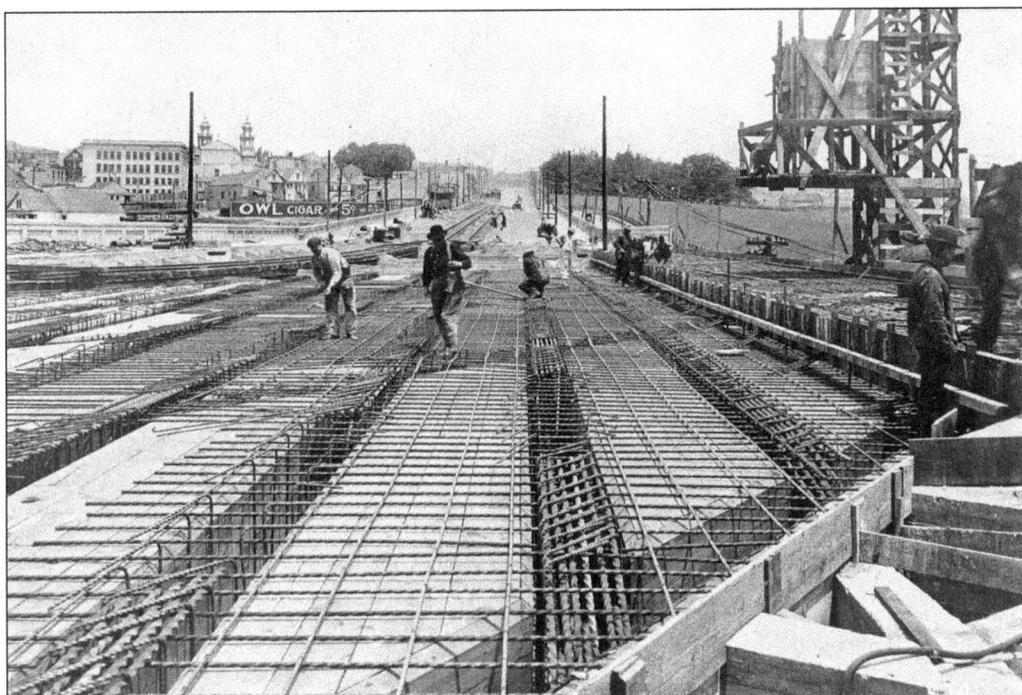

Mission Street follows the path of the old El Camino Real, or King's Road, built by the Spanish to connect their California missions. At the place it crossed Islais Creek, many a wagon got stuck in the mud. An early wooden bridge over the creek also served as a vehicle overpass for the Ocean Shore Railroad. In the 1920s, a steel-reinforced concrete viaduct was built over what was left of the creek where Interstate 280 and Alemany Boulevard run under Mission Street today. The viaduct was completed in 1928.

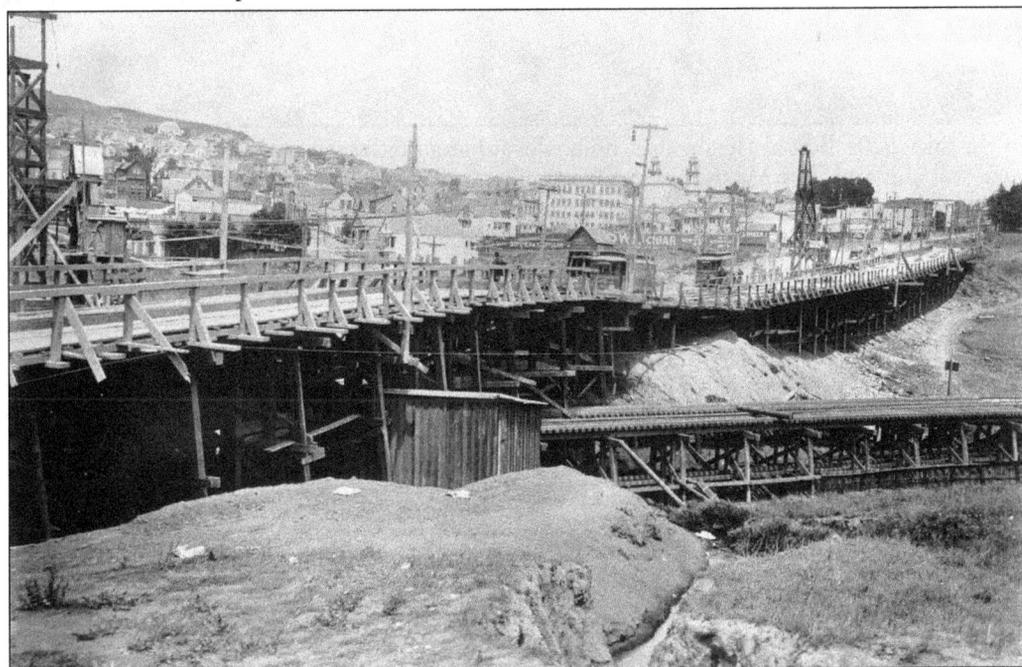

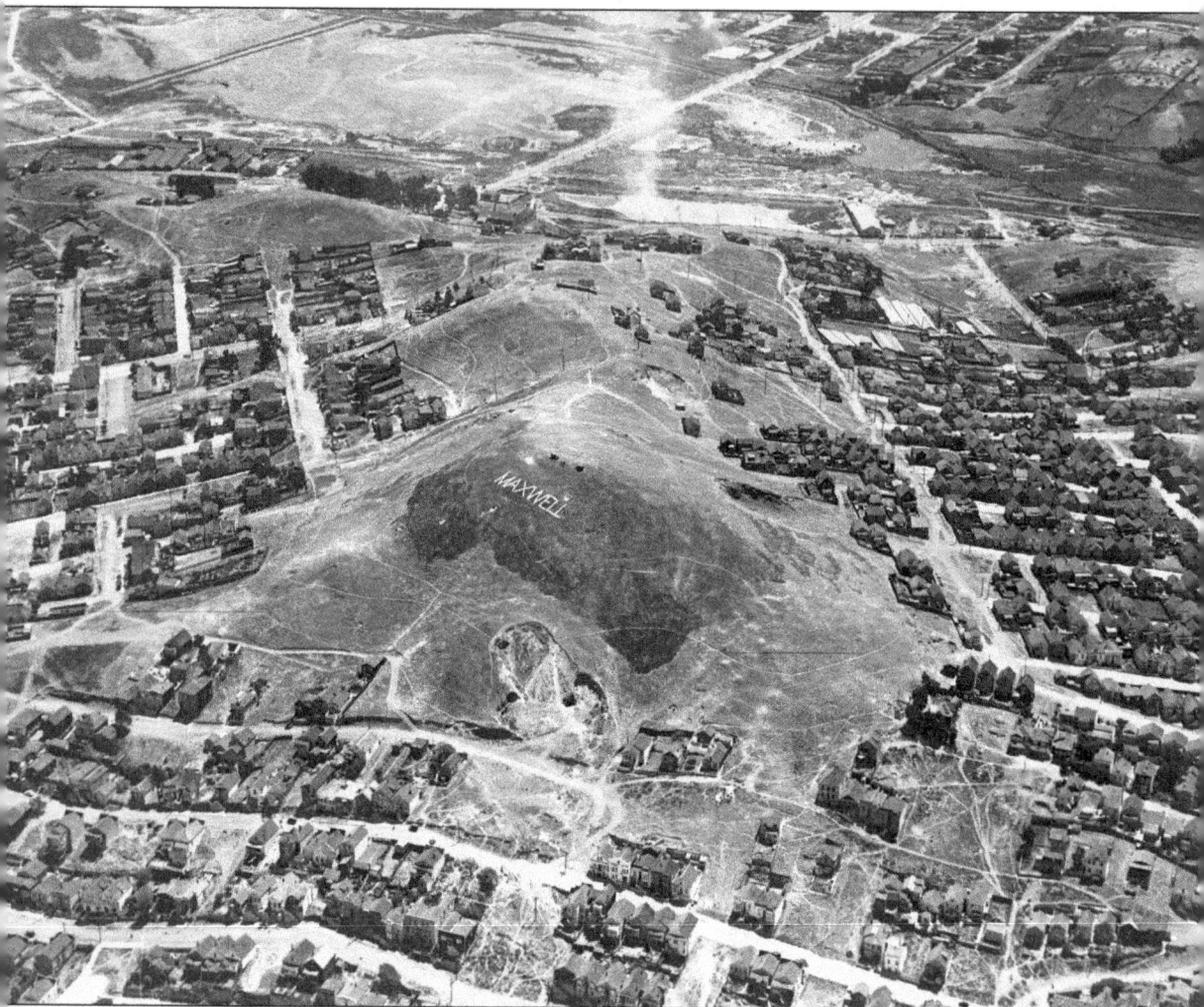

In the mid-1920s, Bernal Heights had no boulevard around the top of the hill and many streets were still unpaved. The Maxwell sign advertised an automobile manufacturer of the era. In this aerial view of the hill taken from the west, the Islais Creek wetlands can be seen in the distance. Oakdale Avenue crosses the wetlands diagonally at the top, and San Bruno Avenue trails off to the right. Horizontally at the bottom are Prospect, Winfield, and Elsie Streets. Wide streets on the left are Norwich and Ripley, and the paths going up from the bottom are on today's Esmeralda Avenue. The little hill on the far left was flattened after World War II, and the excavation of the south side of the big hill took place in the 1940s.

Four

FACES OF
BERNAL HEIGHTS

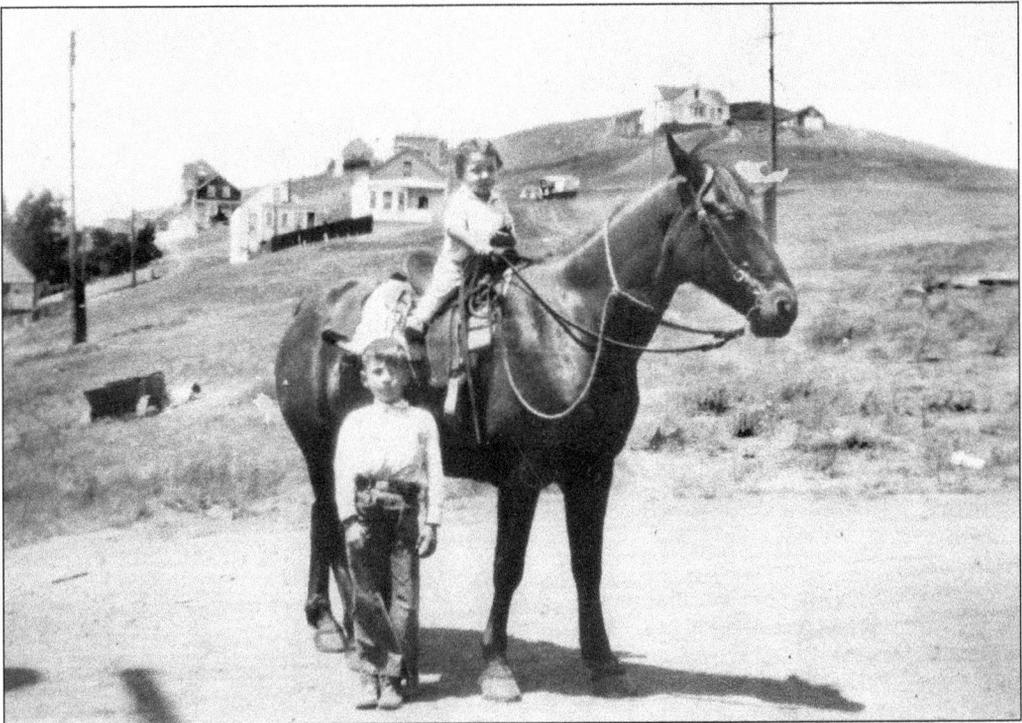

Lloyd (on horse) and George Mayers are seen with their horse Safflo on the east side of Bernal Heights in 1928. Their parents, Edmond and Grace, moved in 1924 to Bradford Street. In the background are houses that still stand on Prentiss and Rosenkranz Streets. A couple of houses on the right were demolished when the city took over the land that eventually became Bernal Heights Park. Traces of the foundations can still be found in the park. (Courtesy Elaine Mayers.)

Elizabeth Hird grew up on Elsie Street in the home her family moved to when she was five months old. Her father, William, was a butcher who was born in Sacramento; his parents emigrated from Scotland. Her mother, Annie Phillips Watson Hird, was born in San Francisco to Scottish immigrants and raised their four children in the same house. In her youth, Elizabeth was a fresh-air-loving tomboy who loved to roller-skate around Holly Park with her friends. (Courtesy Elizabeth Hird Mikulas.)

The Hird family kept chickens and rabbits in the backyard, as pets and for food. The family kept a goat, which they would loan to the neighbors to trim their grass. Their neighbors the Bradleys kept pigs, and other Elsie Street residents kept pheasants and chickens. In this 1934 photograph, Elizabeth holds a bunny that may have been destined for the cooking pot. (Courtesy Elizabeth Hird Mikulas.)

Herbert and Caroline Smith, Herb's parents, pose in their finest Sunday outfits on the edge of Holly Park in 1935. Caroline's family was Hawaiian; Herbert senior was a Scots/Irish sailor who met and courted her in Hawaii. The Smiths' landlord made his own wine during Prohibition, supplying it via an underground pipe that ran from a garage on an empty lot across the street. (Courtesy Herb and Emilia Smith.)

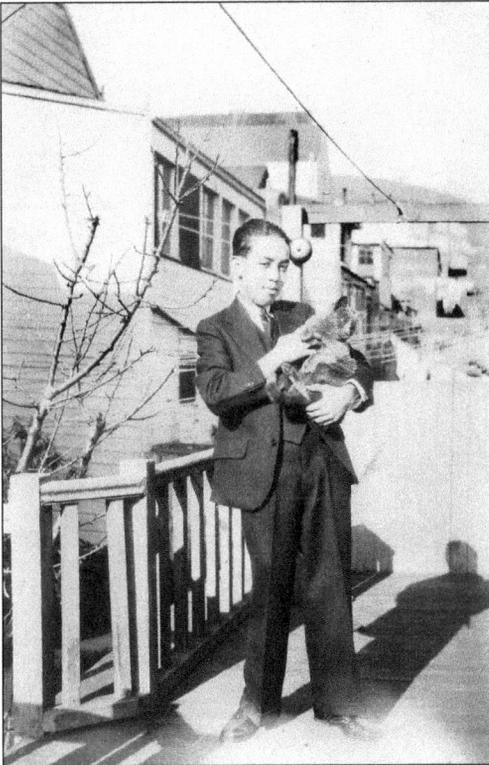

Sixteen-year-old Herb Smith poses in his best Sunday suit on the back porch of his home at 263 Andover Street, where he grew up. He was born in Hawaii. After serving in World War II, he settled in St. Mary's Park, where he was president of the Improvement Association for many years and where he lives with his wife, Emilia. (Courtesy Herb and Emilia Smith.)

Benjamin Franklin Watson and Annie Mann Watson, Elizabeth Hird's grandparents, owned the family home on Elsie Street. This 1920s photograph shows them outside their house with three members of a visiting midget troupe, the middle one of whom, Wee Jean or Wee Jeannie, was related to the Watsons. (Courtesy Elizabeth Hird Mikulas.)

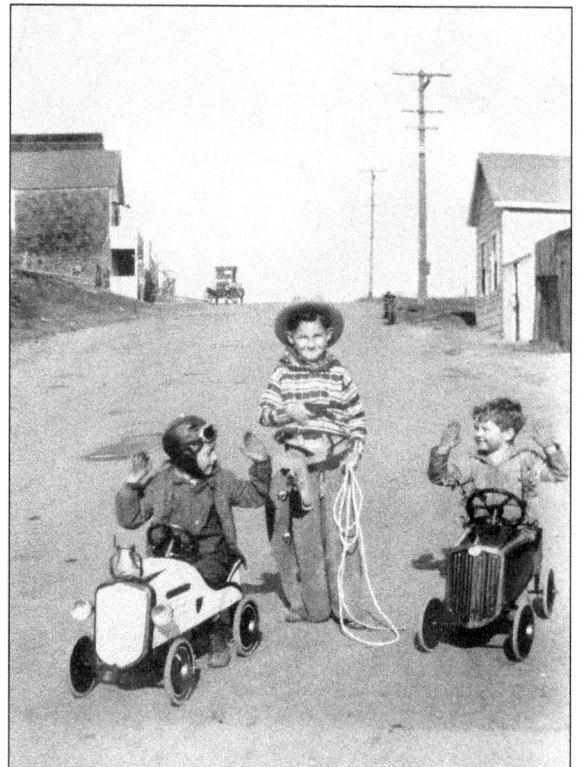

Kids had plenty of room to play cops and robbers on Bradford Street in 1933. Lloyd Mayers (in cowboy hat) is arresting two playmates in front of his family home. The houses at the top of the street are still there, and more development filled in the block near Mayflower Street after World War II. The street was even paved in the 1930s. (Courtesy Elaine Mayers.)

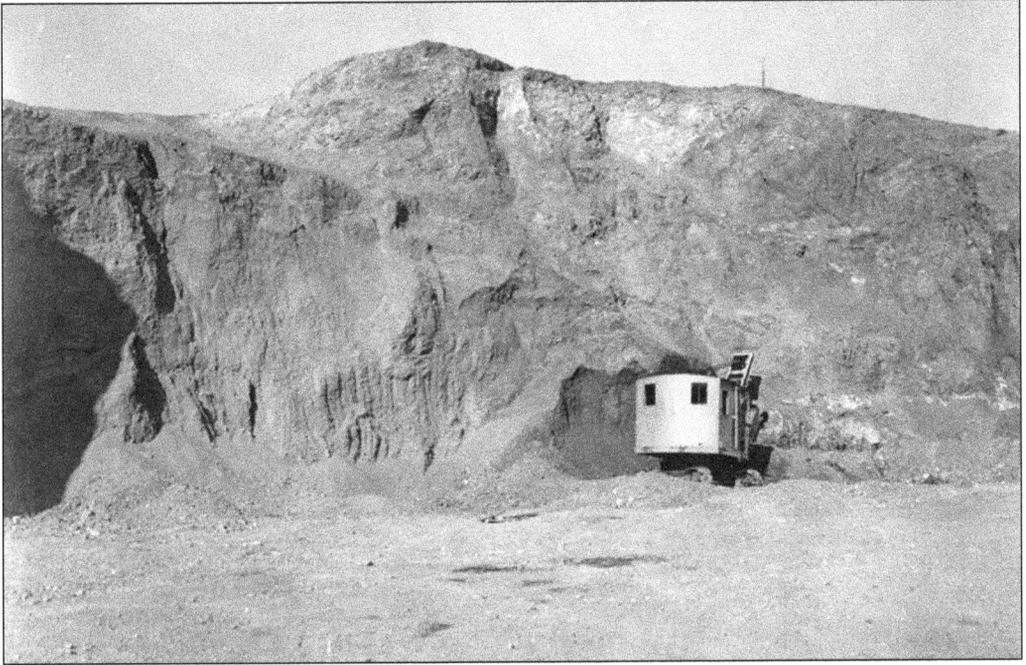

A steam shovel digs into Bernal Hilltop in 1942. The rock from this quarry was used for paving neighborhood streets and for filling Islais Creek on the east side of the hill. Franciscan chert, a sedimentary rock formed 300 million years ago, was uplifted and folded, forming the solid ground of Bernal Heights. This cut can still be seen on the southwest side of the hill below the communications tower near the road gate.

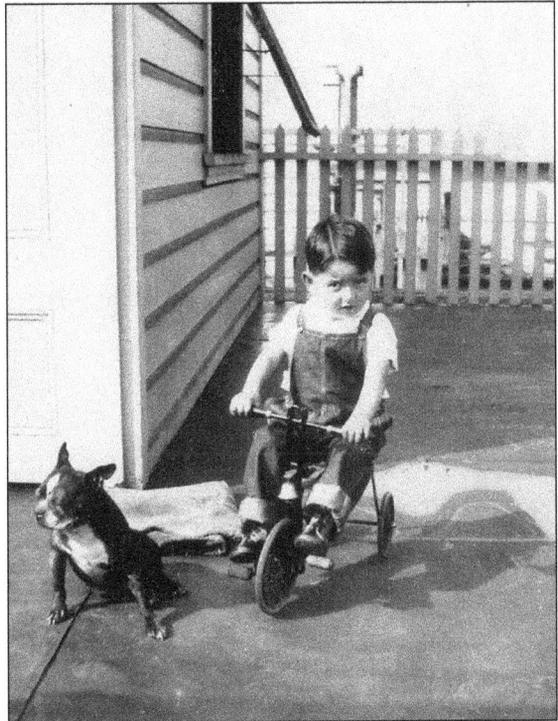

Two-year-old Eugene Tello is pictured on his tricycle on the family's front roof porch on Gates Street in 1930. A fictional book based on the family's arrival in America, *Goodbye, Beautiful Sicily*, was written by his mother's cousin Geraldine Villalba. (Courtesy Rochelle Mankin.)

The Cortland Nursery on the 1400 block of Cortland Avenue was taken over by Guerino and Mary Galeazi in 1918. They installed the glass greenhouses at the side and specialized in growing roses, gardenias, and camellias, which they sold at the San Francisco Flower Market every week. The Galeazis ran the nursery at this site until 1969; the family is still in the flower business. (Courtesy Nancy Schneider Hausmann and Kurt Hausmann.)

Mary Galeazi designed and oversaw construction of the house above, which was modeled on her family home in Lucca, Italy. Completed in 1927, it cost $10,000 and took a year to build. During Prohibition, she made wine in the greenhouses. Federal agents climbed a telephone pole to look for her operation, but couldn't find anything. Her sister Ann ran Marchi's Grocery, next to the Cortland Theater. (Courtesy Nancy Schneider Hausmann and Kurt Hausmann.)

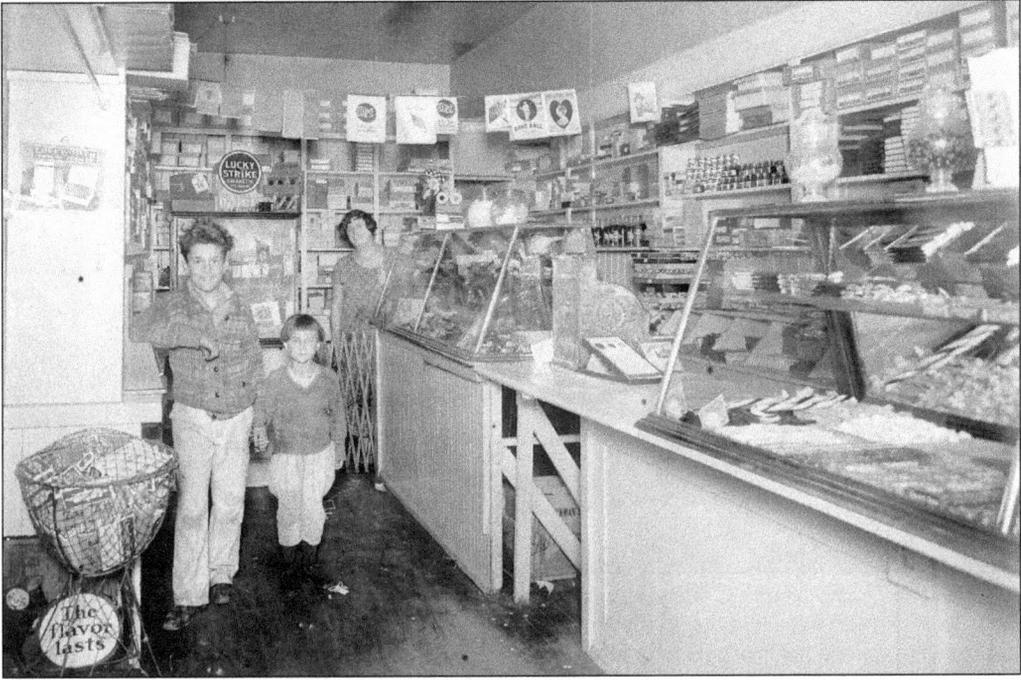

Mary and Carmine Preziosi ran a grocery store at three locations on the 600 block of Cortland Avenue between the early 1930s and the late 1950s. Their six children all helped out after school. The grocery sold general goods and school supplies, and in later years became a creamery and deli. This photograph shows Mary behind the counter and her children Paul and Helen in the store. (Courtesy the Preziosi-Rogers family.)

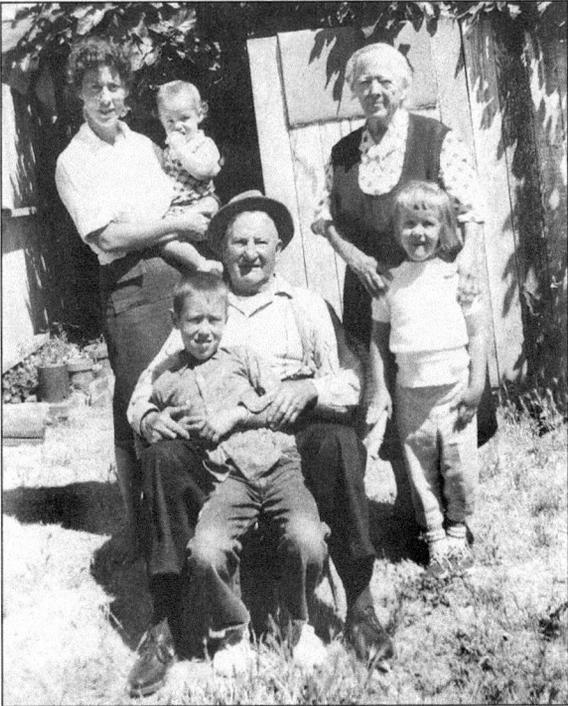

Will and Lottie Hahn moved to Bocana Street around 1906. Will ran the Holly Social Club out of his basement in the 1930s. Printers from the *Call* and the *Bulletin* came there to gamble. During Prohibition, the men used rakes with extended handles to pull confiscated booze out of the fires by the Holly Park Reservoir. Their great-niece, Jo Bailey, loved to visit as a child and get a quarter or a stick of gum. Jo is shown here in the late 1950s with the Hahns and her children David, Eric, and Ellen. (Courtesy Gertrude Jo Bailey.)

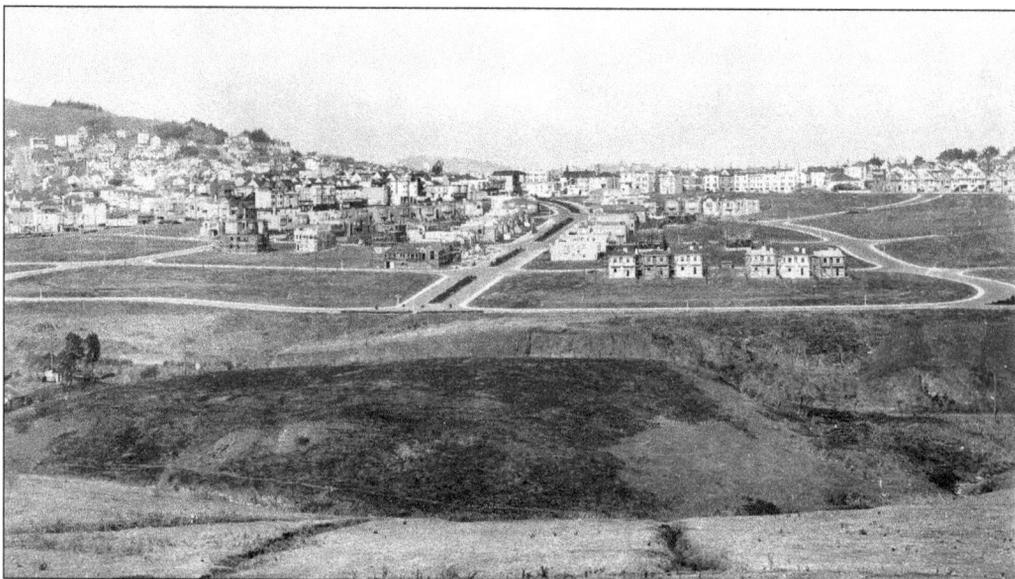

In 1924, the old St. Mary's College site was opened up for a subdivision to be named St. Mary's Park. Its six streets were laid out in the shape of a bell, and three of them (Agnon, Genebern, and Justin) were named for brothers who had taught at the original college. This view from October 1925 shows the outline of the bell taking shape, with houses already built on Benton Street and College Avenue. The ravine in the foreground is Islais Creek, where Alemany Boulevard, and later I-280, will be built. (Courtesy San Francisco History Center, San Francisco Public Library.)

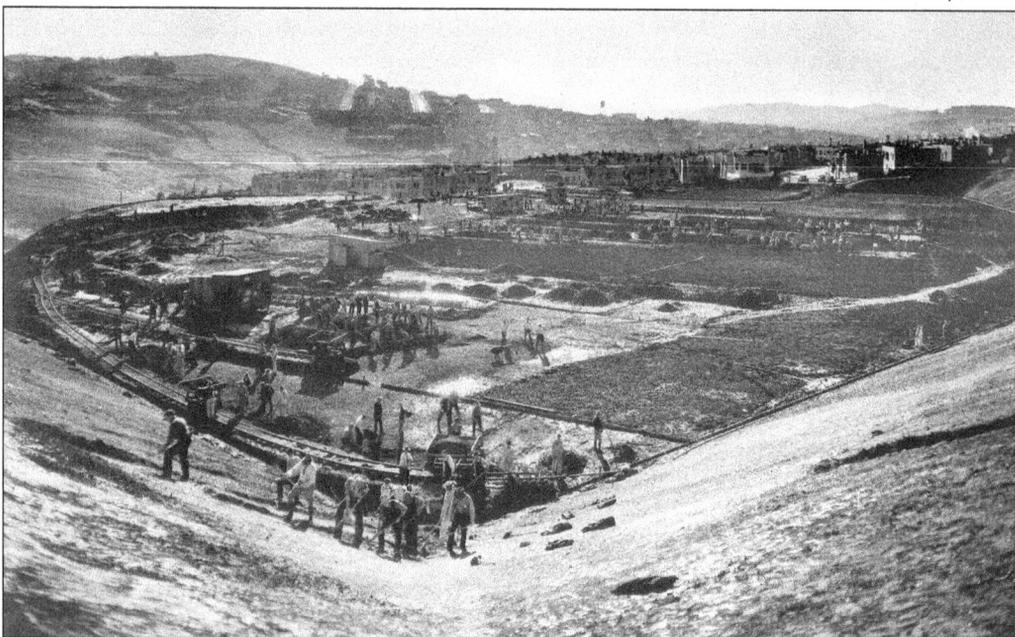

The recreation center and baseball ground at St. Mary's Park were built in the 1930s as a WPA project. This 1934 photograph, looking southwest with the Excelsior District in the distance, shows workers laying out the field. St. Mary's Park Improvement Club, which was founded in 1941, unites neighbors for Easter egg hunts, Mother's Day Cleanup, bingo, and sporting events. St. Mary's is one of the only districts in the city with its own flag.

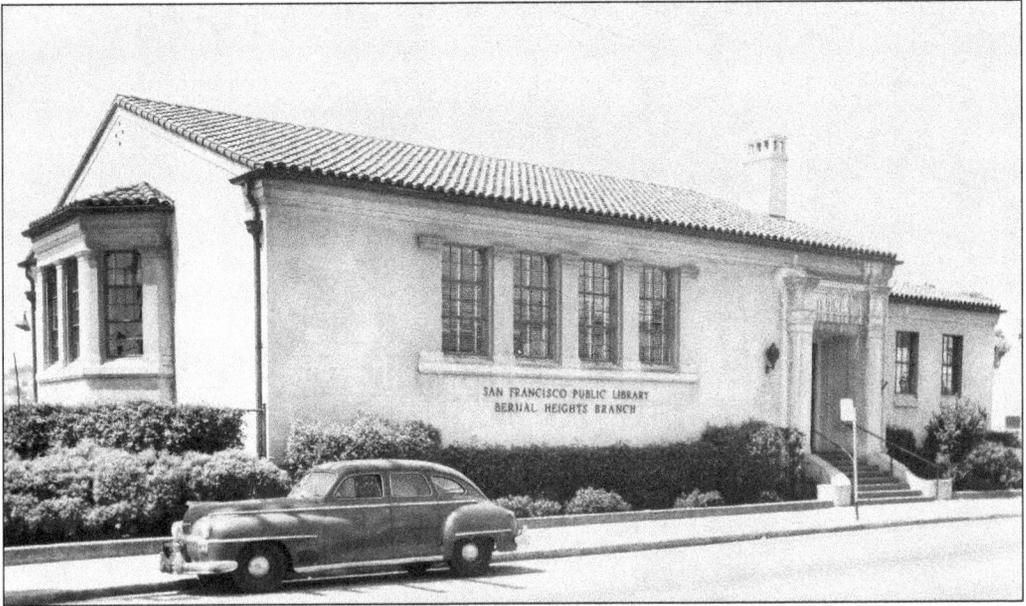

The present-day branch library at 500 Cortland Avenue was dedicated on October 21, 1940, by Mayor Angelo Rossi. Frederick Myers was the architect, and the Works Project Administration funded the construction. The library's interior retains much of the original detail, including high, painted beam ceilings and ornate metal lamps. The first library opened in a rental space at 324 Cotland Avenue in 1936 but soon proved too small, so residents lobbied for a proper building. (Courtesy San Francisco History Center, San Francisco Public Library.)

The stairway at Aztec Street, up from Shotwell Street, was a Depression-era construction that employed men in the Work Projects Administration. The WPA also undertook the grading and paving of Bernal Heights Boulevard around the top of the hill. These projects were all completed about the same time in 1940. Today Bernal has the most stairways in street rights-of-way in San Francisco. The adjacent gardens complement the community's rural character. (Photograph by Milne.)

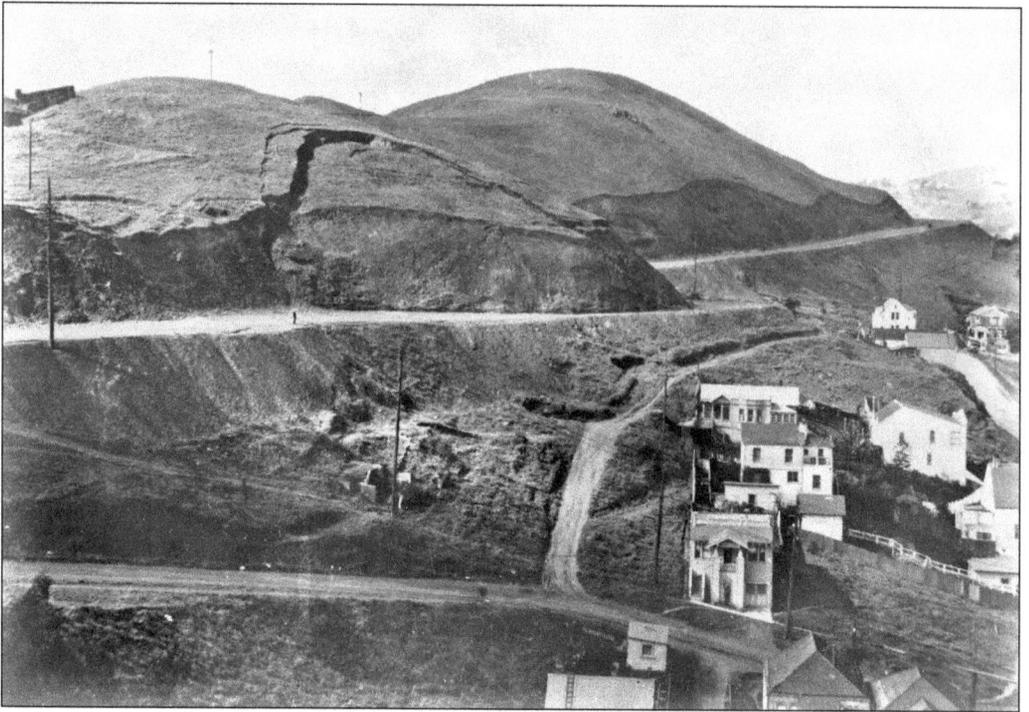

Taken in February 1936, this view of the north side of the hill looks over Alabama and Waltham Streets at the site of a landslide caused by the excavation for Bernal Heights Boulevard. On the right in the distance are 3401 and 3348 Folsom Street. The Egger house (the middle of the three on Waltham Street) was moved down the hill to clear the way for the street construction. Alabama Street (not yet paved) crosses the bottom of the photograph.

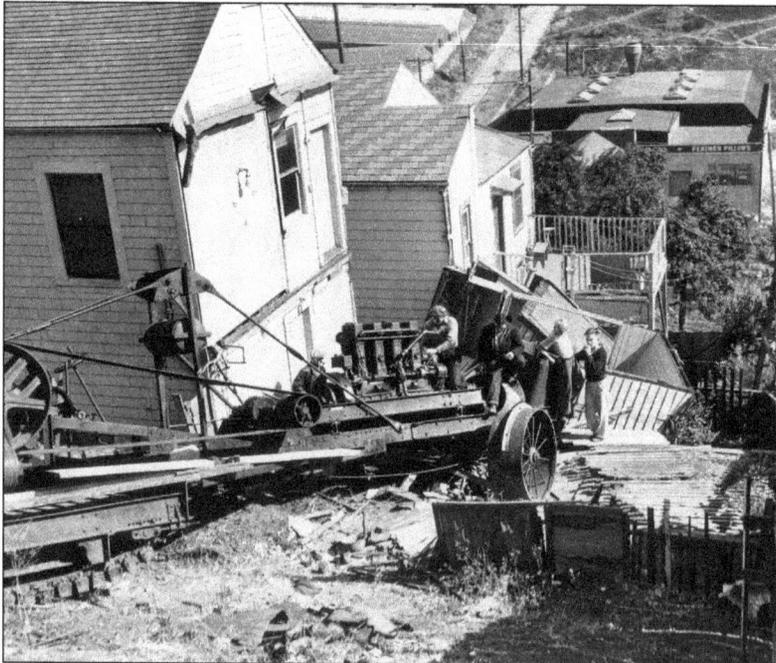

What caused this catastrophe? What kind of machine is this? It may have been street-leveling apparatus working in Bernal Heights. This view north from the Mojave Street wall looks down on greenhouses on Bradford Street and the Hood mattress factory, which was at 1501 Cortland Avenue for more than 40 years. The two houses that have been knocked about are 243 and 239 Bradford Street.

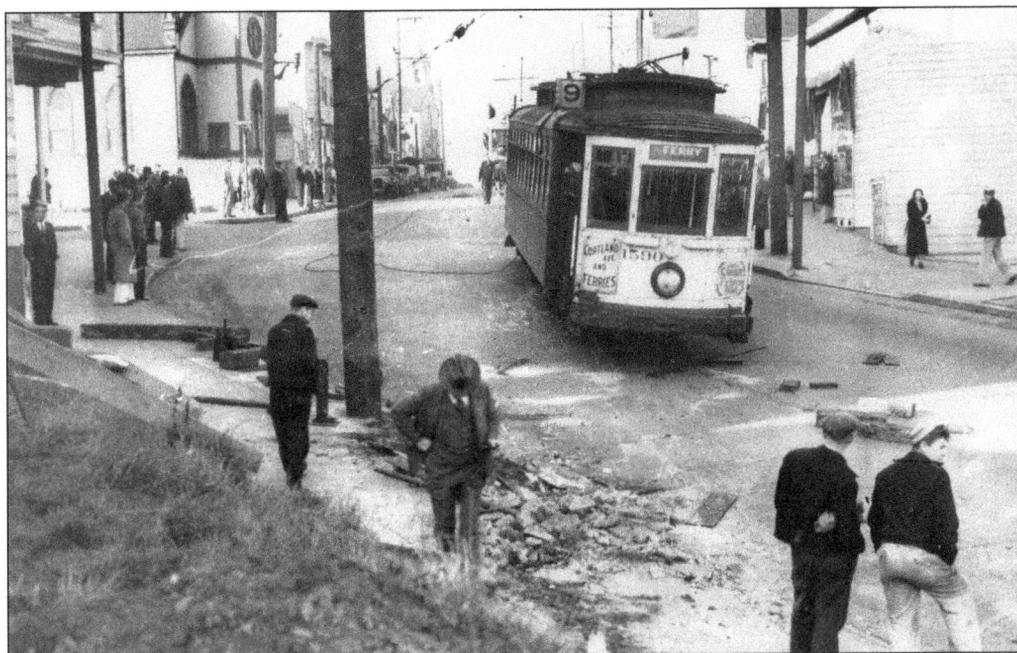

Passersby at Folsom Street and Cortland Avenue carry on their business around a train that had jumped the end of the tracks in 1935. It was common for this to happen if the brakes were incorrectly set or if the driver was going too fast. Sometimes the conductor and motorman on this line would go for a swift drink at Fuzzy Hagen's bar at Cortland Avenue and Gates Street. (Courtesy Philip Hoffman.)

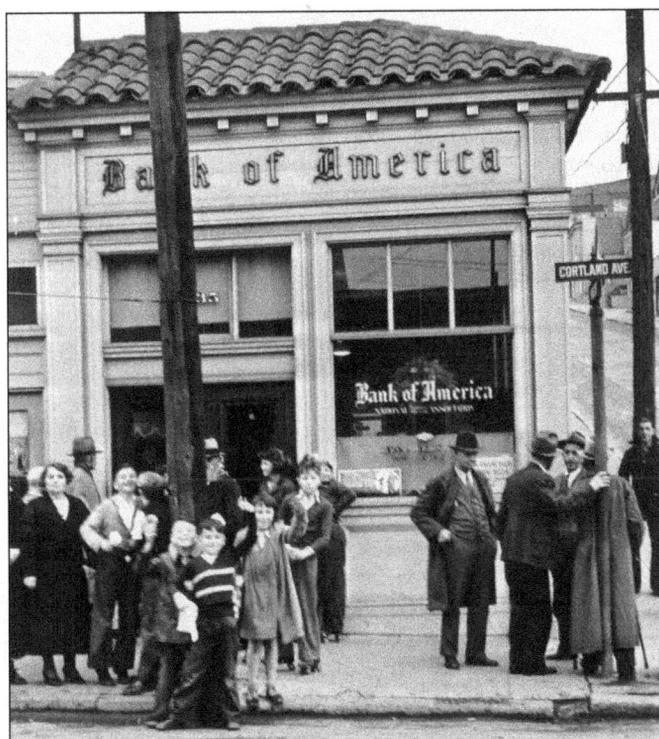

A crowd gathers outside the Bank of America at Cortland Avenue and Wool Street after a robbery on Christmas Eve 1936. As the *Chronicle* reported the next day, the two gunmen were foiled by the bank's newly installed police-alert system. Thanks to Frank Pereira, whose Progress Manufacturing Company was next door, police were able to catch one of the robbers shortly after the holdup. In the 1990s, neighborhood activists fought successfully to keep the bank from moving out of Bernal. (Courtesy San Francisco History Center, San Francisco Public Library.)

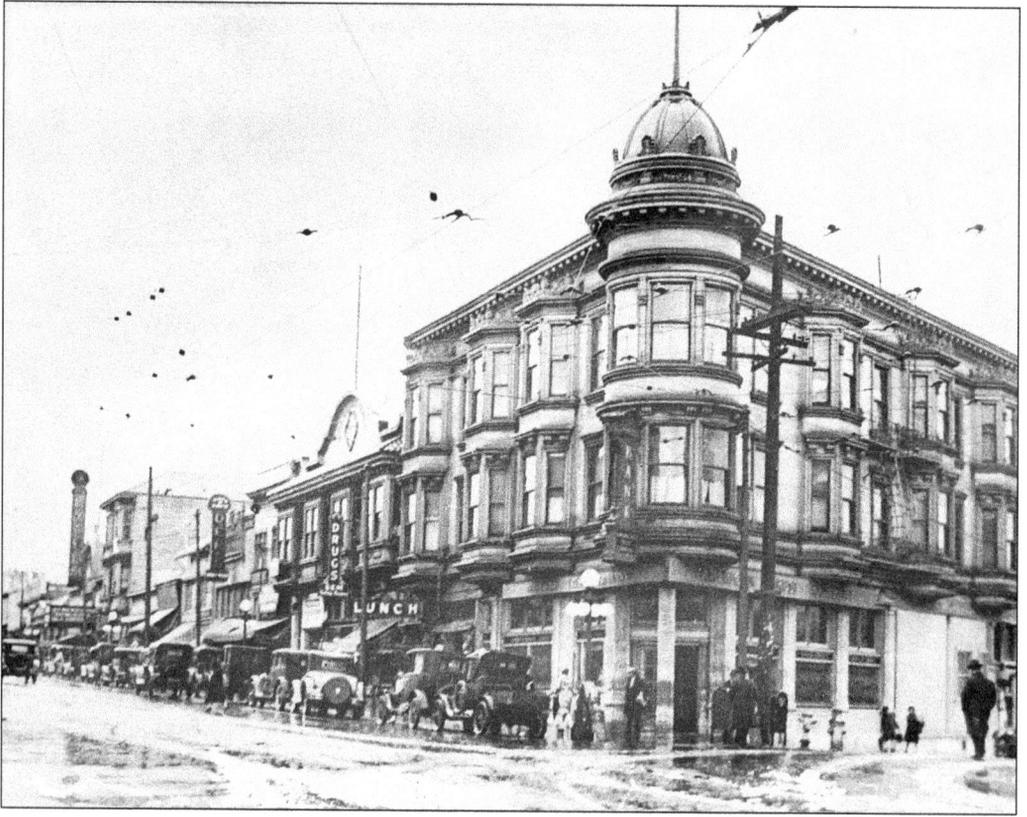

In one form or another, the Graywood has defined the corner of Mission and Twenty-ninth Streets since 1897. Distiller Henry Grauerholz operated a lodging house, restaurant, and bar. The bar was converted into the Anglo California Bank during Prohibition (1920–1933); the photograph dates from that period. Whether known as the Columbus Bakery and Dining Room or the Broken Drum Tavern, it was always a strong union bar catering to working-class men. Jack Keane and his partner Tom Lane purchased the bar in 1956. They covered the trough below the bar, a convenience for drinkers who didn't want to miss anything while relieving themselves, and renamed it the 3300 Club, "Garden Spot of the Mission." When Jack opened the doors at 6 a.m., there would invariably be a batch of guys, from longshoremen to city hall politicos, waiting outside. (Courtesy Nancy Mifflin Keane.)

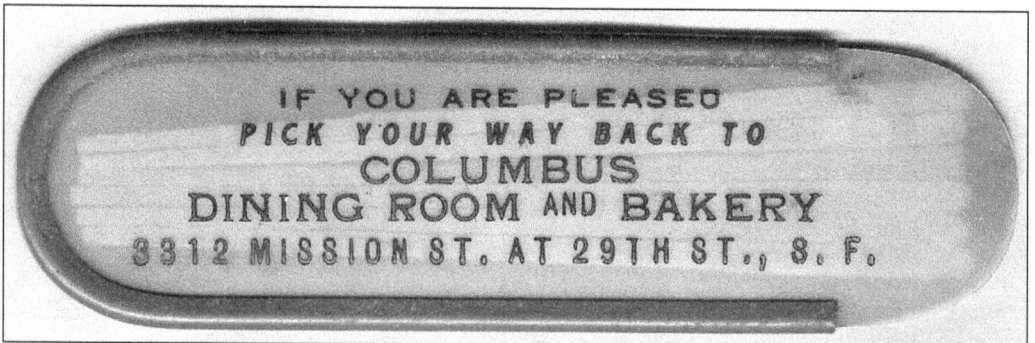

IF YOU ARE PLEASED
PICK YOUR WAY BACK TO
COLUMBUS
DINING ROOM AND BAKERY
3312 MISSION ST. AT 29TH ST., S. F.

Jack Keane, raised on Santa Marina Street, lied about his age to join the U.S. Navy. Home on leave in 1942, he was photographed (right) on Thirtieth Street at Mission Street (unidentified friend, Sharky Berger, Keane) near the 3300 Club. In 1956, Keane married Nancy Mifflin (below), the second youngest of the nine daughters of Benjamin Mifflin, who had a machine shop on Cortland Avenue at Elsie Street. When Jack died in 1990, Nancy quit her job to manage the bar. A poet herself, she added poetry readings and open-mic nights even though, as a regular put it, "Mr. Jack Keane would turn over in his grave if he knew there was poetry in the 3300 Club." Today poets, artists, and writers drink alongside the old-timers at the bar, and Nancy publishes the *Poetry at the 33 Review*. (Courtesy Nancy Mifflin Keane.)

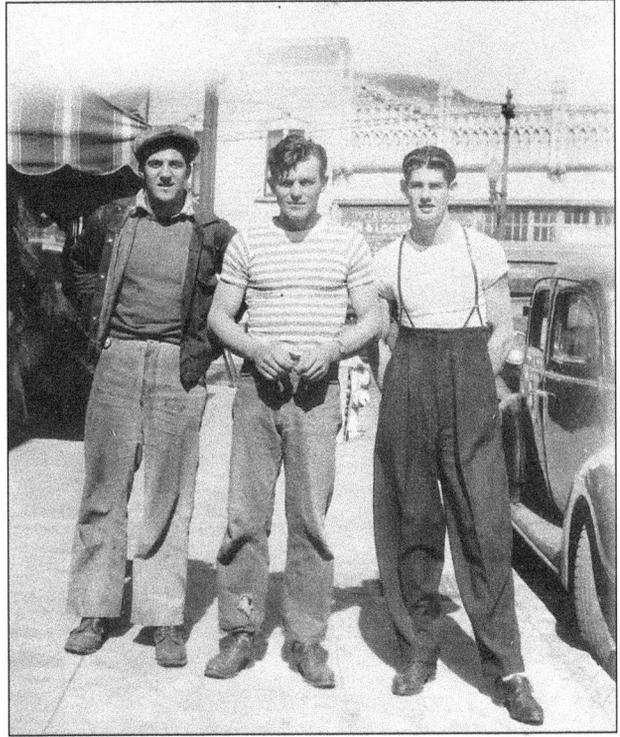

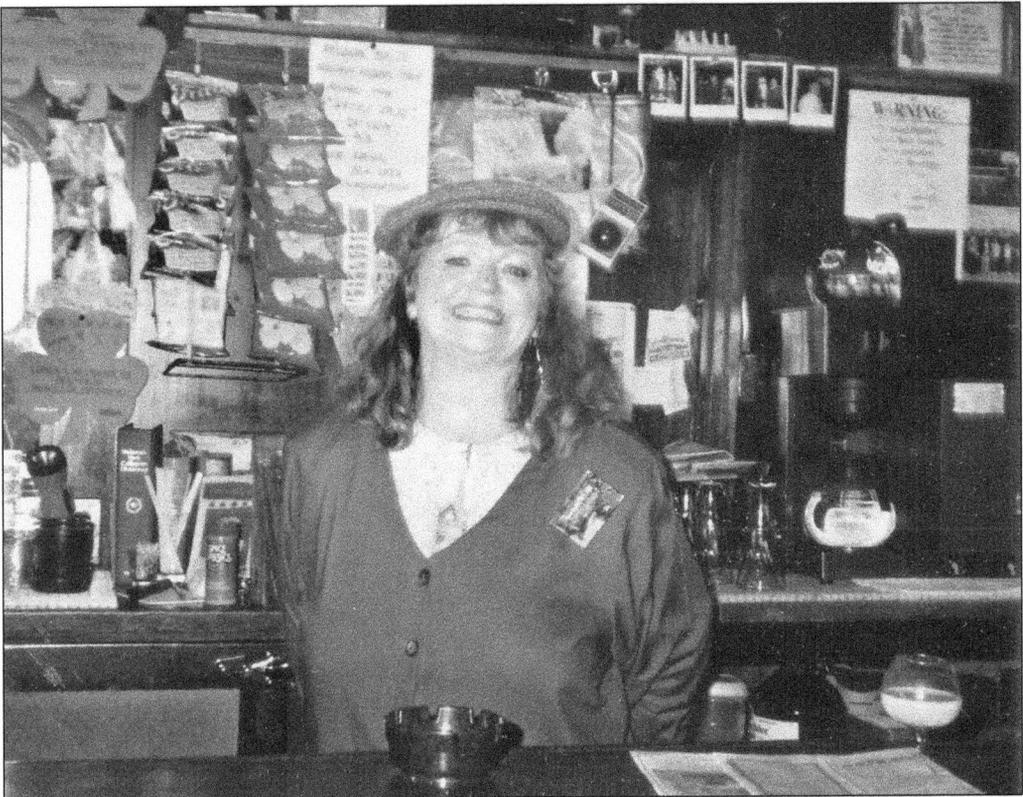

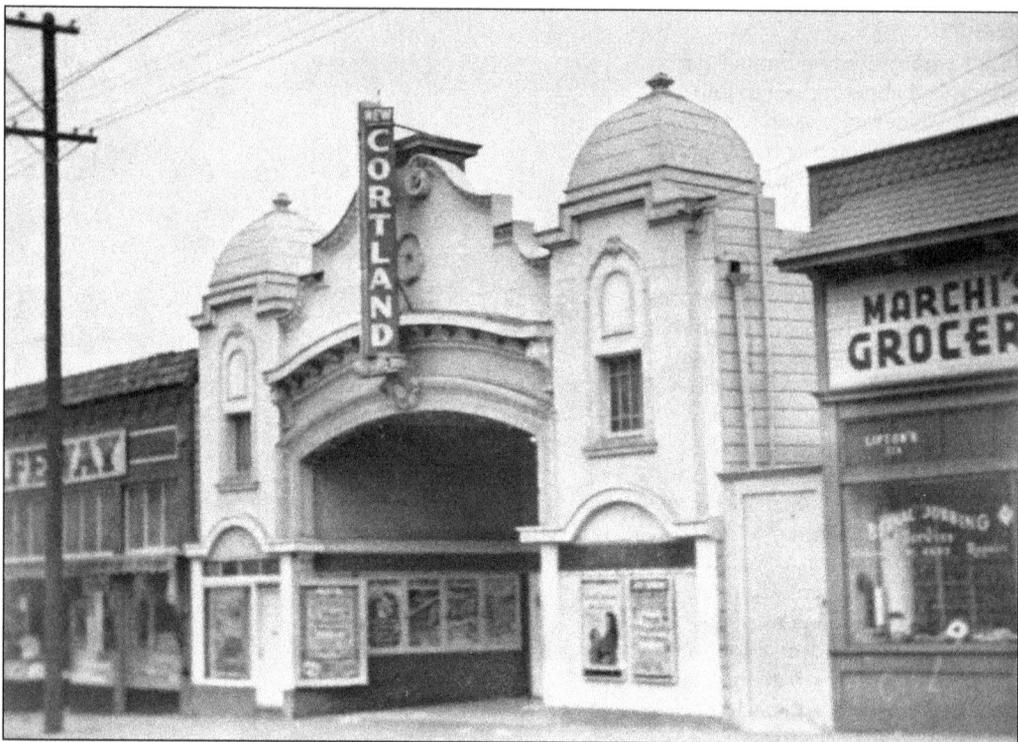

The Cortland Theater opened in 1915 at 804 Cortland Avenue, near Ellsworth Street. In December 1922, the first service for St. Kevin's was held here. The theater was remodeled and its name was changed to the Capri in 1957. It closed as a movie theater in 1969, and the building is now used as a church. (Courtesy Jack Tillmany.)

Theater schedules were handed out at the door when patrons arrived. Neighborhood boys, including Walter Feyling, recall earning free weekly passes from the cinema's manager, Mr. Gatz, if they delivered playbills around the hill. (Courtesy Jack Tillmany.)

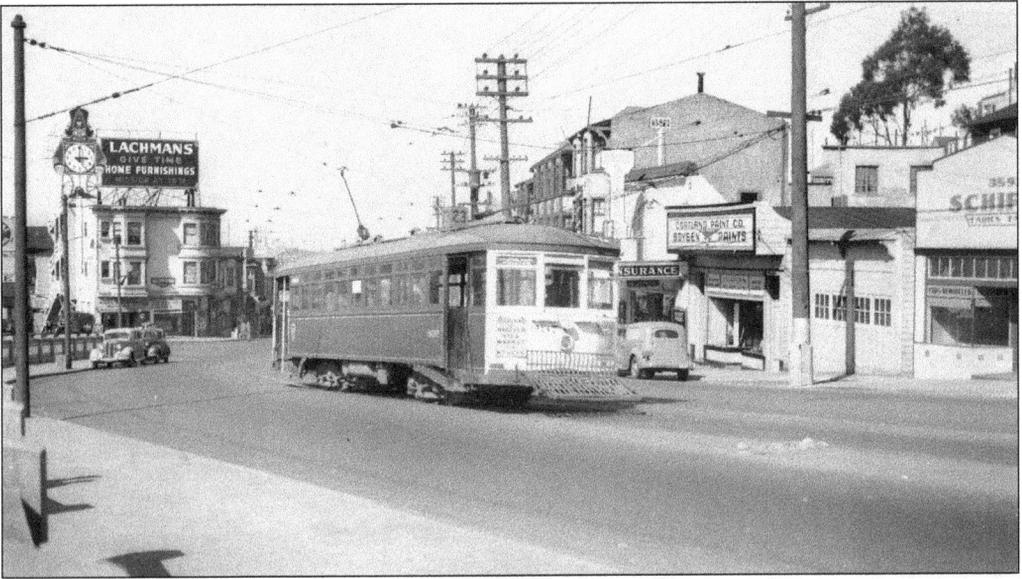

This No. 23 car is heading along Mission Street near Randall Street to the barn at Geneva and San Jose Avenues. Until 1938, this line ran downtown to Divisadero and Sacramento Streets. By 1940, it was just a shuttle along Richland Avenue from Mission Street to Andover Street, but during World War II, it was restored as a branch of the No. 9 line and went all the way to the Ferry Building. The apartment building below the Lachmans sign is now a gas station. (Courtesy Ben Jones.)

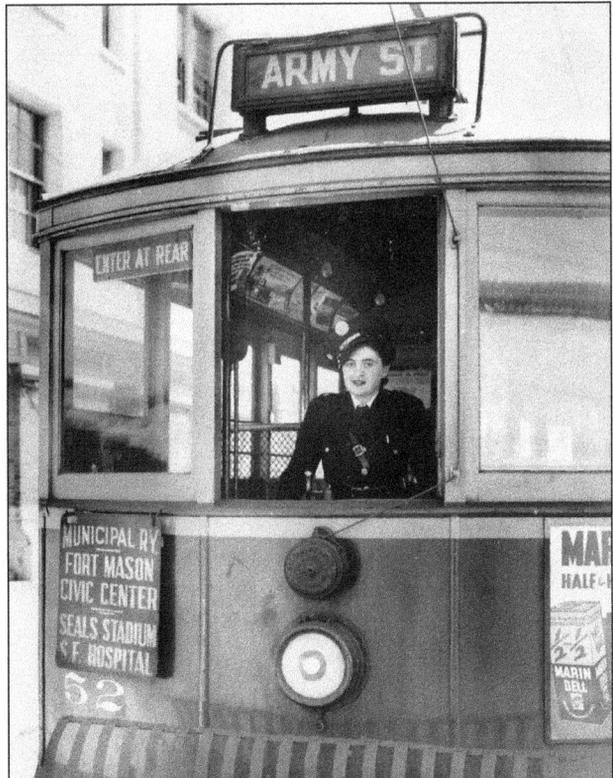

On the Muni Railway H Potrero line, c. 1944–1946, Dolores Piluso piloted car No. 52 on the line that touched Bernal Heights and had its terminus at Army Street. The labor shortage during World War II led to the contentious recruitment of women to operate streetcars. It was common to blame mishaps and accidents on female operators. (Courtesy SF Muni Railway.)

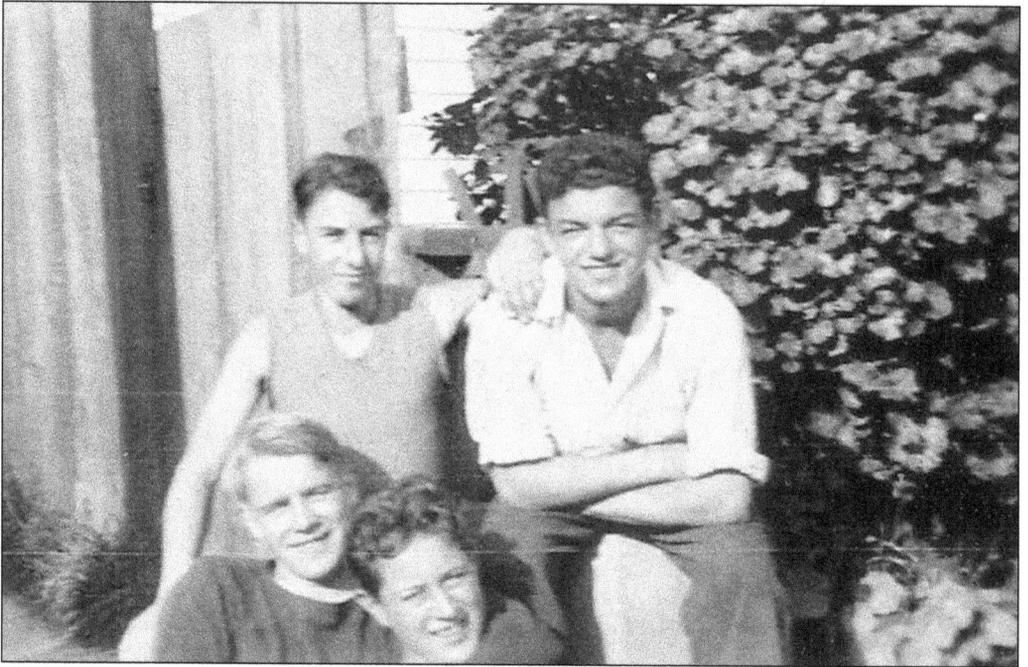

Walter Feyling was born on Andover Street in 1914, the youngest son of Norwegian immigrants. His father Ludvig worked on a fireboat during the 1906 earthquake and fire. The "Andover Boys," shown here in 1934, knocked around together in the neighborhood. Pictured clockwise from top left are Elmer Myers, Louis Gorlier, John Hart, and Walter. (Courtesy Walter and Fern Feyling.)

Walter dug out the basement at his family home to create a garage underneath. His father paid him 50¢ for every load of dirt, which he dumped on Bayshore. After refueling regularly at the Pyramid gas station, he ended up running the place for several years in the 1930s. (Courtesy Walter and Fern Feyling.)

Marie LoBianco grew up on Moultrie Street, where her parents settled immediately after the 1906 quake. She met her future husband, Carmelo "Mel" Annuzzi, on the hill. In this photograph, 15-year-old Marie and 17-year-old Mel are standing in front of Arrow Pharmacy at Cortland Avenue and Wool Street, a popular hangout for local teenagers. The two married in 1944. Mel and his brother Pete went into the concrete business in 1960 with a red pickup truck and $500; business thrived, and Annuzzi Concrete's trucks and equipment are now ubiquitous throughout the city. (Courtesy Marie Annuzzi.)

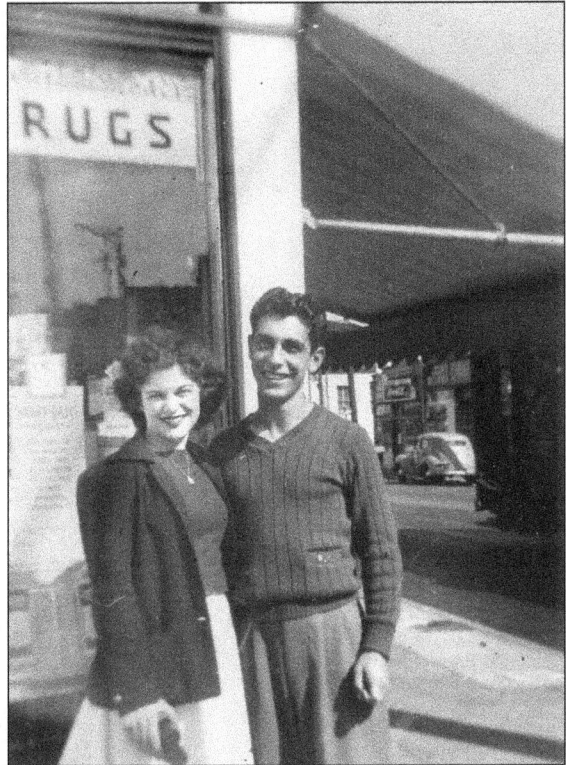

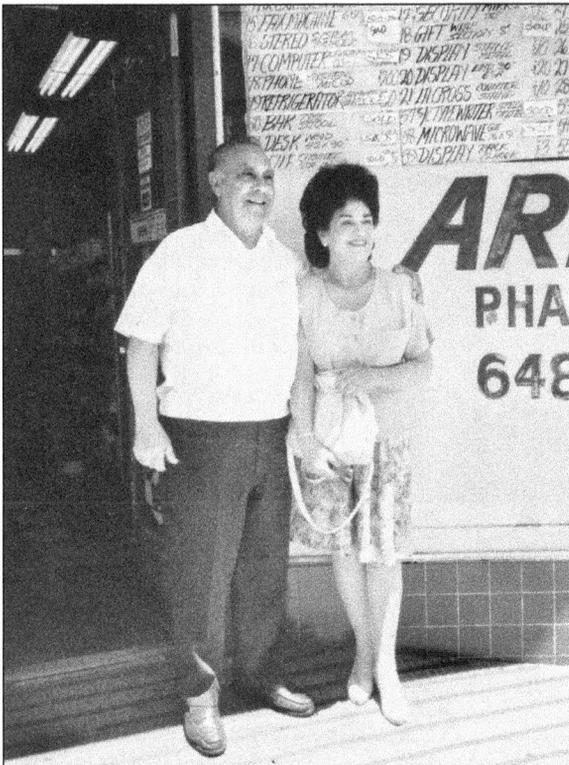

Marie and Mel raised two sons, Mel Jr. and Paul, and became much-loved neighbors in Bernal. The second photograph of Mel and Marie was taken in 2000 outside the same pharmacy, which would close after its owner Mike Callagy retired. Mel passed away in 2005; Marie is still active in the community, working at St. Kevin's Church. (Courtesy Marie Annuzzi.)

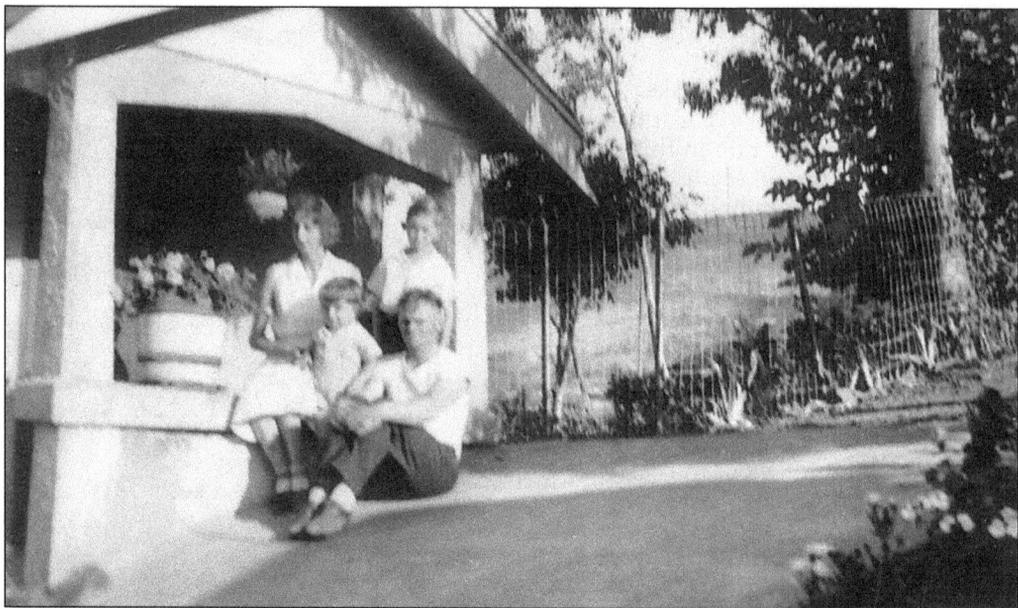

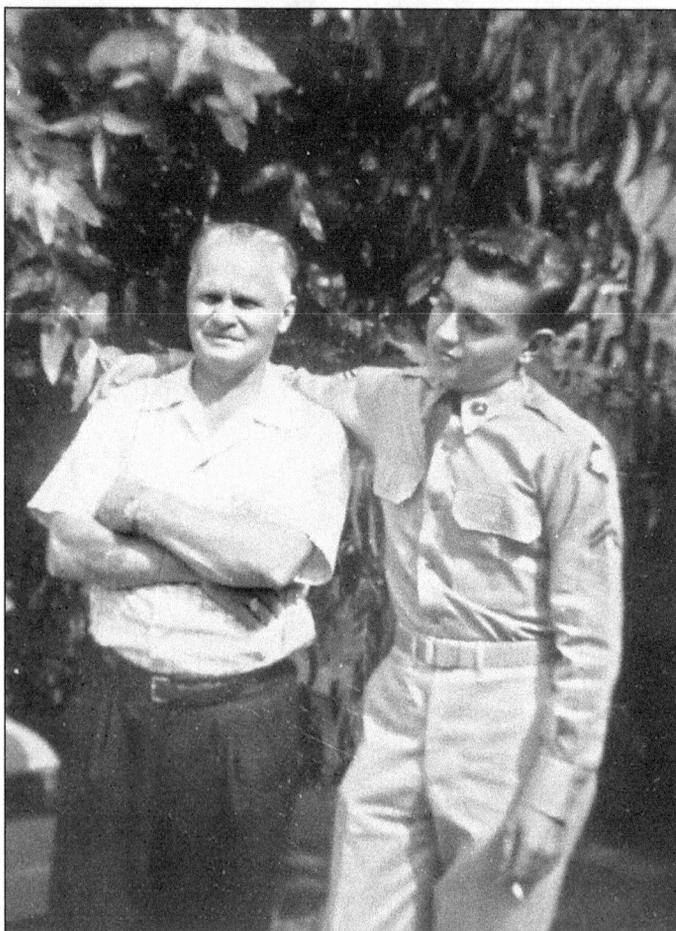

Oscar and Magnhild Kvalvik, Norwegian immigrants, bought their home at the top of Manchester Street in 1929. At the time, it was the uppermost house on that part of the hill—and remained so for decades. The above c. 1933 photograph shows them with their sons Norman and Rolf; Rolf was born in the house in 1929 and has lived there ever since. Oscar became a longshoreman in the mid-1920s and was involved in the great strike of 1934. The police were brutal to the longshoremen, and countless were injured. Rolf recalls taking off his father's boots, as he did each night, and becoming nauseated from the smell of the tear gas. He also worked as a longshoreman before joining the U.S. Army in 1949. The picture at left shows Oscar and Rolf after he signed up. (Courtesy Rolf Kvalvik.)

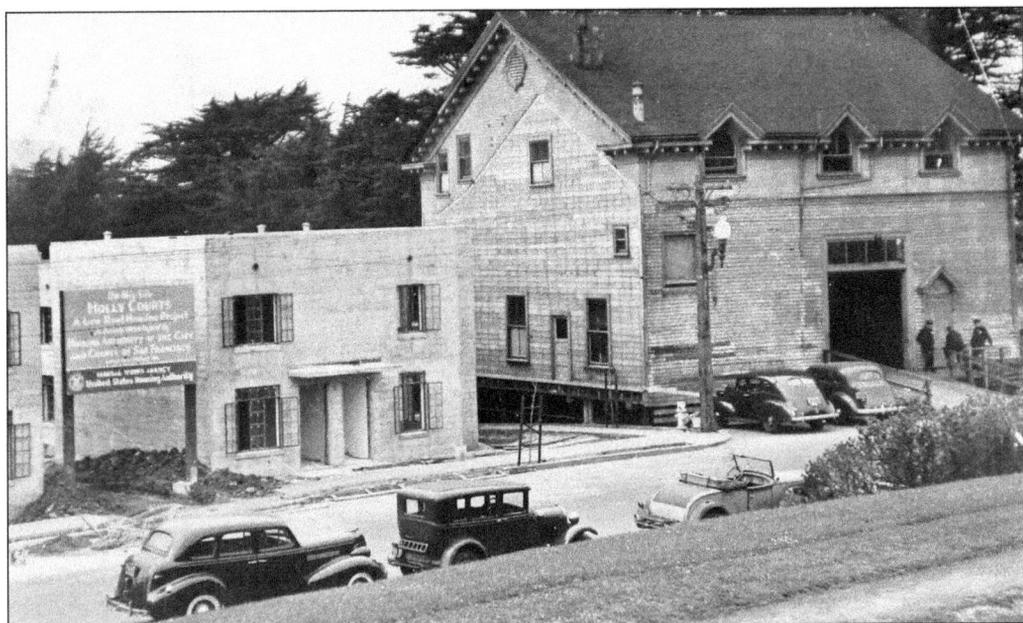

Holly Courts, opened in 1940, was the first public housing project financed by the federal government west of the Mississippi River. It was designed by Arthur Brown Jr., who also designed San Francisco City Hall and Coit Tower. Low-income housing sprang up all over the city, part of the war effort to support service members, war workers, and their families. The old wood Engine No. 32 firehouse, which had stood where the projects were built, was temporarily moved to the middle of Appleton Street before being torn down. (Courtesy San Francisco History Center, San Francisco Public Library.)

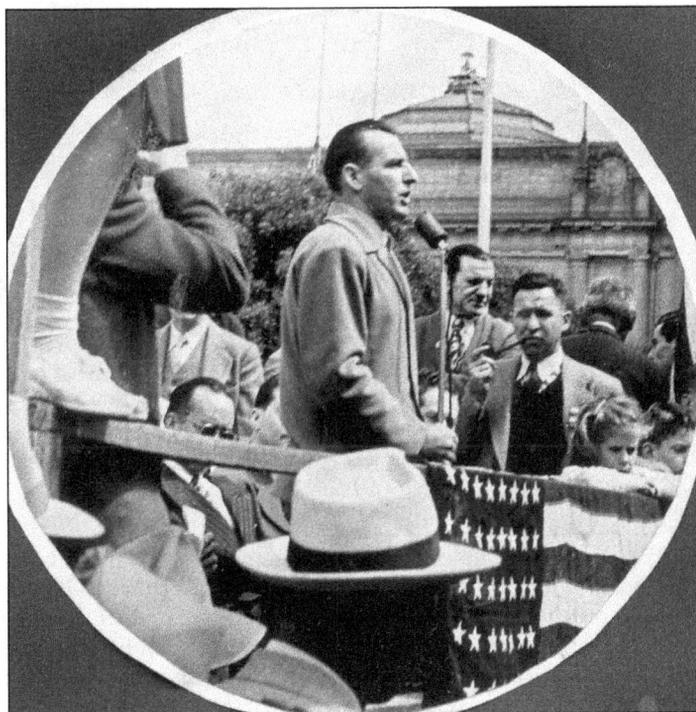

Eugene "Pat" Paton's family lived on Bennington Street. In the 1930s, he was active in organizing labor and became Local 6 president of the International Longshoremen's and Warehousemen's Union. In 1934, the longshoremen and their allies went on strike; employers used police and hired guns to smash the unions and the picket lines. Hundreds of strikers were injured, and six workers were killed. Public support mobilized behind the workers, with a brief but historic general strike called by the unions of San Francisco. (Courtesy ILGWU archives.)

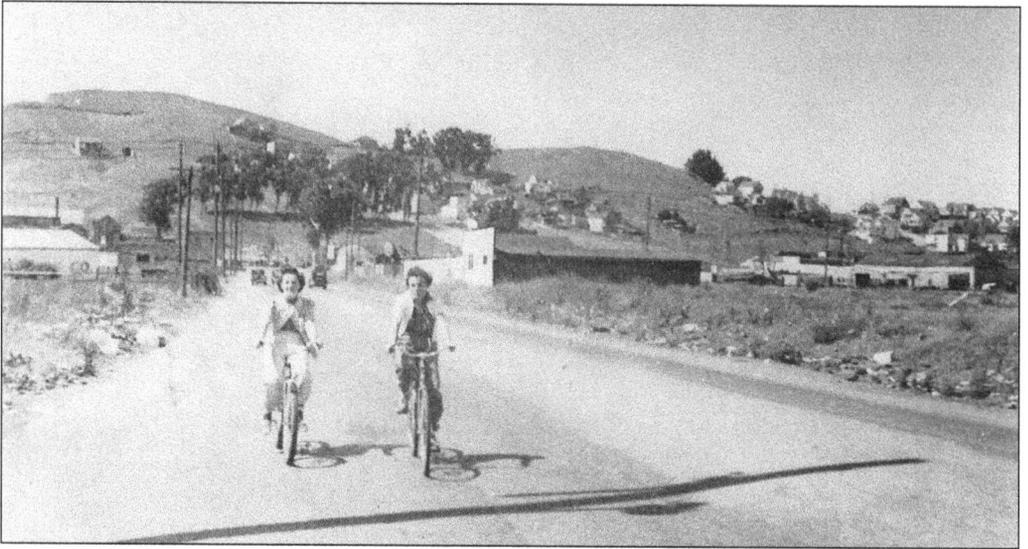

This 1940 photograph of friends Fern Feyling and Lois Navarrette riding their bikes east on Oakdale Avenue from Bayshore Boulevard looks delightfully bucolic. In the trees on the hill behind are Costa, Faith, and Brewster Streets; between the cyclists is the back of the Clam House, which was established in 1861 as the Oakdale Bar and is one of the oldest restaurants in San Francisco. (Courtesy Walter and Fern Feyling.)

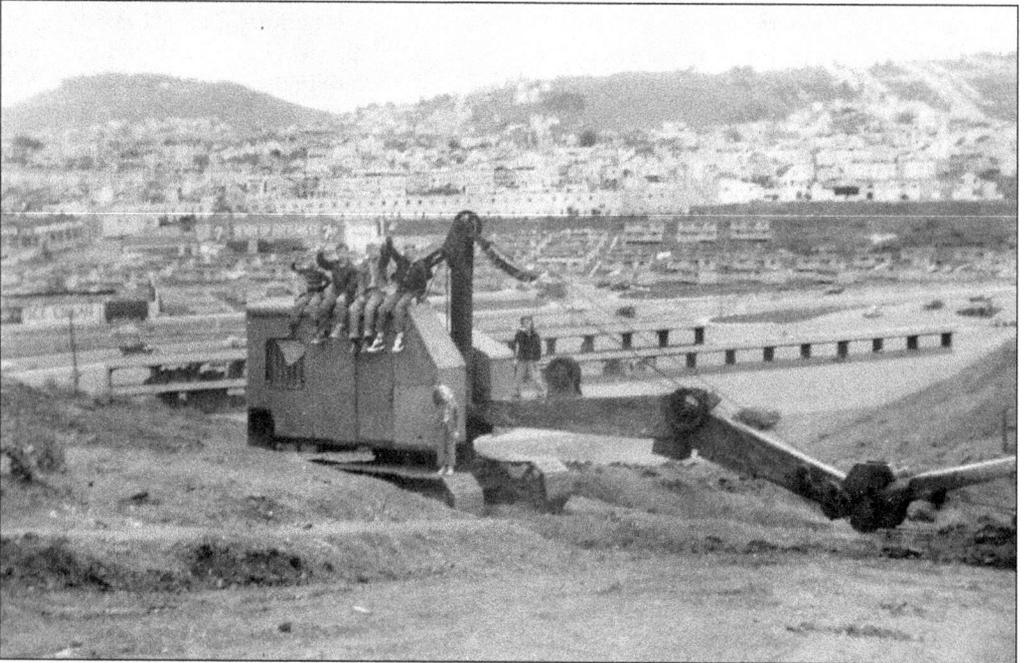

Al Bergstrom grew up on Putnam Street; his grandfather, George, was a Swedish carpenter-contractor who built many houses on the hill. In this late-1940s picture, Al and his friends are perched on the steam shovel that was used to excavate streets for further construction. The farmers' market and temporary military housing can be seen in the background. Pictured from left to right are Al Gerond, Sidney Gruber, Gordon Bracken, Al (waving at front), and his twin siblings Vic and Rick. (Courtesy Al Bergstrom.)

Al Bergstrom (center) poses with his brother Rick and sister Vic in front of the family's 1939 Chrysler on Putnam Street. They often played with a neighbor's dog that had a "US Army" stamp on its belly and had been taught to wriggle along the ground like a soldier. They roamed all over the hill below Putnam Street, which was later excavated for development. (Courtesy Al Bergstrom.)

John and Ruth Bogue raised eight children on Peralta Avenue. John was born in Bernal Heights in 1901 to Irish immigrant parents; his wife, Ruth, was born on Church Street in 1905. This early-1930s picture shows John with his three eldest children, Ruthie, Jack, and Georgia. The Bogue children "sledged" down Bernal Hill in cardboard boxes and bought coconuts from the corner vegetable stand. (Courtesy Georgia Bogue Carrozzi.)

Ray Mode was in the U.S. Navy but missed active service in World War II. He was called up again for the Korean War in 1950 and served in the Philippines. This photograph was taken in 1950 at the Holladay Avenue childhood home of his wife, Dolores Frankson, with Potrero Hills in the background. Mode's parents came from a pioneer family; his father was French-Canadian, while his mother was English and Cherokee. (Courtesy Diane Mode Smith.)

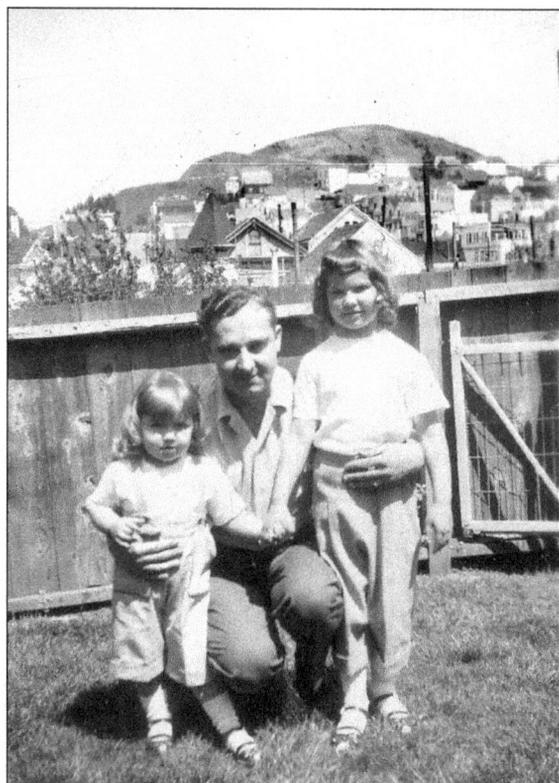

Sisters Janet and Betty Mikulas pose in their Elsie Street backyard with their father, Matej, in this 1948 snapshot showing Bernal Hill in the background. The Mikulas were originally Czech; Matej was raised on Holladay Avenue, and his family owned several properties on Costa Street. He ran a homeopathic pharmacy with his brother in the Financial District. The two girls attended Junipero Serra Elementary School. (Courtesy Janet Mikulas Thompson and Betty Mikulas Kancler.)

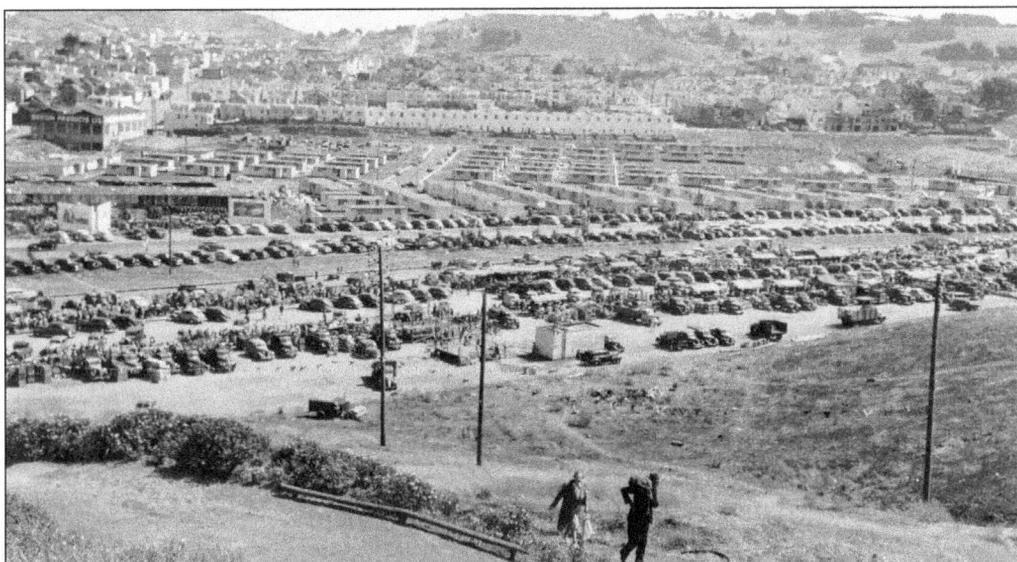

The San Francisco Farmers' Market had been established for three years when it moved from Market and Duboce Streets to its present location at 100 Alemany Boulevard in August 1947. Manager John Brucato organized ceremonies to mark the official opening; the market hosted a record 80,000 visitors that day. The structures visible across Alemany Boulevard were temporary military housing for the Hunters Point shipyard. (Courtesy San Francisco History Center, San Francisco Public Library.)

John Brucato led the movement to create a farmers' market in San Francisco and shepherded its relocation to Alemany Boulevard. After a long and bitter campaign, which included two city ballot initiatives and maneuvering at the state level, the Alemany market opened on August 4, 1947, under a city ordinance. In this 1948 photograph, Brucato (far right in suit) consults with some of the farmers who have come to sell their surplus produce at the market. (Courtesy San Francisco History Center, San Francisco Public Library.)

The Sun Valley Dairy at 300 Alemany Boulevard was a popular destination for Bernal's residents on the south side of the hill. Teenagers met there for ice cream and sodas in the 1950s. A processing plant at the back churned out buttermilk and ice cream. A later incarnation of the store had life-size fiberglass models of a cow and calf above the door. The building, until recently a discount clothing warehouse, is now a kitchen-remodeling center. (Courtesy San Francisco History Center, San Francisco Public Library.)

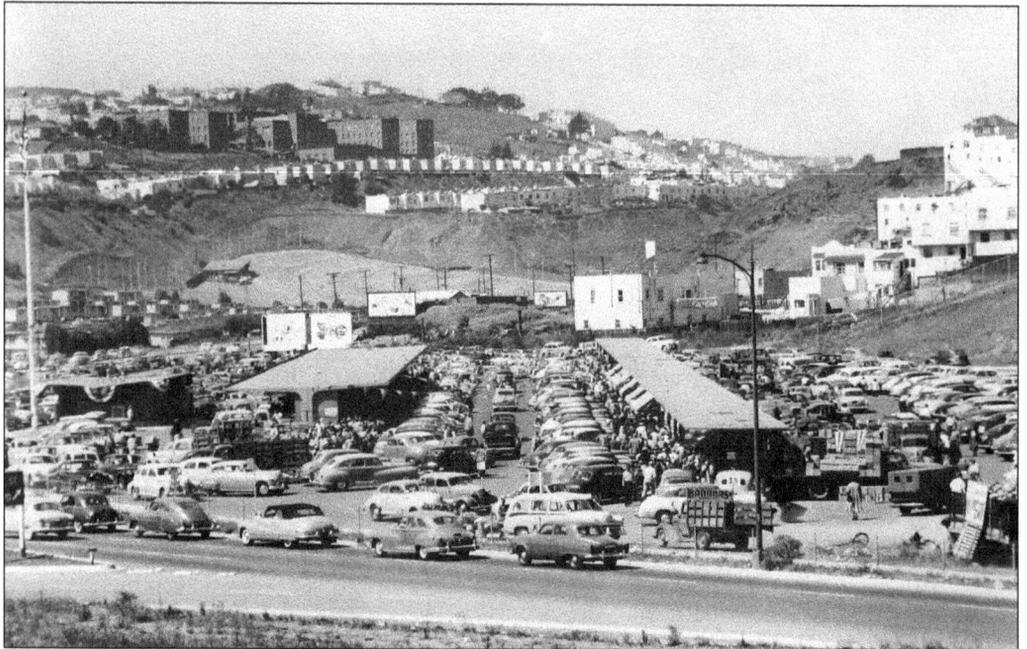

The San Francisco Farmers' Market on Alemany Boulevard is California's oldest continuous farmers' market. This photograph was taken in 1953. The layout of the market today is much the same. The market operated six days a week then; today it is open only on Saturdays. A popular flea market takes over the site on Sundays. The building in the distance was the Simpson Bible College (Courtesy San Francisco History Center, San Francisco Public Library.)

Marie Malveaux (top right) moved from Biloxi, Mississippi, to her Victorian home on Ellsworth Street in 1953, where she has lived ever since. Pictured alongside her are her grandmother Addie Hawkins, Marie's daughters Marianne, Julianne, and Mariette, and son James. Marie was one of the founders of the senior services program that is now run by the Bernal Heights Neighborhood Center; Julianne is nationally known as a writer, syndicated columnist, and media personality who contributes her views on race, gender, and economics. (Courtesy Marie Malveaux.)

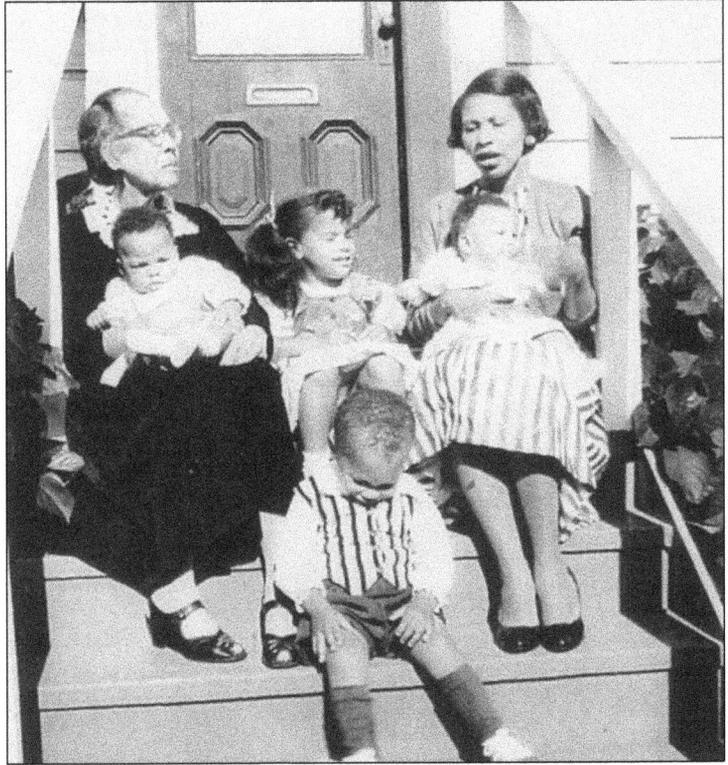

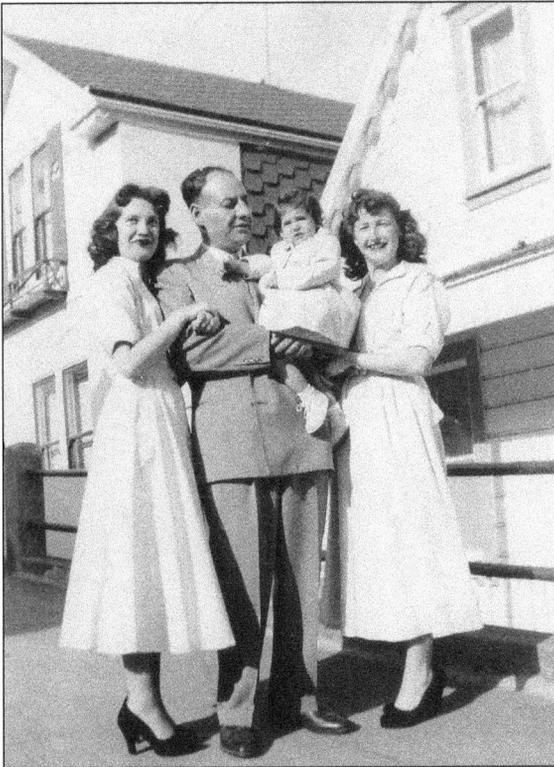

The San Fillippo-Tello-Johnson family, of Peruvian and Sicilian backgrounds, has owned this house on Gates Street since 1906. It still has the original well in its basement, and Lena Tello, its first owner, recalled the pre-car days when horses were tied up out front in the street. The San Fillippos owned several properties in Bernal. This 1950s photograph shows sisters Dorothy Tello and Lorraine Heath Johnson (holding her daughter Denise), and their father, Eugenio San Fillippo. (Courtesy Rochelle Mankin.)

Gus Triandos

CATCHER — BALTIMORE ORIOLES

Gus Triandos, Bernal's baseball All-Star, played in the major leagues from 1953 to 1965 as a first baseman and catcher. He was raised on Alabama Street, and got his start playing at Rolph Field on Army Street. He spent time in the New York Yankees minor-league system until called up to the big club in 1953. Stuck behind Yogi Berra, he was traded to the Baltimore Orioles and started the 1955 season. He was elected to the All-Star team in 1957, 1958, and 1959.

Ken Reitz played third baseman for the St. Louis Cardinals, the San Francisco Giants, and the Chicago Cubs from 1972–1982. Career highlights included playing on the All-Star team and winning a Gold Glove in 1975. His parents lived on Santa Marina Street; his uncle and godfather was Jack Keane, owner of the 3300 Club. Ken was known as "The Zamboni" for his skill in scooping up ground balls.

DEC. 8 SPORTS EXTRA 1975
REITZ COMES HOME TO SAN FRANCISCO

THIRD BASE — KEN REITZ

Five

THE LITTLE TOWN
IN THE BIG CITY

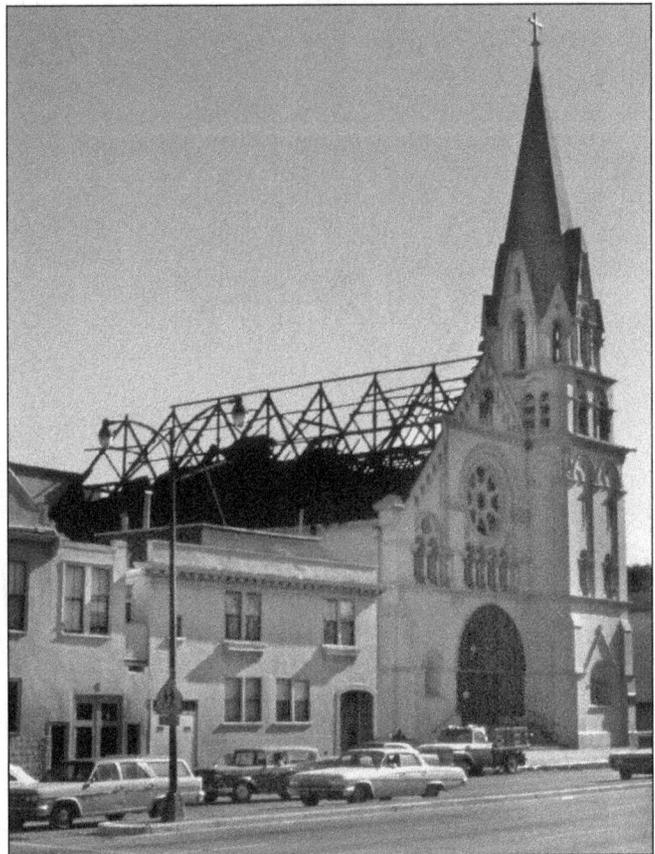

In June 1975, St. Anthony's Church at Folsom and Army Streets was gutted by fire. At first, city leaders announced that it would be restored to its former grandeur, but economics intervened. The entry archway and the bells were rescued, but a much more modestly sized structure replaced the old church. (Courtesy Max Kirkeberg.)

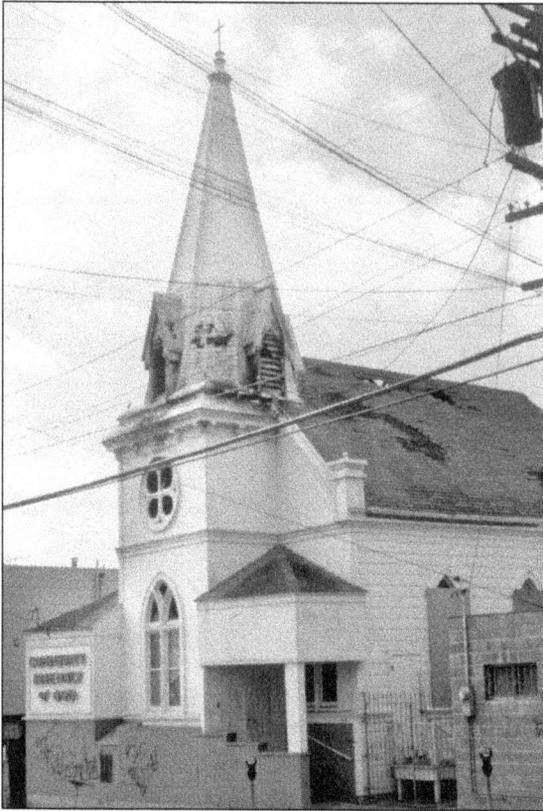

The Community Assembly of God Church at Folsom Street and Cortland Avenue started life in the early 20th century as the Swedish Lutheran Emanuel Church, serving the Scandinavian community. It burned in December of 1979 and was not rebuilt. It was replaced by apartments; today there is no sign that it ever existed. (Courtesy Max Kirkeberg.)

Increasing population diversity of the hill has also produced diversity in its places of worship. The Mosque and Islamic Center of San Francisco was established in the early 1980s on Crescent Avenue in a building that was originally a church. (Photograph by Valerie Reichert.)

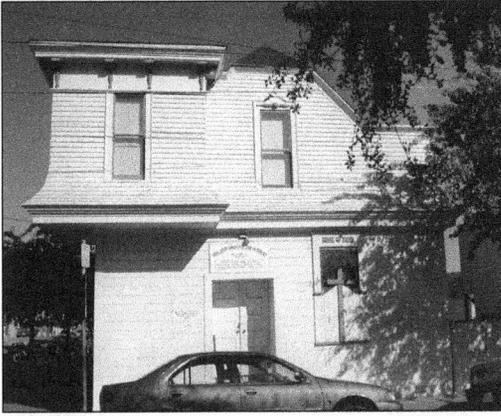

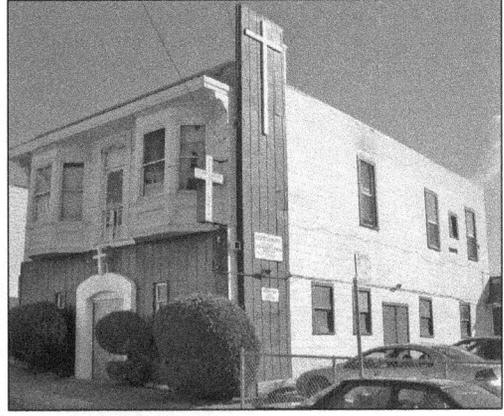

The True Light Church of God in Christ at Tompkins Avenue and Moultrie Street (left) is one of several evangelical churches on the south side of Bernal Hill. Rev. George Dorn established the current ministry in 1981, replacing a Baptist church that had been there previously. George's son, Rev. Yul Dorn, and his wife, Theresa, took over in 2002. The Good Hope Baptist Church (right) has ministered to the African American community since 1957, when it moved to 551 Nevada Street. The Reverend Rance Whiteside started the church in 1953 and is still the minister. (Image at left courtesy of Tim Holland; at right courtesy of Molly Martin.)

In the late 1960s, Bernal Heights was home to Samuel Lewis (1896–1971), known as Murshid Sam or Sufi Sam. He taught Sufism, which is the belief in the essential unity of religions. He attracted a following of hippies to whom he taught rhythmic, repetitive Sufi chants and dances. Sam and his students lived at 410 Precita Avenue. After his death, they took the "Dances for Universal Peace" back to their hometowns. (Photograph by Mansur Johnson; courtesy Violetta Reiser.)

Hispanic, Asian, and African American families began moving to Bernal in greater numbers in the years after World War II. This is Paul Revere Elementary School's sixth-grade class from 1959. (Courtesy Roger Giovannetti.)

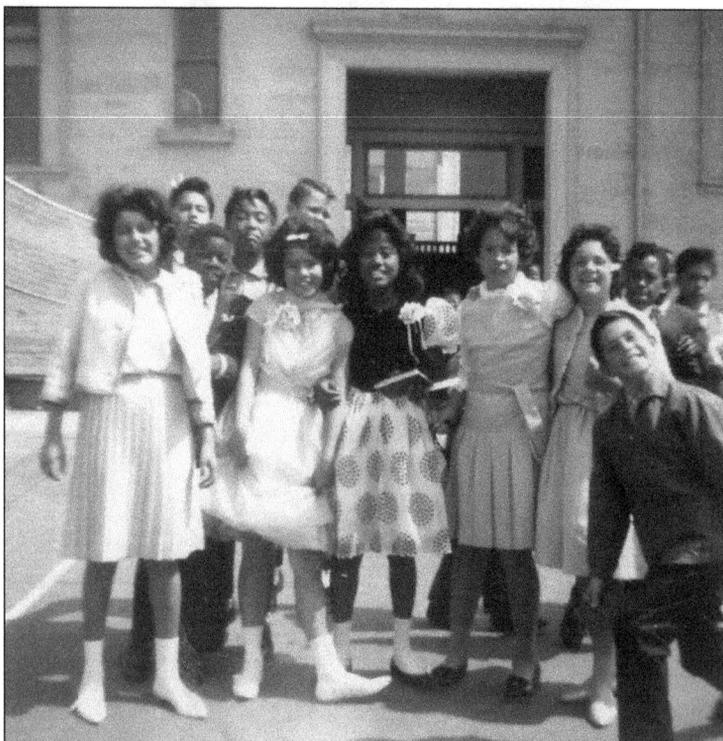

Sixth-grade students at Paul Revere in 1962 are shown here. Three generations of the Williams family have attended Paul Revere. They bought their house on Bernal's southeast slope and moved to San Francisco in 1952. Willard and his wife, Beulah, operated three shoe shine parlors downtown. (Courtesy Sylvia Williams-Reed.)

Shukry "Chuck" Lama and Vera Lama brought their family to Bernal Heights from Chile in 1973. Two of their sons, Mauricio ("Moe") and Alex, are shown in front of Reliable Grocery, the family store on Cortland Avenue at Bocana Street. (Courtesy Antoinette Lama.)

In the winter of 1962, sisters Susan, Denise, and Donna Heath of Gates Street celebrate a rare Bernal Heights snowstorm. (Courtesy Rochelle Mankin.)

Brothers John and Rai Perez and their cousin Victor Perez, shown with some unidentified neighbors, came from Guam to San Francisco in the late 1950s. Here they pose in front of John and Rai's home on Lundys Lane in 1960 or 1961. (Courtesy Paul Miller.)

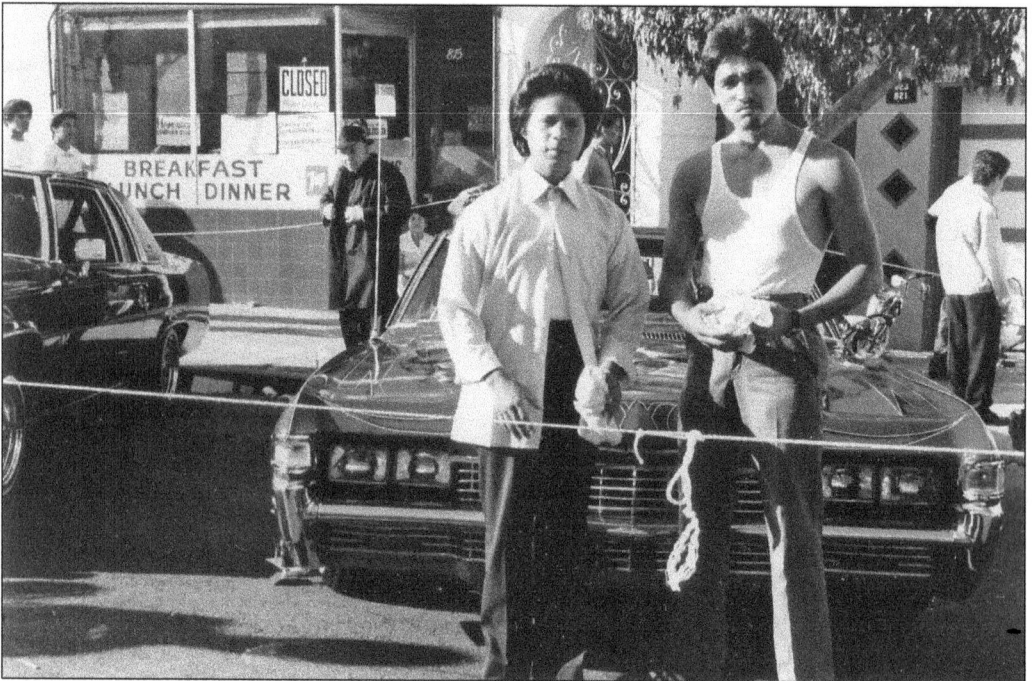

Two car enthusiasts show off their rides at an early Fiesta on the Hill automobile show, possibly in 1978 or 1979. (Courtesy Wild Side West.)

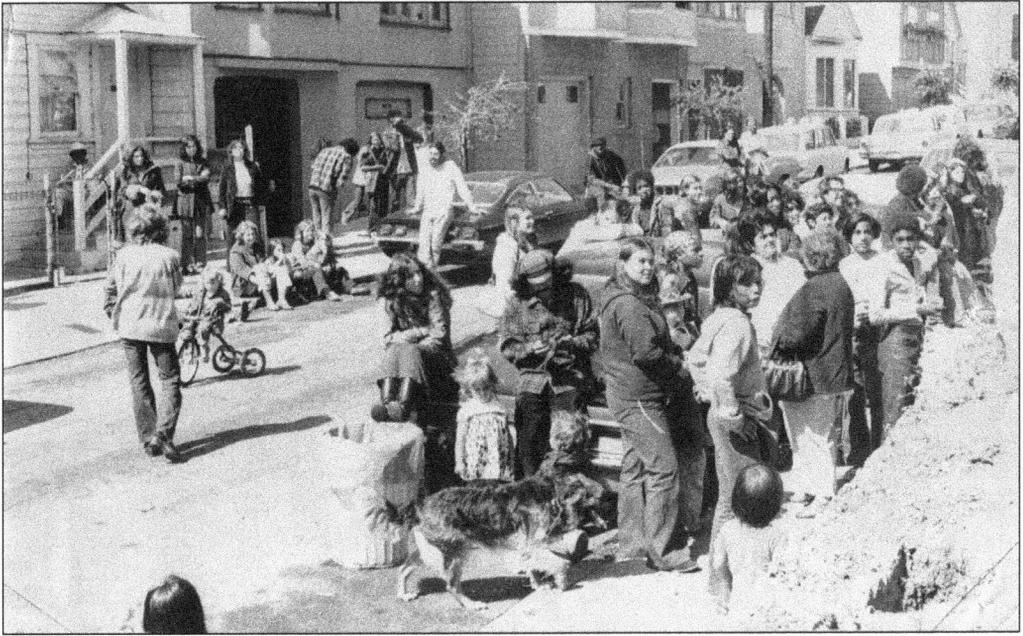

In the early 1970s, Mullen Avenue became known for its parties, its community organizing, and its famous musician-residents, such as Carlos Santana and members of his and Janis Joplin's band. Mullen was also home to Chet Helms, San Francisco's first rock impresario, who brought Joplin to San Francisco. (Courtesy Peter Wiley.)

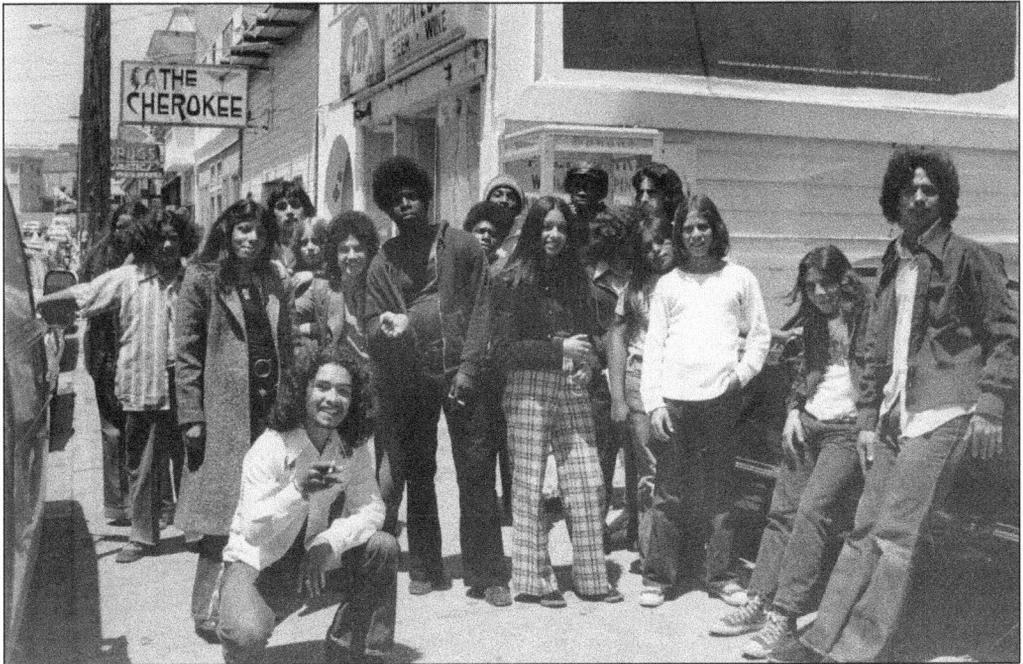

Precita Center Summer Youth Program gathers on Cortland Avenue in 1976. Carole Deutch, founder, is in the middle. Behind them is the famous (or notorious) Cherokee Bar, now Skip's Tavern. The bar's famous interior mural was painted by Paul Revere alumnus Harold Vic. (Courtesy Carole Deutch.)

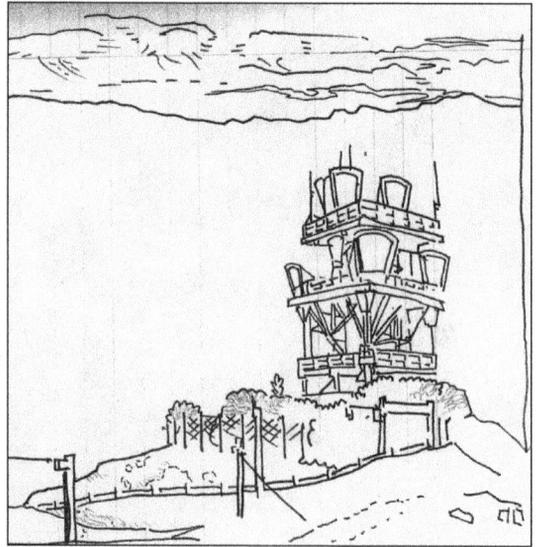

Spain Rodriguez is a legendary underground cartoonist who lived on Mullen Street in the 1970s. He is the creator of *Trashman, Agent of the Sixth International*, and many other comics, and is the illustrator of the graphic novel *Nightmare Alley*. He is shown (left) with his wife, filmmaker Susan Stern (*Barbie Nation, The Self-Made Man*). This undated drawing (right) depicts the microwave tower on Bernal Hill. (Courtesy Spain Rodriguez.)

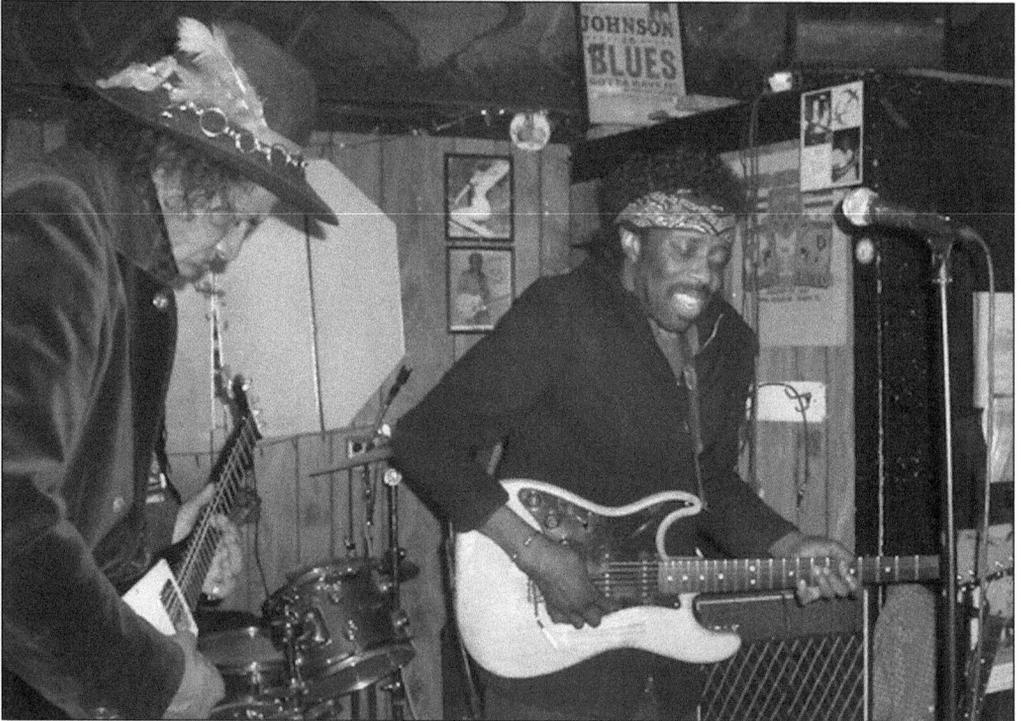

Skip's Tavern was a pool hall many years ago and then became a bar called the Cherokee. All that remains of the Cherokee is the oval bar and a mural across the entire front of the bar's interior. Skip's features nightly live music and a weekly R&B jam session hosted by Regi Harvey (right), dubbed the "Colonel of Bernal" by Skip's regulars.

108

Owners Pat Ramseyer and Nancy White moved their saloon the Wild Side West from Broadway to 424 Cortland Avenue in 1977. Before that, it had been a countercultural hangout in Berkeley for the likes of Bob Dylan and Janis Joplin. The Wild Side is a lesbian bar that provides a neighborhood meeting place where all feel welcome. (Courtesy Wild Side West.)

In Bernal Heights, the lesbian community found a funky neighborhood where property was relatively cheap, and in the 1970s, took their place as the newest wave of immigrants in Bernal's constantly changing demographic. By the mid-1980s, it was rumored that Bernal was home to more lesbian property owners than anywhere else in the world. (Courtesy Wild Side West.)

In 1978, the Northwest Bernal Block Club got city funding and permission to build a mini-park and slide on Esmeralda Avenue between Prospect and Winfield Streets. When it was inaugurated in 1979, Mayor Dianne Feinstein and Assemblyman Art Agnos came to try out the slide. After 20 years of wear and tear, the slide had to be refurbished, and once again the neighborhood united to do it. Above, the 1998 group of workers holds a photograph of the 1979 group. (© Phiz Mezey.)

Mayor Willie Brown and some Bernal children enjoy testing the refurbished slide in 1998. The community action that pushed for the playgrounds, stairs, and gardens went all the way up the hill on Esmeralda Avenue. Neighborhood activism succeeded in rescuing Bernal Hilltop from development and preserving it as a park in 1972. (Both © Phiz Mezey.)

This tile-covered house at 80 Bronte Street honors the Catalan architect Antoni Gaudí, a unique master of Art Nouveau. Beth Pewther, assisted by Eugene Phillips and Jerry Shelfer, transformed a conventional house into a multistory display of tile art. They built out the surface of the house with planters that protrude organically from the building—a remarkable thing to find on a narrow, hilly street. (Photograph by Tim Holland.)

The residence at 288 Precita Avenue is the "SLA House," where Symbionese Liberation Army fugitives Bill and Emily Harris were living when they were arrested on September 18, 1975. Contrary to certain neighborhood tales, Patty Hearst was arrested elsewhere. Roseann Cirelli remembers that St. Anthony's and Immaculate Conception Schools had just let out at the time of the arrests, and an animated mass of uniformed Catholic schoolkids mingled with the large force of heavily armed police and FBI agents. (Courtesy Todd Lapin.)

At one time, Bernal Heights had its own Doggie Diner at the southwest corner of Mission and Army Streets, next to the Sears department store. The enormous dog's head in bow tie and chef's hat that advertised a chain of restaurants has become a beloved icon in San Francisco. (Courtesy Max Kirkeberg.)

In the mid-1970s, Clarence and Claudia Weems allowed their teenage daughter Jane, a punk rock musician, to paint her tribute to the Beatles on their home at 189 Precita Avenue. In the early 1980s, she redid her work, adding the "Savage Young Beatles" of the Hamburg days. This is the version shown. Unfortunately the murals of the Beatles House were painted over in the early 1990s. (Courtesy Jane Weems.)

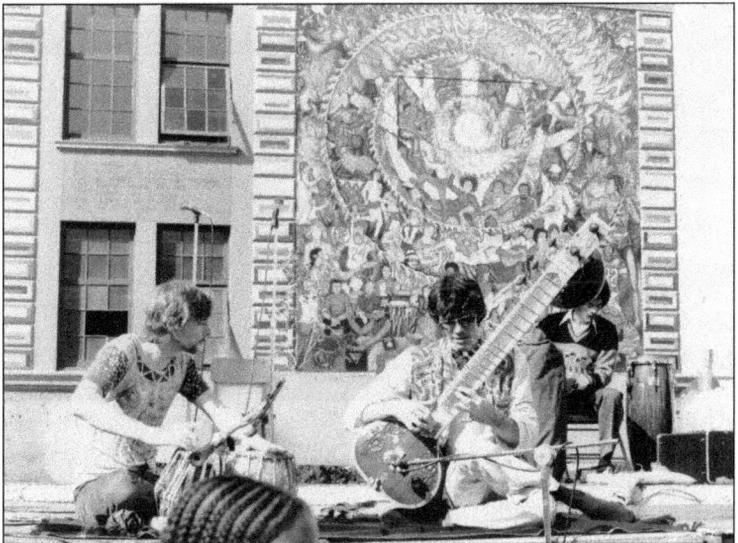

This Precita Park community celebration in March 1977 is for the "Spirit of Mankind" mural painted on Le Conte School by Susan Kelk Cervantes and Judy Jamerson. Joined later by other artists, the group evolved into Precita Eyes. The school changed its name to Leonard R. Flynn Elementary shortly after, memorializing a former principal of the school. (Courtesy Carole Deutch.)

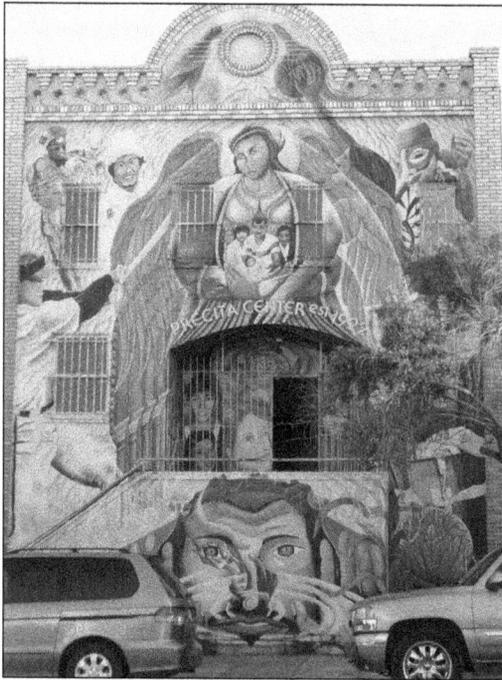

The Precita Valley Community Center provides a support system for Mission District and Bernal youth. The mural *Precita Valley Vision* was painted by Susan Cervantes and a number of other Precita Eyes artists. It includes an homage to a young couple, Sylvia Menendez and Carlos Hernandez, who were shot to death in Precita Park in 1996.

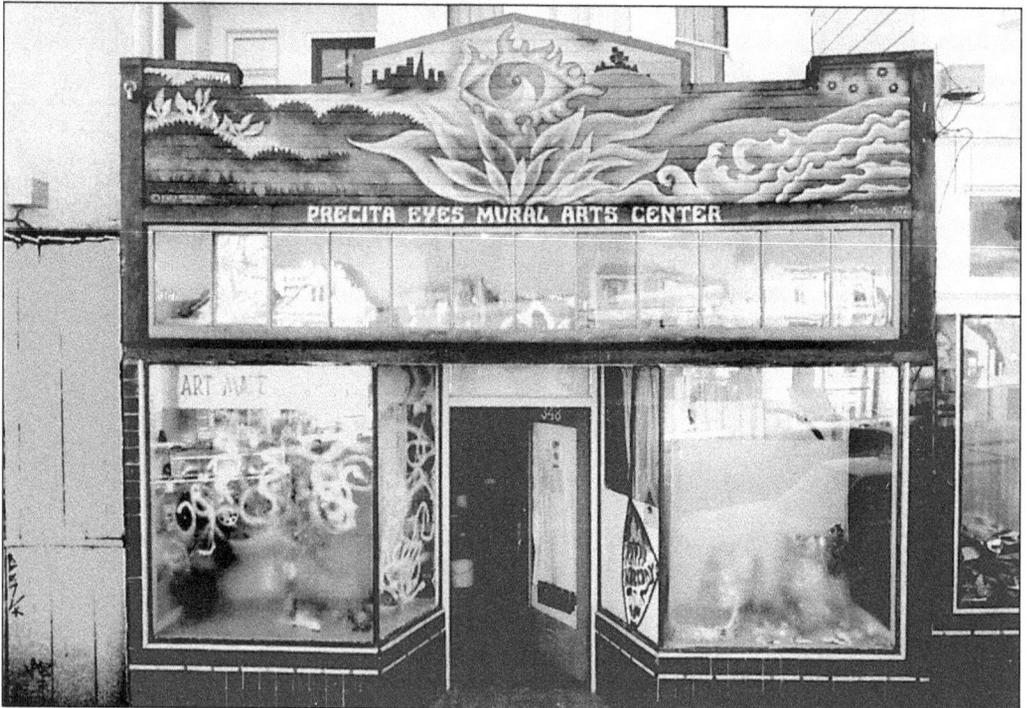

Although it has now relocated to the Mission District, this is the original Precita Eyes studio in Precita Park. Precita Eyes Mural Arts and Visitors Center is a nonprofit community arts organization that has played an integral role in the city's cultural heritage and arts education. One of only three community mural centers in the United States, it sponsors and implements ongoing mural projects throughout the Bay Area and internationally. (Courtesy Precita Eyes.)

In the mid-1990s, filmmaker Gregory Gavin was artist in residence at the Bernal Heights Neighborhood Center (BHNC) and got local teens building soapbox cars. That evolved into his short, *Bernaltown*, a fable of an evil developer who wants to make money by corrupting the area's old-fashioned virtues and who is defeated by some good old-fashioned community spirit. Pictured from left to right are Shila Evanchack, Adaya Brand-Thomas, Josh Morton, David Stoller, and Cortney Davis. (Courtesy Gregory Gavin.)

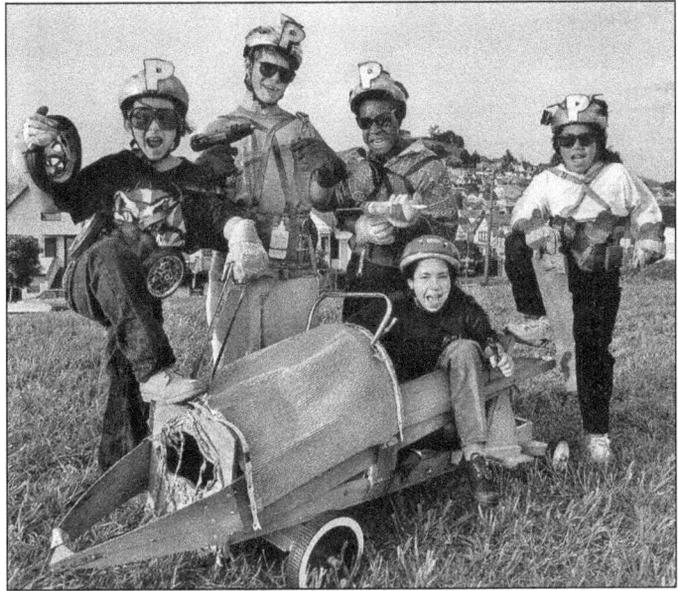

Hollywood captures Bernal Heights (at least on film), as Steve McQueen does a high-speed U-turn at Army Street and Precita Avenue in the 1968 film *Bullitt*. Bernal Heights is clearly visible in the background. This was the start of the famous car chase. After a few more shots of Bernal, director Peter Yates cut without transition to numerous other neighborhoods, creating an imaginary city that has amused San Franciscans ever since. (Courtesy Warner Brothers.)

Bernal Heights has long been home to a vibrant community of artists. Longtime Bernal artists Toby Judith Klayman and Joseph Mack Branchcomb live and work on Prentiss Street. Toby also teaches painting and design; she works in a variety of media, while Joseph works in photography, prints, and paintings. Toby is shown at work in her studio. (Courtesy Toby Klayman.)

Bernal Heights Outdoor Cinema showcases the neighborhood's wealth of filmmakers with outdoor screenings and indoor filmmaker receptions. Experienced audience members are well bundled up in case a Siberian wind sweeps in from the west. Renowned Bernal filmmakers include Oscar-winning Debra Chasnoff (*Deadly Deception*), Pat Ferrero (*Quilts*), Emiko Omori (*Rabbit in the Moon*), and Terry Zwigoff (*Crumb, Ghost World, Art School Confidential*). (Courtesy Ira Schrank.)

During the day, the top of Bernal Heights is a paradise for dogs. In other parts of the city, it's known as Dog Park. The dog has clearly replaced the nanny goat as the totemic animal of this neighborhood. Luckily most owners are good citizens and pick up after their beloved pets. (Photograph by Valerie Reichert.)

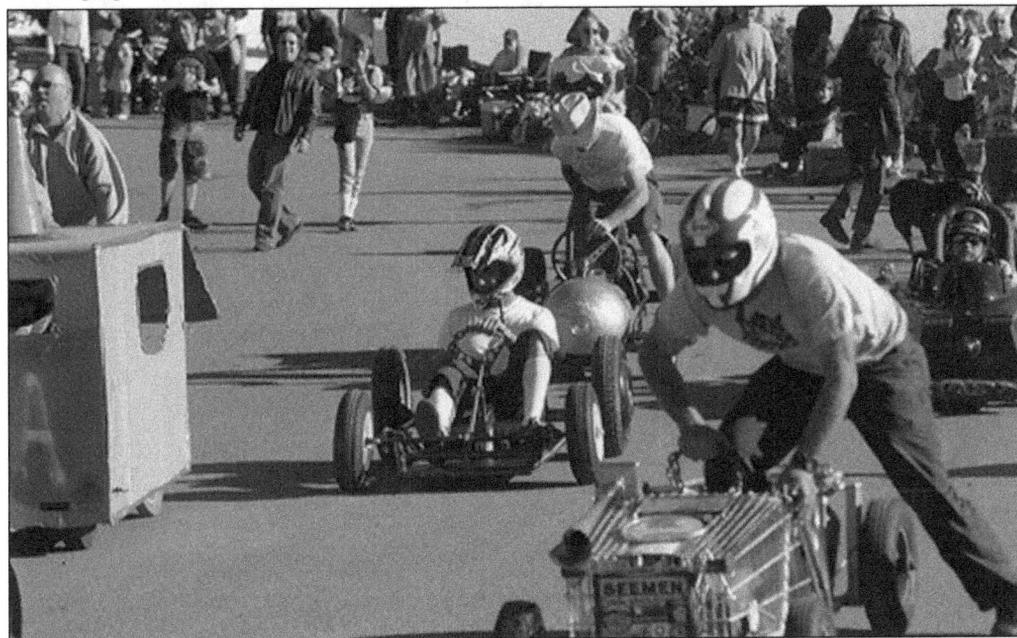

Racers assemble for the Bernal Heights Illegal Soapbox Derby on certain Sundays of the year and race soapbox cars without any official sanction—but with no prohibition either. The eclectic homemade cars, powered only by gravity, reach speeds of 35 or 40 miles per hour on the closed-off part of Bernal Heights Boulevard. (Courtesy Dolanh 2002.)

Multi-instrumentalist Ralph Carney is one of many musicians who live in Bernal Heights. Although he has performed around the world with artists like Tom Waits, the B-52s, and William Burroughs, he has found time to give a tuba concert at Red Hill Books on Cortland Avenue. He is shown in front of that bookstore with a more modest-sized horn. (Courtesy Ralph Carney.)

Bernal's Ruth Brinker founded the groundbreaking nonprofit Project Open Hand in the mid-1980s, serving meals and helping with shopping for people with AIDS in San Francisco. It has since expanded to offer meals and services for seniors and the critically ill. By 2005, it had delivered a million bags of groceries and provided more than 9 million meals to people in need. In this 1988 picture, Brinker and chef Chris Medina prepare meals for clients. (Courtesy Project Open Hand.)

Jackie Jones, a longtime Manchester Street resident, plays her handmade guitar, the musical saw, and many other instruments at the Alemany Farmers' Market every Saturday. She records the accompaniment herself. A pink wooden cat dances along to her performance, controlled by a foot pedal. There is always a knot of entranced kids around the cat, while adults stop shopping long enough to watch Jackie play wonderful 1920s popular tunes. (Photograph by Molly Martin.)

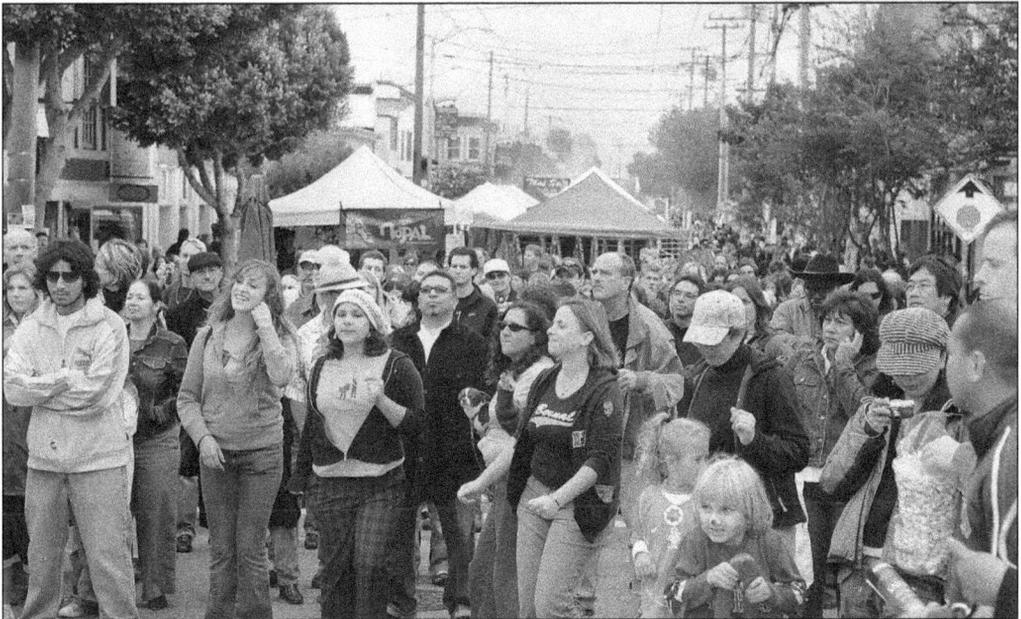

Every year, on a Sunday in October, several blocks of Cortland Avenue are closed to traffic and the crowds descend for Bernal's own street festival, Fiesta on the Hill, organized by the Bernal Heights Neighborhood Center. There are two stages with nonstop music and booths offering food, drink, and crafts. There are a petting zoo and a pumpkin patch for the kids, and everyone has a good time. (Photograph by Kingmond Young.)

In 1978, Bernal residents succeeded in fending off speculators attempting to build houses on some of the community's last open space. After their victory, those residents formed the Bernal Heights Neighborhood Center (BHNC). They bought these previously derelict properties on Cortland Avenue and renovated them before moving in 1982. The buildings had previously housed the Nickelodeon Theater, a World War I draft office, and the Iudice family barbershop. (Courtesy BHNC.)

The neighborhood center is today a hub of activity, with a strong record of success in programs for youth and seniors and particularly in building affordable housing. The BHNC has constructed homes all around the hill and in the Excelsior District. (Courtesy BHNC.)

Tom Ammiano, District 9 supervisor since 1994, is a longtime resident of Bernal Heights. He came out as a gay teacher and agitated for gay rights in the 1970s at a time when an initiative on the state ballot would have prevented gays and lesbians from teaching in public schools. Best known for his write-in campaign in the 1999 mayoral election, which forced incumbent Willie Brown into a runoff election, Ammiano continues to shake up the status quo. (Courtesy BHNC.)

Helen Helfer (shown here with Henry Cisneros, the secretary of HUD, in 2000) was a director of the BHNC who presided over several of its affordable housing construction projects. They are at the site of the Market Heights development at Putnam Street and Tompkins Avenue. (Courtesy BHNC.)

Bernal Heights was the last neighborhood in the city to have its dirt roads paved, as befits its lingering rural nature. Even as this book is being written in 2007, there are several left. The place on the hill with the most unpaved streets was the east slope, overlooking Route 101. During the real estate boom of the late 1990s, most of its dirt streets were finally paved. These photographs show Brewster Street in 1996, before and after. (Courtesy Joel Kamisher.)

Community gardens proliferated in Bernal Heights in the 1970s. Artist and gardener Mike Corbin used a city grant to build the Bernal Community Garden on the south slope of the hill between Gates and Banks Streets at the top of Folsom Street. Volunteers did the work, while city funds paid for some of the materials. The result was a neighborhood garden growing vegetables and flowers that is still maintained today. (Photograph by Valerie Reichert.)

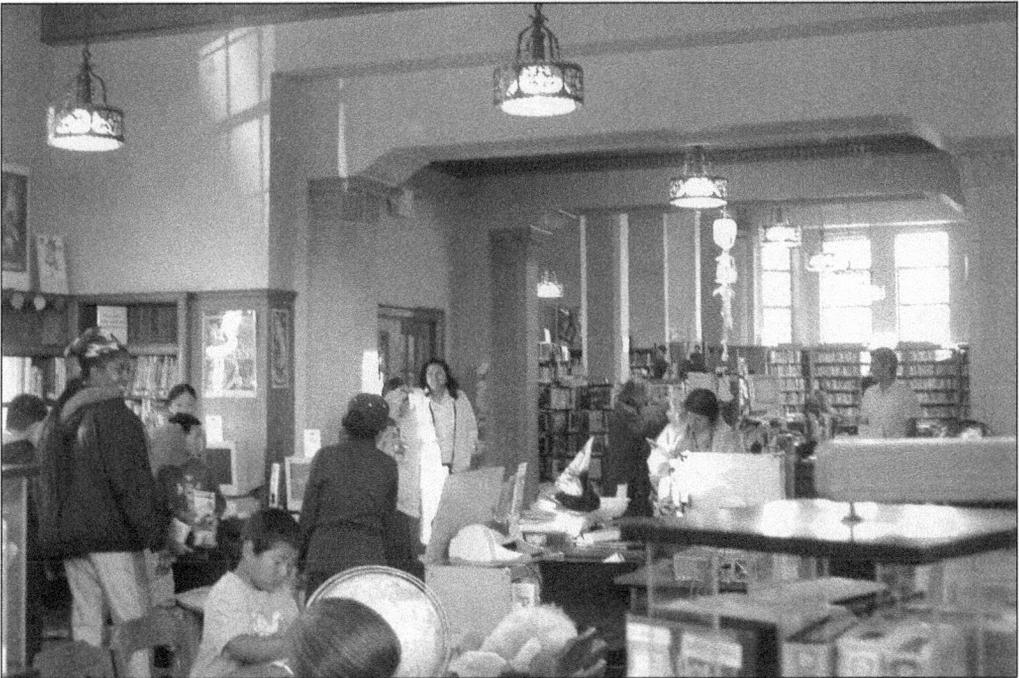

The Bernal Heights Branch Library will never again look like it does in this recent photograph. In late 2007, it will close for two years for a major earthquake retrofit. Renovation highlights include a new expanded children's room on the lower level and a designated teen area on the main floor. The building's original architecture will be respected, and many historic features will be restored. (Photograph by Valerie Reichert.)

Barbara and Roland Pitschel have been protecting and teaching about the natural history of Bernal Hill for more than 30 years. The hill is one of the few remaining small pieces of the Franciscan Biological Region and is the home to unique species of native plants. Part of Bernal Heights Park is slated to be preserved as a San Francisco Natural Area. The Pitschels lead monthly restoration and planting parties on the hill. (Photograph by Margo Bors.)

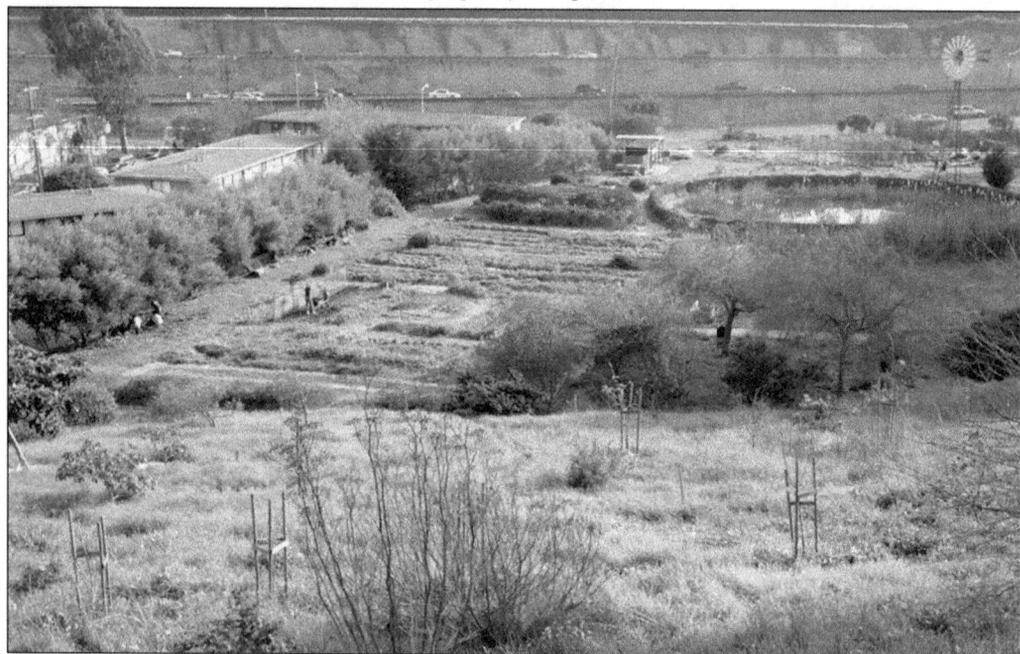

Founded in 1995 by the San Francisco League of Urban Gardeners (SLUG), Alemany Farm is a 4.5-acre parcel of land located on the far south slope of Bernal Hill next to the Alemany public housing project. A unique volunteer program involving neighbors and kids has made the old dump site a productive community garden, and Bernal again has a windmill.

Cortland Avenue, Bernal Heights's own commercial strip, had fallen on hard times by the 1980s, and many businesses had closed. Most residents did their shopping on Mission Street or in Noe Valley. The first step in the revitalization of Cortland Avenue was the 1991 opening of the Good Life Grocery, a branch of a successful store of the same name on Potrero Hill. (Courtesy Good Life.)

Good Life owner Lester Zeidman received a letter from a former Potrero customer pleading with him to open a store in Bernal Heights. He investigated the possibility, went ahead, and it was an immediate success. Once there was one thriving business to draw shoppers back, other stores opened on Cortland Avenue. (Photograph by Valerie Reichert.)

David Ayoob was the unofficial mayor of Bernal Heights. He was the owner of Four Star Video, the cochairman of the Cortland Merchants' Association, a car buff, and another of the hard-working people behind the renaissance of Cortland Avenue. He was a popular, friendly man who contributed much time and energy to improving the neighborhood. He died suddenly at the age of 53 in late 2006. (Courtesy the Ayoob family.)

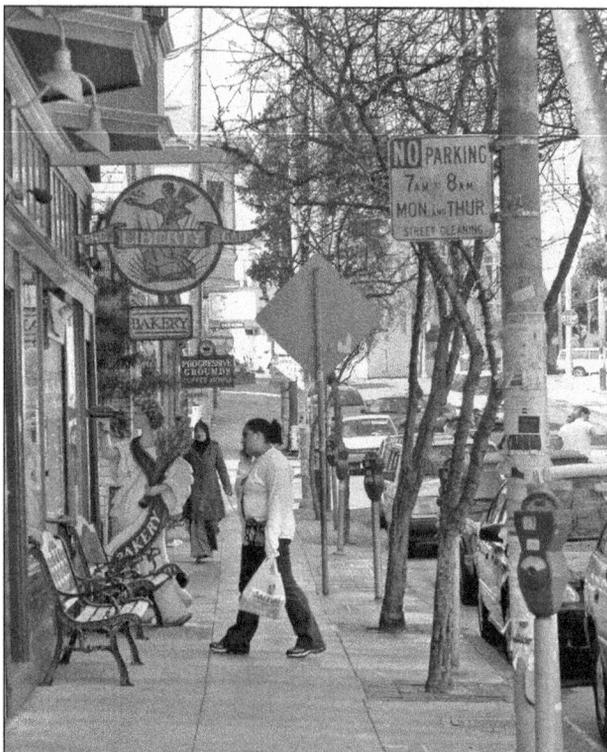

Shortly after it opened in 1994, the Liberty Cafe on Cortland Avenue began to get rave reviews for owner Cathy Guntli's American comfort food. Suddenly, in food-crazed San Francisco, people were driving to Bernal Heights to eat. Since then, several other excellent destination restaurants have opened along Cortland, including Little Nepal, Moki's, and Valentina. (Photograph by Valerie Reichert.)

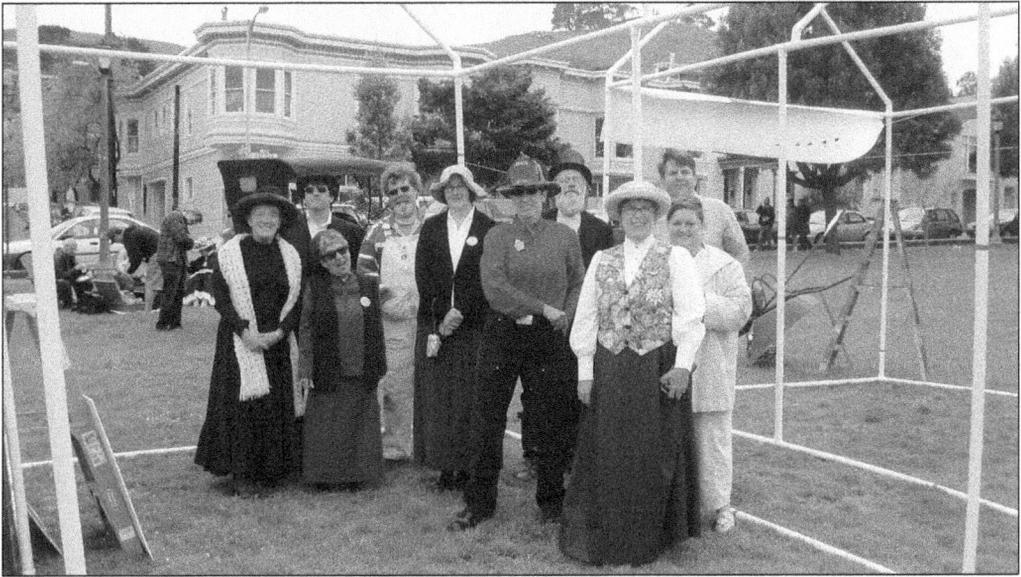

April 2006 marked the centennial of the 1906 earthquake and fire. Bernal Heights Preservation organized walking tours of the existing refugee shacks on the hill (of which Bernal has more then any other neighborhood) and constructed two "virtual" shacks from PVC pipes in Precita Park (site of a 1906 refugee camp). The local history group sponsored a picnic to commemorate the city's survival of that great disaster. (Photograph by Tim Holland.)

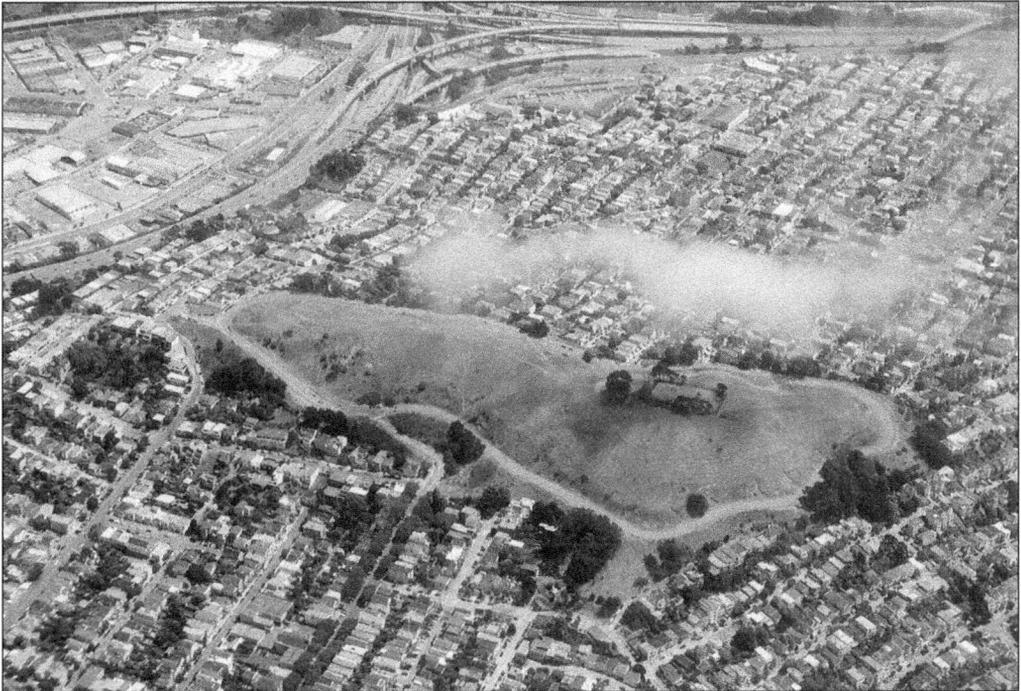

In this recent aerial photograph looking south, the "urban island" of Bernal Heights seems to have its own weather system. In the opening years of the new century, the continued revival of the hill has led to fears of traffic congestion and housing priced out of most people's means, but the neighborhood still retains its funky and contrarian ethos. (Courtesy Todd Lappin.)

Visit us at
arcadiapublishing.com

www.ingramcontent.com/pod-product-compliance
Lightning Source LLC
Chambersburg PA
CBHW050549110426
42813CB00008B/2303